Dear Ursula — the my best
— to your always
love,
Joe

A WOMAN'S TOUCH

A WOMAN'S TOUCH

WOMEN IN DESIGN FROM 1860 TO THE PRESENT DAY

ISABELLE ANSCOMBE

Elisabeth Sifton Books
Viking

ELISABETH SIFTON BOOKS • VIKING

Viking Penguin Inc.
40 West 23rd Street
New York, N.Y. 10010 U.S.A.

Published in 1984

ISBN 0–670–77825–7

Library of Congress Catalog Card Number: 84–40262 (CIP data available)

Printed in Great Britain
by St. Edmundsbury Press
Set in Perpetua

Contents

This book is dedicated to Howard Grey and
Anthony Anscombe – and to all the women
designers whose work inspired me.

Acknowledgements

This book would not have been possible without the generous help of the following people, all of whom I should like to thank: George Adams, Anni Albers, Lady Madge Ashton, the late Gudrun Baudisch, Norah Braden, Marianne Brandt, Elspeth Burder, Prunella Clough, Catherine Cobb, Michael Colefax, Susie Cooper, George Costakis, Lucienne Day, Geoffrey Dunn, Jacqueline Groag, Vicky Hayward, Dorothy Hutton, Hilda Jesser, Betty Joel, Biddy Kay, Margery Kendon, Eyre de Lanux, Christopher Lorimer, Enid Marx, Elisabeth Masterman, Mrs Curtis Moffat, Madalene Pasley, Sally Patience, Katharine Pleydell Bouverie, Lucie Rie, Barley Roscoe, Muriel Rose, Marian Russell, Werner J. Schweiger, Cecilia Lady Sempill, Mary and Willard Sheets, Lilian Stevenson, Gunta Stadler-Stölzl, Marianne Straub, Mary Newbery Sturrock, Elisabeth and Istvan Telegdy.

Acknowledgements and thanks are also due to the individuals, institutions and photographers listed below.

Annan Photographers, Glasgow, p 52; *Art & Antiques Magazine*, New York, p 71; Australian National Gallery, Canberra (by courtesy of Fischer Fine Art Ltd), p 106; Bauhaus Archiv, Berlin, pp 126, 143; British Museum, London, p 142; Christie's, London, p 182; *Country Life,* p 32; Crafts Study Centre, Holburne Museum, Bath, pp 149, 151, 157, 177; Martin Eidelberg, New York (photograph by Eric Pollitzer), p 107; The Fine Art Society and Haslam & Whiteway Ltd (photograph by Howard Grey), p 23; Madge Garland (photograph by George Platt Lynes), p 173; Angelica Garnett and Quentin Bell, p 83; Glasgow School of Art, p 57; Galerie Gmurzynska, Cologne, pp 92, 94, 98; Jacqueline Groag, p 194; Harry Hemus, p 189; Isabella Stewart

Gardner Museum, Boston, pp 74–5; John Jesse, p 55; Jordan-Volpe Gallery, New York, p 43; Biddy Kay, p 125; Eyre de Lanux, pp 125–7; Galerie Metropole, Vienna, p 104; The Metropolitan Museum of Art, New York, p 39; photographs by Millar & Harris, London, pp 77–8, 80, 170–1; National Portrait Gallery, London, pp 21, 26; Oakland Museum Association, Gift of the Art Guild, p 49; L'Odeon, London, p 109; Phillips, London, p 191; Royal Academy of Arts, London, p 132; Sotheby's, London, pp 60, 117, 123; Gunta Stadler-Stölzl, p 138; *The Studio*, p 129; The Tate Gallery, London, p 13; Tulane University, New Orleans, p 48; University City Public Library, Missouri, pp 44, 47; Victoria & Albert Museum, London, pp 65, 90, 119, 136, 154, 158–9, 162, 164, 174–5, 178, 186, 192; Wedgwood, Stoke-on-Trent, pp 180, 182; William Morris Gallery, Walthamstow, pp 18, 24–5; Mrs J.M. Williams, p 66.

In the colour section, the fabrics of Phyllis Barron and Dorothy Larcher are reproduced by kind permission of the Crafts Study Centre, Bath; Gudrun Baudisch ceramic by L'Odeon, London; photograph of 'Charleston', Howard Grey; Clarice Cliff pottery by Christie's, London; Alexandra Exter and Liubov Popova fashion designs realised by Erika Hoffman-Koenige and loaned by Van Laak, photograph by H. Ross Feltus, Sunday Times Magazine; Eileen Gray chair by Philippe Garner; Frances Macdonald painting by the Hunterian Art Gallery, University of Glasgow Mackintosh Collection; Newcomb College Pottery by Tulane University, New Orleans; photograph of Katharine Pleydell Bouverie pots, Howard Grey; Lucie Rie bowl by the Crafts Council, London, photograph David Cripps; Susi Singer and Vally Wieselthier ceramics by Herr Gerhart Baresch, photograph Herr Prutscher; Sophie Taeuber-Arp embroidery by Fondation Jean Arp und Sophie Taeuber-Arp, Bonn.

The jacket illustration, 'Designs for Fashion in an Interior', is taken from *Sonia Delaunay, Ces Peintures, Ces Objets, Ces Tissus Simultanées,* published by Chrépien, Paris, 1930. Photograph by Marina Henderson, London. Photographs on the back of the jacket are reproduced by permission of the following. *From left to right, top row*: Isabella Stewart Gardner Museum; Annan Photographers; Angelica Garnett and Quentin Bell. *Bottom row*: Galerie Gmurzynska; Galerie Metropole; Wedgwood.

Introduction

The history of the major design movements since the 1860s, when John Ruskin and William Morris put forward the theory that a nation's design and architecture reflect its social and political health, has been told through countless books and monographs. But so far these publications have been almost exclusively about men's role in these movements – despite the traditional belief that a woman's touch transforms a house into a home. *A Woman's Touch* describes the enormous contribution that women designers, artists and craftswomen have made to the major movements of the past 120 years. The work and careers of outstanding individual women also represent the countless others who designed textiles, decorated tablewares, painted murals, designed furniture or devised weaving patterns for industrial looms.

This book concentrates on those women designers whose work contributed to the modern house and its furnishings. Before the 1860s women had little or no place in the workshops and manufactures which produced furniture, metalwork, textiles, glass and ceramics, nor did they have much direct control over the choice and purchase of such items for the home. Their entry into design education and practice coincided with their emergence as patrons, clients and customers at the turn of the century. Areas such as fashion and jewellery design, which are not related to the home, have been omitted, except where they have been redefined – as in the case of fashion in Revolutionary Russia – in relation to current design theories. Architecture and the fine arts have also been excluded except in relation to the career of an individual designer, since both are subjects too large to be summarily included here.

Women first gained entry into the world of design through the iconography of the Pre-Raphaelite painters, whose medieval visions included the chatelaine at work upon her embroidery. The decorative arts – delicate, painstaking, refined – were thought by the Victorians to be peculiarly suited to female talents and, indeed, natures, whereas the fine arts, which required ambition and strength and purpose of vision, were suited only to men. Decorative art, in the hands of women, was considered to be the more successful for gracefully accepting its limitations, in seeking only to enhance

Companion to Manhood, from a triptych illustrating *Woman's Mission* by the popular mid-Victorian painter George Elgar Hicks

the home, where women guarded love, sanctity and honour against those very elements of challenge and contention so praised in men's art. John Ruskin encouraged women to play their part in the 'beautiful adornment of the state' and, albeit slowly, a new profession for women emerged.

Women welcomed their part in the Arts and Crafts Movement not because they enjoyed pretending to be medieval damsels, but because it allowed them to be active, creative and professional. Nevertheless, in the nineteenth century women were largely dependent on working under the aegis of father, brother or husband and their work was subsumed within the artistic personality of their partner. It is also notable that the majority of women who began to make independent careers for themselves towards the end of the century were in their mid-forties or older before they had both the confidence and the freedom from family life to strike out on their own. Only in America did women inhabit a society that not only allowed them some measure of autonomy, but also encouraged them to establish co-operative ventures and self-help networks.

Nevertheless, by the end of the First World War, women had sufficiently infiltrated the world of design to be able to take an equal place with male designers in the new movements, schools and professional opportunities which then emerged. Through the early ideals of the Modern Movement, women gained access to workshops, schools and professional training and, most importantly, were gradually allowed by the social conventions of the day to put their 'traditional' skills – a woman's touch about the home – to commercial use.

The Modern Movement was never merely aesthetic in its aims, although it absorbed ideas from the fine arts, but also espoused social and political theories which could no longer exclude women from its ranks. The horror of the First World War and the political upheavals that followed in some countries had forced the ideals of the Arts and Crafts Movement into a more radical mould.

Modern design was born at the Bauhaus, where all the former disciplines of the applied arts were linked with art and architecture to form a new approach to the teaching and practice of design, an approach which believed that good design served the needs of ordinary people, of the workers. This revolutionary concept, although interpreted differently in practical and aesthetic terms by different groups in different countries, underlay the work of most designers in the 1920s and 1930s.

Although women designers contributed little to the theoretical writings on modern design, their practical influence was enormous. The fact that their contribution has been overlooked has led to a narrow and distorted interpretation of the true scope and achievements of the design movements of the twentieth century.

Women are traditionally associated with nature rather than culture, a division which, in design terms, has placed them in fields where manual dexterity, a feel for texture, a familiarity with natural materials – such as clay

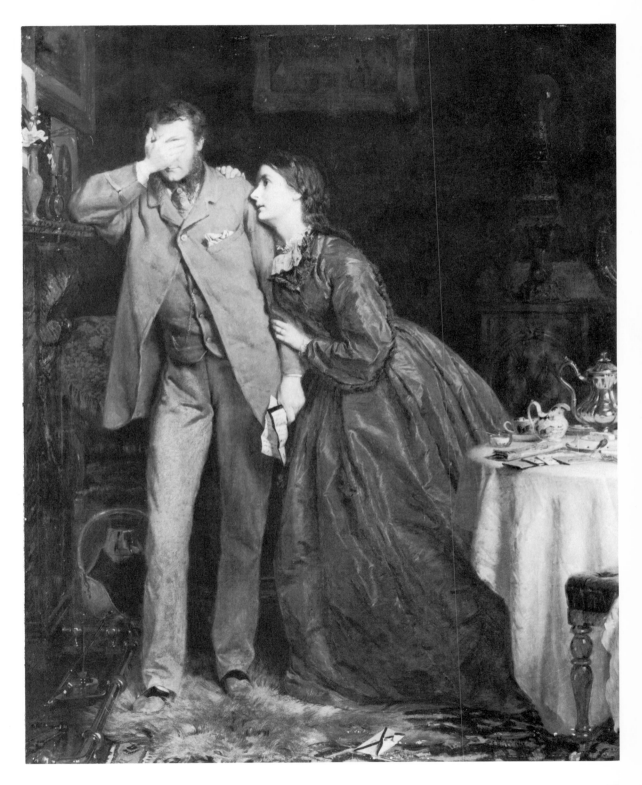

or vegetable dyes – and small, home-based workshops take precedence over man-made materials, large-scale machine production or an eye for three-dimensional form.

Ironically, it was in textiles – the field traditionally held to be female because of the iconography of the lady with her embroidery frame – that women pioneered, whether in America, Russia, France, Germany or Britain. It was women who adapted the skills of the hand-loom weaver to industrial production; who rediscovered formerly disregarded techniques of dyeing and printing; who re-interpreted Cubism and other forms of abstraction for use in the home and in fashion design; who, for the first time, went outside European culture to find patterns and colour combinations; and who re-mained true to their theoretical ideals while bringing colour and pattern into line with modern architecture.

The vital contribution made in other fields by women designers in the 1920s and 1930s also casts doubt on many of the assumptions that society has made about artistic experience and practice and suggests that, in design, the division between nature and culture is a false one. Gunta Stölzl in Germany and Ethel Mairet in Britain integrated the experience of the hand-loom weaver with industrial production, and their successful designs brought a vital touch of colour and texture to the otherwise stark concrete and glass of modern architecture. Charlotte Perriand, in her collaboration with Le Corbusier on a range of chairs, took her inspiration from contemporary car design. Betty Joel introduced a recessed handle into her furniture designs in order to reduce the number of surfaces which required dusting.

Women have often been thought to lack the driving ambition to face physical danger or to show single-minded dedication to a task. Yet, to take only two examples, Phyllis Barron chose to research discharge printing and happily undertook work that was perilous and physically exhausting, while Katharine Pleydell Bouverie spent a lifetime documenting the different glazes that can be made for pottery from vegetable and wood ash. Women designers have displayed a variety of talents, from business acumen to aesthetic merit, from a flair for public relations to the mastery of intricate technologies, which show that once women were able to bring their skills into a world wider than their own homes, they were remarkably successful.

Women's artistic achievements have also been belittled by the idea that it is natural for a woman to demonstrate good taste, to be interested in the home and express her personality through it, which has in turn led to the belief that, in designing for the home, women were professional designers by default. In the 1920s the links between abstract art and design became very close. Significantly, it was women who pioneered the practical application of abstraction to the domestic interior in this period. Sonia Delaunay's apartment in Paris's Boulevard Malesherbes, Sophie Taeuber-Arp's house at Meudon or Vanessa Bell's decorative schemes, executed in collaboration with Duncan Grant, at 'Charleston' in Sussex were perhaps the most complete and important decorative schemes each of these women undertook and mark a

vital interaction between art and life. Yet precisely because their art was so successfully integrated with life, it is all too easily dismissed as a natural extension of woman's role.

The years after the First World War also saw the beginning of dramatic changes in household technology. It was women who incorporated a practical knowledge of the needs of the housewife or servant in designs for rugs, furniture, curtain and upholstery fabrics or tablewares. Equally, it was women who called for architects to consider such amenities as communal kitchens or wash-houses, despite the fact that even the most avant-garde of the male architects continued to design houses on the basis of the nuclear family.

Few of the women involved with the Bauhaus, the Wiener Werkstätte or the advance of modernism in France or Britain have received the acclaim given to the 'Old Masters' of these movements – Charles Rennie Mackintosh, Josef Hoffmann, Walter Gropius and Le Corbusier. Like the majority of designers who trained or worked with the masters, the women were among the more humble members of the team. But, looking at the part women played, it is possible to re-evaluate these movements, to see them less in terms of the theories put forward and more in terms of their practical achievements. Some, such as the Wiener Werkstätte, fell far short of their aims; some, such as the Bauhaus, have had a vital influence on the way household furnishings are still designed and manufactured; others succeeded in ways that have never received their due attention – with such quietly revolutionary innovations as stacking tableware, sound-absorbent fabrics or the push-button light-switch. The pragmatism of the women who ran the weaving workshop at the Bauhaus and who made real the ideal of the anonymous designer creating furnishings for worker housing; the artistic integrity of Sonia Delaunay and Sophie Taeuber-Arp, who transferred the aesthetic beauty of their art from canvas to walls, curtains and dresses – all achievements that fulfilled the aims of the Modern Movement – have been consistently overlooked; not simply because these were women's achievements but because design literature has focused on theoretical writings rather than the objects produced by designers. In fact, as this book will show, the study of the lives of women designers and their pragmatic approach to design leads inevitably to a radical reassessment of the history of twentieth-century design.

I. The Blessed Damozel

The Gothic Revival began as a search for the renewal of an English art for England. It was both the stylistic embodiment and the symbol of an apparently liberal ideology: those who marched under its banner were opposed to the unchallenged expansion of industry and sought to ameliorate the conditions of working people. But in fact the social model which they advocated was both paternalistic and idealised, offering freedom of artistic expression as a panacea in place of working-class organisation and agitation. The artist and social critic John Ruskin, for example, championed the Gothic Revival because he admired the supposed model of medieval society – where the workman was both protected and free to express his individuality – that it espoused. His medieval ideal was adopted by the middle classes as a veil between themselves and the threat of revolution posed by the Chartist uprisings of the 1840s: middle-class Victorian England was to be saved from chaotic social upheavals by a dream of a state based upon a medieval idyll.

While many university-educated, prosperous young men were liberated from careers in business or law and found their choice of art, architecture or design sanctioned by the Arts and Crafts Movement which developed out of the Gothic Revival, the few attempts to set up co-operative craft workshops failed to compete with the established firms and were short-lived; in practical terms, the working man and woman received little benefit from the movement's aims.

The role awarded to women was just as deceptive. Workers and women alike were offered art as a reward for obedience. Ruskin saw women's task as 'sweet ordering, management and decision' within the home and, further, 'The woman's duty, as a member of the commonwealth, is to assist in the ordering, in the comforting, and in the beautiful adornment of the state.'[1] One of the many women writing on decoration in the 1870s eagerly quoted the French architectural historian, Viollet-le-Duc, who wrote that 'with the sway of feudalism the role of women became important . . . she assumed in the castle an authority and influence over the matters of everyday life superior to that of the castellan himself.'[2] Women were to take part in the great patriotic

adventure of the Gothic Revival and to assume a new authority by remaining where they were, in the home, as guardians of the temple of the hearth.

There is no doubt that many middle-class women welcomed this new portrayal of their role. Some passively adopted it as a fashion and as a means of self-expression; others discovered that it created a useful gap in the ideological fence and they flocked through to learn skills such as embroidery, book-binding or china-painting, which gave them a small independent income and widened their range of opportunities in the market-place. And a few found that they possessed talents which won them a place of honour in the history of nineteenth-century decorative arts. Nevertheless, the dominant image of women remained passive: women were the embodiment of beauty and, if they were to take up such 'elegant and useful amusements' as embroidery, it was merely to stress one of the more charming aspects of that image.

The romantic medieval nostalgia of writers and artists such as Alfred Lord Tennyson, Poet Laureate, and the Pre-Raphaelite painters created a new model of female beauty. Beauty was the Pre-Raphaelites' religion and physical beauty something to be worshipped. Edward Burne-Jones's wife, Georgiana, recorded the impressions of a woman who sat for her husband and for Dante Gabriel Rossetti. 'I never saw such men,' she said, 'it was being in a new world to be with them . . . they were different to everyone else I ever saw. And I was a holy thing to them – I was a holy thing to them.'[3]

Another writer, the tiny, vivacious Mrs Haweis, an expert on Chaucer and friend of painters such as W. P. Frith and Lawrence Alma Tadema, gave this advice to 'The Plain Girl':

> Those dear and much abused 'prae[sic]-Raphaelite' painters whom it is still in some circles the fashion to decry, are the plain girls' best friends . . . Morris, Burne-Jones, and others, have made certain types of face and figure once literally hated, actually the fashion. Red hair – once, to say a woman had red hair was social assassination – is the rage. A pallid face with a protruding upper lip is highly esteemed. Green eyes, a squint, square eyebrows, white-brown complexions are not left out in the cold. In fact, the pink-cheeked dolls are nowhere; they are said to have 'no character' . . .[4]

The woman who became the icon of this ideal beauty was William Morris's wife, Jane Burden. It was Rossetti who first saw the strikingly beautiful girl at the theatre with her sister in Oxford in 1857 and he asked her to come and sit for him. She did so and immediately became the centre of an admiring circle of young painters who were decorating the Oxford Union with scenes from Malory's *Morte d'Arthur*. At this time, when Morris first met her, he was brimming over with unfocused ideals and enthusiasms, unsure whether to be a painter or a poet, deeply immersed in tales of medieval chivalry and romance. He painted Janey both as La Belle Iseult – the subject of his Union fresco – and as Queen Guenevere – the heroine of his first volume of poetry; a disarming tribute for a seventeen-year-old who was unused to such rhetoric. By the following spring they were engaged.

In the summer of 1858 Morris went on a rowing trip down the Seine with

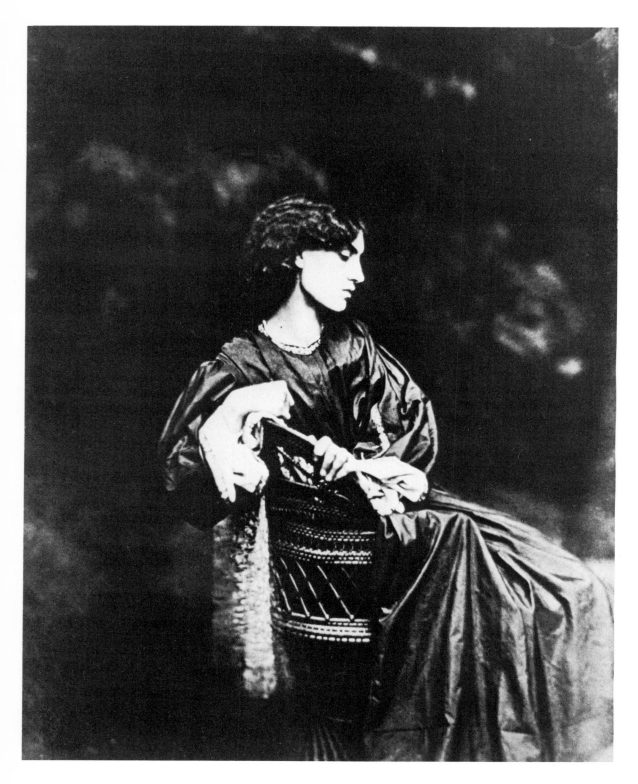

Philip Webb and a former Oxford friend, Charles Faulkner. Webb and Morris had become friends when Morris was briefly articled to G. E. Street, an architect in whose offices some of the most influential designers of the Arts and Crafts Movement trained. Amid the medieval châteaux and churches of France, Morris and Webb discussed the matrimonial home that Morris planned to build in an apple orchard he had bought in Upton in Kent. Later that year Webb designed an L-shaped house of red brick with steep roofs and irregularly set windows; inside the bricks were left bare in places. It was to be the ideal setting for Janey, Morris's 'glorious lady fair', whom he married in Oxford in April 1859.

Morris and his friends planned to decorate the Red House in the medieval manner, with richly painted furniture and embroidered hangings. It was an important part of Morris's attempt to recreate medieval England. As a friend later wrote, 'he did all he could to forget six centuries or so and make believe we were living in the Middle Ages – a feat impossible for most of us, but all of a piece with the childlike simple-mindedness of the man'.[5] Morris and Webb had both become interested in embroidery and other forms of medieval decorative arts when working with G. E. Street and Morris taught Janey how to do simple woollen crewel work. For their bedroom she embroidered a repeating 'Daisy' motif 'in bright colours in a rough simple way' on dark blue serge; she also helped Morris to paint a floral design on the drawing-room ceiling and she and her sister, Elizabeth, worked a set of large figurative panels for the dining-room. Rossetti and Burne-Jones painted furniture and walls as well as designing stained glass and tiles. Their collaboration prompted the idea of forming a decorating firm, which was established in 1861 as Morris, Marshall, Faulkner & Co. (later Morris & Co.).

Janey was pregnant with their first daughter, Jenny, when they moved into the Red House in the summer of 1860. A second child, May, followed in March 1862. In these early years of marriage, the Morris household, with its hospitable and easygoing atmosphere, was full of visitors: Elizabeth Burden, Edward and Georgie Burne-Jones, Philip Webb and Charles Faulkner with his two sisters, Kate and Lucy, joined Janey and Morris in decorating the house, exploring the countryside, singing old English songs and playing bowls, hide-and-seek and practical jokes. Despite the difference in Janey's background (her father was a stableman), she was accepted easily by the other women in the group and became good friends with Georgie Burne-Jones and the Faulkner sisters. A common loyalty to their menfolk and their ideals bound them together.

In 1865, however, Morris sold the Red House and settled his family and his business in London at 26 Queen Square. Janey began to suffer from nervous rheumatism, brought on by living in the centre of London with two small children and acting as hostess to noisy weekly gatherings of all those associated with Morris & Co., and became a chronic invalid at the age of twenty-five. In a world of railways and hansom cabs, there were few occupations open to a woman idealised as the chatelaine of a castle riding out

Photograph of Janey Morris posed by Dante Gabriel Rossetti in 1865, when she was twenty-five

to gather flowers, a falcon on her wrist. Henry James visited Queen Square about this time and wrote home to his sister:

> Oh ma chère, such a wife . . . she haunts me still . . . It's hard to say whether she's a grand synthesis of all the pre-Raphaelite pictures ever made – or they a 'keen analysis' of her – whether she's an original or a copy . . . There was something very quaint and remote from our actual life, it seemed to me, in the whole scene . . . and in the corner this dark silent medieval woman with her medieval toothache.[6]

In 1867 Rossetti, now a widower, asked Janey to sit for him again and promptly fell in love with her. In 1871 he and Morris took a joint lease on Kelmscott Manor in Oxfordshire in the hope that Janey's health would improve and that the love affair could unfold in seclusion. Away from Morris – who usually remained in London – Janey did recover, but Rossetti's drug addiction and suicidal moods worsened and, as his love for her grew into an obsession, he broke down completely. He finally left Kelmscott in 1874. Janey continued to see him and to sit for him until his death, eight years later.

Janey's beauty, as depicted by Rossetti, set a fashion; the stage designer W. Graham Robertson even went so far as to describe one woman as 'Mrs Morris for Beginners'! She had all but become a myth by the time she was forty. Yet during the 1870s her life became more wretched; her health grew worse, her eldest daughter began having epileptic fits of frightening intensity and, despite her husband's valiant attempts to 'look at things bigly and kindly', she had his misery to contend with as well. Robertson was keenly aware of the sense of captivity Janey must have felt in her role by this time:

> Mrs Morris required to be seen to be believed, and even then she was dreamlike . . . I fancy that her mystic beauty must sometimes have weighed rather heavily upon her . . . I feel sure she would have preferred to be a 'bright, chatty little woman' in request for small theatre parties and afternoons up the river.[7]

After Rossetti's death, Janey's marriage continued uneventfully: she took frequent trips abroad and, after Morris's death, continued to live in their house in Hammersmith. But she never fully escaped the mythology that had surrounded her in her youth.

By the 1870s the stained glass, tiles, wallpapers, fabrics and furniture designed by Morris, Webb, Rossetti and Burne-Jones were in demand among the avant-garde middle classes. It was a sign of modernity to furnish one's home with Morris & Co. rugs, chintzes and simple 'Sussex' dining chairs, demonstrating that one espoused art, romance and social concern in contrast to the vulgar show of wealth which typified the earlier generation.

Several women were drawn into the circle of artists and craftsmen surrounding Morris & Co. The conception of women as medieval chatelaines sanctioned their involvement in decorative arts, especially embroidery, which was an important part of the firm's stock: Janey Morris, Elizabeth Burden, Kate and Lucy Faulkner, Catherine Holiday (wife of the stained-glass designer

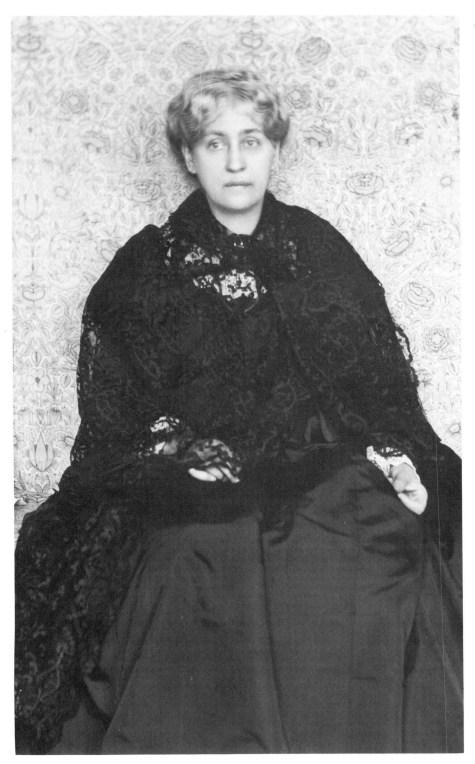

Janey Morris,
photographed when
she was probably in
her mid-fifties. The
negative has been
re-touched

Henry Holiday), Lucy Yeats (W. B. Yeats's sister) and Madeleine Wardle (wife of the firm's business manager) all executed embroidery for the firm.

Among this group, Bessie Burden, who lived with the Morrises in Queen Square, was later to become chief instructress at the Royal School of Art Needlework, opened in 1872 to provide a form of respectable employment for needy gentlewomen. Both Kate and Lucy Faulkner decorated tiles for the firm. Lucy married the wood engraver Harvey Orrinsmith in the 1860s and her involvement with the firm ended, although she continued to write on decoration and her daughter, Ruth, later became a wood carver. Kate executed gesso decoration for Philip Webb's furniture, designed wallpapers and china decoration and, at Burne-Jones's suggestion, 'reformed' pianos.

These women were not encouraged to pursue careers independent of the firm (their contributions remained unpublicised) and their activities were sanctioned by their membership of a protective, extended family group. Kate Faulkner, for example, who never married and in the 1880s shared a house in Caroline Place, Bayswater, with her brother, Charles, became a close friend of Georgie Burne-Jones, who appreciated her gentle nature and keen sense of humour, and both Webb and Burne-Jones were very fond of her. When Charles Faulkner suffered a stroke in 1888, Webb used to call in almost every evening to see her until her death in 1898.

The group also, however, extended a welcome to women who were social exiles. Madeleine Wardle, for example, had been at the centre of an infamous murder trial in Scotland where the passionate letters she had written to the victim, a social inferior, a mere tutor, had been a major source of scandal. But while there was a radical awareness and a fairly liberated attitude to social class among the group, these women were not pioneers (with the notable exception of Mrs Pine who, some years later, worked for Morris's Kelmscott Press and became the first woman member of the London Society of Compositors) and their activities remained centred on the work of their husbands, fathers and brothers.

Janey Morris's younger daughter, May, was the only woman within the circle to gain any real autonomy as a designer, although throughout her life she remained under her father's shadow. In 1885 she took over the management of the embroidery section of Morris & Co., although Morris remained active in the firm until his death in 1896. As a child she had been surrounded by the activities of the firm; her favourite doll was a wooden, jointed artist's lay figure, used as reference for posing the human figure, and Rossetti had taught her to draw at Kelmscott Manor. She had also probably attended classes at the Royal School of Art Needlework when her aunt was teaching there.

In the decade following May's arrival as manager of the workshop, Morris & Co. produced dozens of designs, both ecclesiastic and domestic, for curtains, screen panels, work bags, cushion covers, table-cloths and cot quilts. Customers could buy either finished work or marked-out designs, complete with dyed silks or wools, to be worked at home. Many of the designs were by

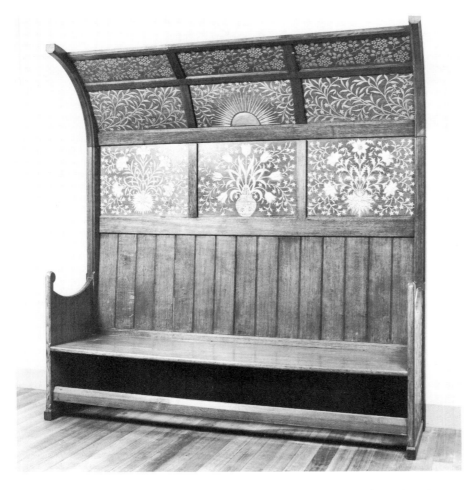

Oak settle designed by Philip Webb for Morris & Co., with gilded gesso decoration thought to be by Kate Faulkner, *c.* 1880

May herself or by Morris's young pupil J. H. Dearle, although earlier designs by Webb, Morris, Rossetti and Burne-Jones were also still used.

Where her father portrayed figures in his embroidery, May concerned herself almost exclusively with flowers and trees, showing a lightness and directness distinct from his patterning. First study nature, she wrote, then

> the living flowers should inspire a living ornament . . . but the forms all simplified, leaves flatly arranged, stems bent into flowing curves to fill the required spaces . . . [so that] in exchange for the subtle, unconscious and untranslatable beauty of nature, we get the charm of conscious art; the artist exacting service from nature, and obtaining it, graciously and ungrudgingly given just in so far as it is lovingly and frankly asked for.[8]

Her work displays an easy familiarity with historical pattern and a firm technical understanding of how to space a flowing design, but lacks any great boldness – or determination to express her own ideas. May also designed wallpapers and bookbindings and later made jewellery, but she was regarded

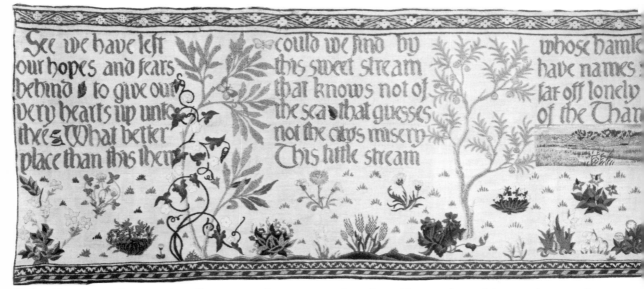

See we have left our hopes and fears behind & to give our very hearts up unto thee. What better place than this then

could we find by this sweet stream that knows not of the sea that guesses not the city's misery. This little stream

whose hamlet have names far off lonely of the Than

Embroidery in wools on linen designed and worked by May Morris. The inscription is *June* from William Morris's poem, *The Earthly Paradise*

primarily as an authority on embroidery. She taught and lectured in London and Birmingham; in 1893 she published *Decorative Needlework* and in 1910 undertook a lecture tour of America.

May adored her father – her friends later said that she never regarded any man as his equal and that the words 'my father' were never off her lips – and her writing and lecturing were perhaps undertaken more as a homage to his beliefs than from personal commitment. Certainly her embroidery shows her to have been his faithful disciple rather than a passionately motivated artist.

Neither did she manage to escape his dominating influence in her personal life. When May was in her twenties, Morris became increasingly involved in the socialist movement. In 1885 he founded the Socialist League and began editing *The Commonweal*, which became a weekly paper devoted to the propagation of socialism. His political beliefs were heavily imbued with a utopianism based on his medieval nostalgia and to those who came to socialism through his personal influence – and they were many – he was a revered and romantic figure, the poet-craftsman whose vision of the future was as beautiful as it was humane. Regular meetings were held in the converted coach house next door to Kelmscott House in Hammersmith where the family then lived and on Sunday evenings many idealistic young men joined the family around the great oak trestle table in a room hung with Oriental rugs. May had her mother's looks, if not her beauty, and she had several admirers among her father's followers. Bernard Shaw believed that a 'Mystic Betrothal' took place one evening as May bade him good night in the hall; their eyes met in a long, intense look and Shaw took this as her tacit acceptance of his equally tacit proposal. But May was already engaged to Henry Halliday Sparling, a rather sensitive-looking young man who idolised her father. They were waiting to marry until Harry found gainful employment; in the event, Morris gave him a job, first as joint editor of *The*

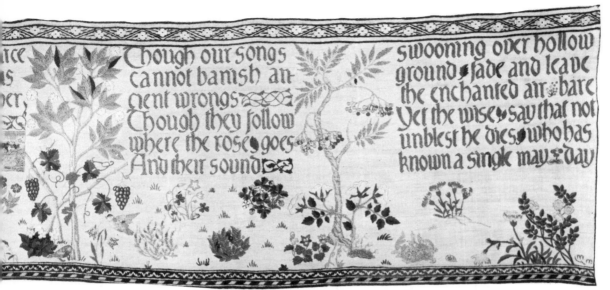

Commonweal, then as proofreader and secretary to his new Kelmscott Press, and the couple married in 1890.

However, Shaw went to live with them. According to his account, he realised that he and May must either consummate their love, risking a scandal within the Socialist League, or that he must leave. Shaw left and he believed Harry had also left, never to return, but this was not the case; Sparling continued to work for Morris in Hammersmith until 1893, when he left for Paris, and it was not until 1898, sixteen months after Morris's death, that the couple were divorced.

Even after her father's death May remained slavishly devoted to his memory. She continued to live in her house in Hammersmith Terrace, where she ran an embroidery workshop and edited his complete works for publication. In the early 1920s she severed all connections with Morris & Co., sold her London house and retired to Kelmscott Manor with her companion, Miss Lobb, who had first come there as a Land Girl during the First World War. Visitors to Kelmscott in the 1920s and 1930s would be shown around the house; the pages of Morris's vellum books turned with an ivory knife, a bunch of roses cut from the trees he had planted. In addition, May frequently lectured and also broadcast about her father's work and she organised the building of a Memorial Hall at Kelmscott (designed by Ernest Gimson and opened in 1934 – the centenary of Morris's birth). Perhaps most tellingly of all, at the age of seventy-five she went to Iceland, visiting on horseback the barren places which had first captivated her father over sixty years before. She died in 1938 on her return to England.

The changes in the style of interior brought about by Morris and other Arts and Crafts designers and the ideal of female beauty symbolised by Janey Morris were part of a general development in taste, which had an impact even

May Morris in the early 1900s, when she was in her forties

on the way women dressed. Mrs Haweis, in *The Art of Beauty*, recommended oak furniture and dark tapestries for interiors where harmony would replace brilliance and detail would become important; women should abandon loud patterns and gaudy colours for loosely draped clothes in soft colours, worn with delicate jewellery, for the new woman was subtle, gentle and mysterious. Indeed, much of the language used in the debates on design centred on light and reflection; gleaming diamonds, flashy cut glass, ostentatious chandeliers were all condemned as vulgar, while subdued colours and plain, unreflective surfaces showed discrimination and good taste. One of the most indicative changes in fashion was in jewellery. Several of the designers working in this field were women: Georgie Gaskin, Edith Dawson, Phoebe Traquair, May Morris and, in Glasgow, the Macdonald sisters and Jessie M. King. They designed inexpensive jewellery with materials such as pearls, mother-of-pearl and semi-precious stones (moonstones for example), which made wide use of enamelled decoration: to flaunt diamonds, rubies or emeralds showed a flagrant lack of taste.

By the 1880s, however, another very different image for women had been created by the Aesthetic Movement; it began in the 1860s with the first glimpse of Japanese ornament and developed into a craze for ebonised furniture, peacock feathers, apple blossom and sunflowers, all motifs which were readily absorbed into new patterns for textiles, china, jewellery and clothes. It was essentially a decorative fashion with little ideological content other than an overt demonstration of sophisticated taste and it promoted an innocently sexy image of young women. The most familiar images of the Aesthetic woman who shopped at Liberty & Co., decorated her home with Japanese fans and wore the fashionable 'greenery-yallery' colours, were, apart from those lampooned in *Punch*, the pastel, bonneted figures of Kate Greenaway, criticised by contemporaries as a demasculinised version of Walter Crane, and the blond heads and dimpled arms of W. S. Coleman's portrait plaques, painted by the ladies of Minton's Art Pottery studio at South Kensington; the most erotic were the veiled bathers in the paintings of Sir Lawrence Alma Tadema. The movement's creed was often expressed through witty paradox, as when Wilde's Lady Bracknell declared that 'a girl with a simple, unspoiled nature, like Gwendolen, can hardly be expected to reside in the country'.[9]

The Aesthetic Movement emphasised the social cachet of good taste and, to reinforce this message, furniture, pottery and other decorative items were given the prefix 'Art'; a sophisticated customer bought Art Furniture and Art Pottery or even dressed in 'demure Art colours'. As certain types of craft work were reclassified as Art-work, the benediction of good taste spread not only to the possessor of such objects but also to their makers, an enormous number of whom were women, as such work was redefined as an artistic activity. One of the major problems of the late nineteenth century was the need to find employment for unmarried middle-class women who had no father or brother to support them, but who had been brought up in a society that believed

working for money entailed loss of caste. The model of the medieval lady with her embroidery frame created by the Arts and Crafts Movement had sanctioned Art-work as a suitable female occupation; now, thanks to the Aesthetic Movement, the boundaries of decorative work suitable for women were redefined to include crafts such as china-painting, bookbinding, poker-work and metalwork which did not have the traditional feminine association of embroidery. However, this did not imply any significant shift of values or view of women's roles: indeed, it was crucial for the suitability of those crafts that they did not entail the supposedly unfeminine traits of personal ambition or the egotism of the fine arts and, in the vast majority of cases, women were merely executing designs created by male artists. Despite William Morris's claims for the vital importance of applied arts, the cultural split between art and craft remained, leaving crafts to take an inferior place in the hierarchy of artistic values.

Nevertheless, the cachet and popularity of Art-work allowed women's active involvement in the decorative arts to break out of the narrow circle it had previously inhabited and did lead to the creation of a wider range of opportunities for women's employment. In what appears to have been a successful attempt to cater for the market created by women's entry into these fields, the publishing house Macmillan & Co. launched a series of books in the 1870s called 'Art at Home', giving advice on how to decorate one's home in the new Art style, which suggested a gradual but radical shift in attitude.

In *The Drawing Room, Its Decorations and Furniture*, Lucy Orrinsmith (née Faulkner) advised the fashionably artistic young lady to learn to stain and polish wood rather than dabble with watercolours for which she had no real aptitude nor access to proper training. In recommending the Queen Anne style, which was adopted by such architects as E. W. Godwin, she wrote of the eighteenth century:

> Women of the middle and upper classes could not disdain to take an active part in the management of their households, for, as comparatively few servants were employed, there was absolute need for their mistress' help . . . their lives were more busy, therefore more healthy and more tired, their chairs were made for rest, their sofas for repose, their tables for substantial needs.[10]

Mrs M. J. Loftie, who wrote *The Dining-Room*, was a regular contributor to the *Saturday Review*, where she gave firm support to a professional, businesslike attitude among the younger generation of women. She applauded the 'growing and most encouraging desire amongst young girls to be taught to earn their own livelihood' and to show 'some ambitions besides those of being fashionably dressed or getting a pair of new earrings', but added that 'women have only begun to learn that there is no market for unskilled labour . . . in no employment will ladies succeed until they cease to be merely amateurs'.[11] The old ideas that women should conspicuously abstain from useful employment outside the home and that they were constitutionally incapable of hard work

and mental concentration were being challenged.

However, it was more difficult to translate theoretical acceptance into personal action and those who took Mrs Loftie's advice found that the traditional view of women was still strongly held. Agnes and Rhoda Garrett, who contributed *Suggestions for House Decoration in Painting, Woodwork, and Furniture* to the Macmillan series in 1876, decided to set up their own decorating business. Agnes was the sister of Elizabeth Garrett Anderson and Millicent Fawcett; Rhoda, who was their cousin, was a clergyman's daughter from Derbyshire who came to London when she was twenty-six, hoping to train as an architect. Although architecture was by then established as a fashionable profession for young middle-class men, there was great opposition to the idea of women in trailing skirts, out in all weathers, inspecting muddy building sites, or hiring and firing workmen. It took the Garrett cousins several years to find an architect prepared to take them on as clerks, but eventually Mr J. M. Brydon of Marlborough Street (who was later to design the New Women's Hospital in Euston Road for Dr Garrett Anderson) employed them when he formed his own firm. After a walking tour around England, visiting and sketching old buildings and interiors, they succeeded in setting up their own decorating firm, designing furniture, chimney-pieces and wallpapers in the Queen Anne style. They were particularly concerned to provide decent interiors for those who could not afford to employ a firm like Morris & Co. Among their commissions were the new women's university colleges.

Rhoda later spoke bitterly of the frustrations she had experienced in attempting to learn a useful trade. Addressing a meeting of the National Society for Women's Suffrage, she told her audience:

> I know women who have tried to do so, and whose difficulties lay, not in their want of power to acquire the requisite knowledge, but in the almost over-whelming prejudice of those already in possession of the vantage ground which stops them at every turn.

She had also been confronted with the argument that women did not possess the physical strength to undertake such work; the reactionaries declared that ladies were too delicate to be thrust into the market-place of professional life, even though the reformers insisted that inactivity, boredom and unnatural fashions in dress and furniture made women nervous, listless and prone to ill health. Rhoda's own health was poor (she in fact died of typhoid at the age of forty-one) but, she maintained,

> No amount of hard work, with the hope of success at the end, would break down a woman's health in comparison with the struggle with anxiety, disappointment and contempt, which she now has so often to endure, and which truly makes 'the whole head sick, the whole heart faint'.[12]

Most of the women who succeeded in making a name for themselves still did so only because they were able to enlarge their sphere of activity under the aegis of a husband, father or brother, as the women in the Morris circle had

done. Walter Crane's sister, Lucy, lectured on dress and decoration and her talks were published posthumously by Macmillan & Co. in 1882. The watercolourist Edith Dawson and the illustrator Georgie Gaskin both turned to designing jewellery in collaboration with their husbands; Edith became a superb craftswoman while Georgie supplied the designs which were executed with the help of assistants and her husband who specialised in enamelling.

Other women worked within the havens of the new art schools which taught crafts, such as Mary Newill at Birmingham, or within established firms, such as Hannah Bolton Barlow, one of Doulton's chief designers. Among the aristocracy, the women in the circle of cultivated statesmen and landowners known as the 'Souls' were able to express their artistic talents through patronage; the Hon. Mrs Percy Wyndham was a founder of the Royal School of Art Needlework and commissioned Philip Webb to build her a house, 'Clouds', which was decorated by Morris & Co. She executed embroidery and enamelwork as an after-dinner occupation.

Only a few managed to attain a fair degree of autonomy and prestige. The bookbinders Sarah Prideaux and Katherine Adams had their own workshops; in Edinburgh, Phoebe Traquair executed decorations for buildings and furniture by the young architect Robert Lorimer as well as working on her own embroidery, bookbinding, illumination, metalwork, enamelling and also painting; the illustrator Kate Greenaway earned extremely good money from her books.

The real turning point in women's involvement in the decorative arts came not through the acceptance of their right to work in a wider number of fields in the 1880s, but in the women craft workers' emergence from isolation in the 1890s and 1900s. The Arts and Crafts Exhibition Society, founded in 1888, organised exhibitions which provided an invaluable shop-window for those who worked at home. May Morris, for example, sold her jewellery there. In 1893 *The Studio* magazine was launched; through its pages women working independently could find designs for embroidery, stained glass, lace or metalwork and could enter its regular competitions, the winners of which had their work published. Local guilds sprang up all over the country, many of them centred on a local craft industry, and in 1907 the Women's Guild of Arts was formed; May Morris, who was also active in the local Women's Institute at Kelmscott, was a founder member and later chairwoman.

More and more women began to enrol in the new progressive art schools, such as those in Birmingham, Liverpool, Glasgow and, especially, London's Central School. Their access to proper training began the move away from the traditionally accepted view of women's contribution to the arts as being an essentially amateur pursuit. The first generation of Victorian women to find a commercial outlet, however, had done so without the benefit of professional training, with the inevitable result that their work compared badly with that of the professional male designers, and their efforts were often blamed for the stylistic degeneration of the Arts and Crafts Movement. Nevertheless, these women had opened the door for others by establishing that design was an

acceptable career for women, and their daughters were to go on to confound the myth that women were naturally incapable of first-rate work.

One woman who won a place of honour in the history of nineteenth-century design did so by carving out an entirely idiosyncratic career for herself. Gertrude Jekyll became to gardens what her friend Ruskin was to architecture. For centuries, there had been garden designers for the aristocracy; but Gertrude Jekyll, like William Morris, catered for the middle classes, basing her idiom on their needs rather than trying to adapt a grander style to them. Born in London in 1843 into a comfortably wealthy family, she went to the South Kensington School of Art at the age of eighteen; on her return from a tour of Greece at the end of 1863 she established a studio in her parents' house in Surrey, painting animal studies and trying her hand at wood-carving, illumination and metalwork. In March 1869 she met William Morris and immediately became interested in embroidery, designing her own patterns of pomegranates, dandelions, periwinkles, mistletoe and 'a design with scrolls of fishes' which so captivated the artist Lord Leighton that, through an intermediary, he commissioned her to work him a table-cloth: 'It is of course a very delicate matter to ask such a question of a lady,' he wrote, trying to establish the cost, 'but you will I am sure feel the ground with tact.'

In 1874 Gertrude Jekyll was commissioned by the Duke of Westminster to design silk panels and curtains for Eaton Hall and the work was executed, under her supervision, by the Royal School of Art Needlework. She exhibited this work at a friend's house in London and received flattering reviews and further commissions from Lord Leighton and Burne-Jones. By now she had made friends with many artists and with Ruskin, whose writings she greatly admired. In 1873 she was introduced to the painter Barbara Bodichon, who became a close and influential friend; sixteen years Gertrude's senior, Barbara had for long been active in the campaign for women's education and suffrage and was a friend of Elizabeth Garrett Anderson and her sisters.

In 1876, when Gertrude was thirty-three, her father died and she and her mother moved to Munstead Heath in Surrey, where Gertrude was to remain for the rest of her life, building herself a cottage near their original house. As a child she had been fascinated by plants and she now put into practice her ideas for garden design. The following year she began a scheme for Barbara Bodichon's cottage garden in Sussex and from then until her death in 1932 she was never without a garden plan in hand. In her workshop she continued to embroider and to execute silver repoussé work (plates, trays or boxes) with the same floral designs as her embroidery – formally disposed, curving stems and leaves with a Renaissance elegance and beautifully observed buds, blooms and flowers. In 1890, however, her eyesight became so bad that she was advised to abandon close work and from then on she devoted herself to gardening.

Gertrude Jekyll believed in natural beauty, in the exploitation of the natural shapes, colours and harmonies of individual plants and trees, and she rejected

Gertrude Jekyll, aged eighty, in the Spring Garden at 'Munstead Wood'

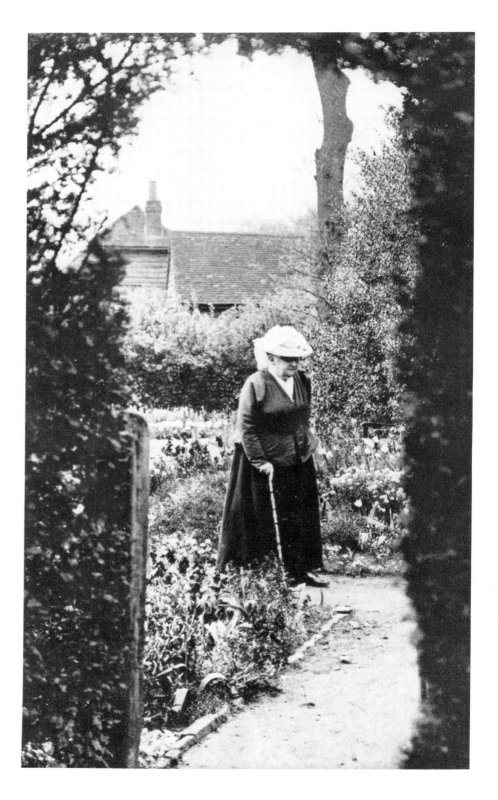

the then fashionable formal garden with plants bedded out in geometric patterns. Like Ruskin, she believed in the value of a creative relationship with nature and held that the role of the gardener, like that of the painter, was to unfold the beneficial beauties of nature before the untrained eyes of those who were not artists. Gardening was a fine art. It was not enough to collect rare species of plants; rather one had to use them, like the painter his palette, to paint a picture that would enhance their qualities. 'Given the same space of ground and the same material,' she wrote,

> they may be either fashioned into a dream of beauty, a place of perfect rest and refreshment of mind and body – a series of soul-satisfying pictures – a treasure of well-set jewels; or they may be so misused that everything is jarring and displeasing. To learn how to perceive the difference and how to do right is to apprehend gardening as a fine art.[13]

In the 1890s she began to collaborate with a young neighbour, the architect Edwin Lutyens; they made a formidable team and she is now best remembered for the gardens she designed to complement his houses. Influenced by the Aesthetic Movement, she introduced Oriental plants and trees, such as azaleas, yuccas, lilies, maples and cherries, to English gardens and also encouraged the Japanese art of flower arranging, designing a range of special flower glasses for that. At the age of fifty-seven, she began to write about gardening and went on to publish fourteen books and to contribute to the newly founded magazine, *Country Life*. Her views on gardening proved to be tremendously popular and she won international renown for her writings on both the role and the design of gardens. Although she drew upon traditional English cottage gardens in her ideas, her perception of the interrelationship between the new rhetoric of domestic building and the aesthetics of garden planning was revolutionary. And while her desire to popularise gardening as a pastime was entirely in sympathy with the aims of the Arts and Crafts Movement, the active participation of women in the ambitious schemes she advocated marked a decisive break with the image of women that she herself had been brought up to respect.

The Arts and Crafts Movement had begun by incorporating women as the passive subjects of its ideology, casting them as medieval damozels for whom the appropriate setting would be created, but by the end of the nineteenth century it had created a new sphere of professional activity for the middle-class women designers who were taking an active part in the craft revival. While the movement had visibly failed to achieve its main social aim, the transformation of the working lives of the lower classes, it had proved to be the start of an entirely new way of looking at architecture and design, linking the quality of design to the actual living conditions of the population. Women designers were now poised to take this radical shift of emphasis out of the hands of orators and dreamers like Ruskin and Morris and into a more practical world, revolutionising the middle-class home to meet the changing role and needs of the middle-class woman.

2. Not a Lady Among Us!

In art and design, mid-nineteenth-century America was ambivalent about its relationship with Europe. When America emerged from the Civil War in 1865, people felt the need to create a coherent identity for a nation which was less than ninety years old; yet in the 1860s and 1870s architecture and design were dominated by European models more than ever before. The simplicity and elegance of the colonial style gave way, at least in the cities, to a Parisian *beaux-arts* grandeur and Louis XVI extravagance, and painters flocked to the studios of Paris. The arts seen at the Centennial Exposition held in Philadelphia in 1876 to celebrate one hundred years of independence were dominated by foreign design: Royal Doulton, Ernest Chaplet's 'Limoges' glazes, Japanese decorative arts and embroidery from the Royal School of Art Needlework in South Kensington all attracted admiring attention and inspired many Americans to copy their techniques. As the century progressed, Americans began to absorb the new idioms of the British Arts and Crafts Movement and of French Art Nouveau.

While American designers were happy to derive inspiration from European styles, they had little interest in espousing European issues, and the American Arts and Crafts Movement took a very different course from its British cousin. Theirs was a stylistic rather than an ideological association. Industrialisation in a country of pioneers did not present the same threat to national well-being and did not provoke the divisive class antagonisms that had inspired Ruskin and Morris to call for social change. When British Arts and Crafts designers visited America towards the end of the century and took as much interest in working-class politics as in the craft workshops they visited – Walter Crane, for example, was deeply concerned by the fate of the Chicago anarchists, who had been condemned to death after a bomb exploded among police waiting to break up a meeting of strikers, and wanted to meet Labour leaders in New York and Philadelphia – their hosts were surprised and embarrassed.

Throughout the last decades of the nineteenth and the early years of the twentieth century the American Arts and Crafts designers were primarily

concerned with creating a style which found its source in American life and nature. Even Morris's most vocal American supporters, Gustav Stickley, who founded the Craftsman workshops in Syracuse and edited *The Craftsman* magazine, and Elbert Hubbard, who established the Roycroft craft community near Buffalo, held as their true ideal a return to the simple, community life of pre-industrial America, and their extremely plain oak furniture had more in common with the rhetoric of the Shakers, a fundamentalist religious community in New York State which during the 1850s began to offer its plain, simple furniture for sale, than with European Gothic.

Many of the designers who did most to depict American motifs in their work were women. Among the merchant class, the lawyers and old bankers who had ruled society before the Civil War, women were, as the novelist Edith Wharton observed, a '"a toast" and little else . . . "the ladies, God bless 'em", sums it up'.[1] But the years after the Civil War saw the gradual beginning of social change. Foreign travel became more common: for some it was a necessary social convention, while other families departed for Europe during the inflation which followed the Civil War, letting their town houses to the new rich. In America European tutors and governesses were plentiful and, as a new middle class emerged, it modelled itself on European fashions. In the home, skills such as embroidery gave way to music; novels, formerly banned as 'untrue', became acceptable reading for young ladies; women learnt to paint, often taking lessons while in France or Germany. As knowledge of European culture became widespread among this class, American women, unlike their European sisters, began to put it to practical use in the decorative arts, especially in the field of ceramic decoration. It was the daughters of Puritan families who were most frequently to ignore the social conventions which tended to inhibit the women of the older, established families and who went to work in the decorative arts industry.

Candace Wheeler, the woman who made the most remarkable and still largely unrecognised contribution to American decorative arts, came from just such a background. One of eight children, she was born in 1827 in the village of Delhi on the Delaware River in central New York State. Her Puritan childhood was not untypical of the period, when memories of the early settlers' struggles to survive were still potent. Her father, Abner Thurber, was the local deacon and he made their home a part of the 'Underground Railway' for runaway slaves heading for Canada. Her mother, Lucy, worked to supply the family's needs, spinning her own flax, weaving their clothes and making their candles. At the age of seventeen Candace married Thomas Wheeler, an engineer from New York. Ten years her senior and university educated, he introduced her to the world of literature and art. They lived first in Brooklyn and then in Long Island, where they brought up their four children and entertained their many friends.

During the 1840s and 1850s the Wheelers became friends with many of the leading East Coast artists, writers and poets. John La Farge, who did much to introduce recent European decorative arts to America, F. E. Church, a leading

member of the Hudson River School of painters, and the artists George Inness and Sandford Gifford, and Frederick Law Olmsted, who designed New York's Central Park and pioneered the establishment of the National Parks, were all frequent visitors, as were such literary men as Washington Irving and William Cullen Bryant. In such an atmosphere it was perhaps only natural that Candace herself learnt to paint, and her flower studies – she was an enthusiastic gardener – were exhibited at the New York Academy of Design. After the Civil War the family travelled in Germany, Italy and France and, in Paris, their eldest daughter, Daisy, was married.

At the Centennial Exposition of 1876, the designs of Morris, Burne-Jones and Walter Crane, executed by the Royal School of Art Needlework, caught Candace Wheeler's notice, 'for it meant the conversion of the common and inalienable heritage of feminine skill in the use of the needle into a means of art-expression and pecuniary profit'.[2] As an artist, she admired the originality of the work; as a woman, she was struck by its financial value. She wrote later that,

> Women of all classes had always been dependent upon the wage-earning capacity of men, and although the strict observance of the custom had become inconvenient and did not fit the times, the sentiment of it remained. But the time was ripe for a change . . . In those early days I found myself constantly devising ways of help in individual dilemmas, the disposing of small pictures, embroidery, and handwork of various sorts for the benefit of friends or friends of friends who were cramped by untoward circumstances.[3]

In the year of the Exposition, Daisy died. Candace Wheeler threw herself into a new project as a distraction from her sorrow; in February 1877 she went to see Mrs David Lane, who had been President of the New York Sanitary Fair which had aided victims of the Civil War, and outlined her plans for a society modelled on the aims of the Royal School of Art Needlework, which would organise the sale of needlework, china-painting, wood-carving and paintings by women who needed or wanted some small independent income. Mrs Lane, in turn, discussed the idea with Mrs J. J. Astor, Miss Cooper (daughter of the philanthropist, Peter Cooper, who founded the Cooper Union, an educational institution in New York which provided for the poor) and Miss Bryant (daughter of William Cullen Bryant). Shortly afterwards the New York Society of Decorative Art came into being; artist friends were asked to form a selection committee and Elizabeth Custer, General Custer's widow, was appointed secretary. The society found outlets for work, set standards and organised education and instruction: 'the new society which was to open the door to honest effort among women was launched, and if it was narrow it was still a door . . . the idea of *earning* had entered into the minds of women.'[4] In Candace Wheeler the society had its greatest asset, for she possessed boundless energy, had invaluable contacts and never doubted the intrinsic worth of the work the society promoted,

believing its aim to be 'the great remedy of a resuscitation of one of the valuable arts of the world, a woman's art, hers by right of inheritance as well as peculiar fitness'.[5] Societies soon followed in other American cities and in New York a Women's Art School was founded by Susan Carter at the Cooper Union.

However, Candace Wheeler, no doubt fired by her own Puritan childhood, felt that the scope of the society was too narrow, as the aims of pure philanthropy were constantly at odds with its artistic standards and a majority of women still remained excluded from the market-place. To redress the balance, she and Mrs William Choate founded the Women's Exchange, to which any woman could bring whatever she had to sell; the restaurant there, which specialised in home-made pies, was particularly successful. Again, however, Mrs Wheeler did not become completely involved in the day-to-day running of the organisation she had helped to found. It was only in 1879, at the age of fifty-two, that Candace Wheeler began the career which was to occupy her for the next twenty years. That year she resigned from the Society of Decorative Art along with Louis Comfort Tiffany, the artist son of the founder of Tiffany & Co., and together they founded a separate decorating firm with George Coleman, an expert in Oriental textiles, and Lockwood de Forest, who specialised in carved and ornamental woodwork, calling it L. C. Tiffany and the Associated Artists. As Tiffany put it, 'we are going after the money there is in art, but the art is there all the same'.[6] Candace Wheeler was to be responsible for the execution of textiles.

The company's first commission was a drop curtain for the new Madison Square Theatre; a woodland landscape in appliquéd textiles, it was designed by Tiffany, the colours chosen by Coleman and materials by de Forest, and it was executed by Wheeler. Other work followed – for the Union League Club House, the Veterans' Room at the 7th Regiment Armoury, Samuel L. Clemens's ('Mark Twain') house in Hartford and, in 1882, President Arthur's White House in Washington, DC. In her early work Mrs Wheeler depicted paintings in textiles, with added three-dimensional effects, using a wide variety of materials. The work was incredibly accomplished for one who had never before undertaken such complex commissions and, as orders flowed in, her talents expanded with her expertise. In 1882 she patented the fabric and the special 'needleweaving' technique which she used to obtain her painterly effects. The design would be sketched on a loosely woven canvas and the outline delineated in silks. It then took months of careful stitching to fill in the delicate shades, tints and tones which created an 'atmosphere' in as much detail as painted brushwork.

The Fourth Avenue studios of the Associated Artists attracted many famous European visitors. In 1882 Oscar Wilde bestowed 'an hour of twilight loiter upon us, filled with speculative conversation';[7] Ellen Terry, Sir Henry Irving and Lily Langtry were also entertained amid Mrs Wheeler's silks and embroideries. Lily Langtry, 'an Oriental butterfly, which flitted across our sober, serious by-path of business and labor, looking for honey',[8] com-

missioned a canopy of creamy silk 'with loops of full-blown, sunset-colored roses' for her bed, with a coverlet of 'the delicatest shade of rose-pink satin, sprinkled plentifully with rose petals fallen from the wreaths above'.[9] On her later travels Mrs Wheeler met painters and writers such as Edward Burne-Jones, J. M. Whistler, Lord Leighton, Robert Browning and Thomas Hardy. Although she worked principally for wealthy city-dwellers, she never lost her practical approach or her desire to help ordinary women to find worthwhile employment.

By 1883 the founders of the company had begun to go their separate ways: Coleman had returned to Newport to paint, de Forest was in the Far East and Tiffany was busy with his experiments in stained glass. Candace Wheeler and the Associated Artists split with Tiffany and continued on their own; now run entirely by women, it became one of the most successful decorating firms on the East Coast. Candace Wheeler used her patented technique in a series of five panels depicting the Winged Moon, the Spirits of Air, Water and Flowers and the Birth of Psyche for Cornelius Vanderbilt II's fantastic Fifth Avenue French château, a copy of the Château de Blois. Less magnificently, she also executed a series illustrating *Hiawatha* for the poet H. W. Longfellow.

Yet despite the nature of these commissions and unlike so many of the Art Nouveau artists who believed in art-for-art's-sake, Candace Wheeler believed in the paramount importance of creating interiors which enhanced the pleasures of the home. Furnishing a home, she wrote, was like painting a picture, 'but a picture within which and against which one's life and the life of the family, is to be lived', using 'the power in colors and in lines, to make an atmosphere'.[10] She constantly encouraged women to excel and looked forward 'to the time when the education and training of women decorators will fit them for public as well as private patronage'.[11]

Associated Artists developed their style hand-in-hand with their commercial success. The cartoons for Mrs Wheeler's work were now designed by her daughter, Dora. Dora was still in her twenties in the 1880s, but she had studied painting with William Chase and at the Académie Julien in Paris. She and her mother were both admirers of the English artist Walter Crane, who visited their East Twenty-third Street studio in 1890, and her work followed the idiom set by Crane and the artists of the Aesthetic Movement. 'Morning', a design by Dora Wheeler for a tea screen, is typical of her style, showing 'a girl with out-stretched arms, with tress of floating hair against a sunset sky above the water-line – a net held in her hands, a few birds flying overhead, daisies sprinkling the turf beneath her feet'.[12] Other artists who designed for Candace Wheeler were Rosina Emmett, who had studied painting with Dora, Ida Clark and Caroline Townsend. Their images were more directly appealing and prettier than Tiffany's extravagant creations and far more luxurious than the plain 'Craftsman' style of American Arts and Crafts, but they provided a style which was rapidly establishing itself as a favourite for interior decoration, in keeping with stylistic developments in American glass, silver and studio ceramics.

The years after the break with Tiffany saw Associated Artists' greatest achievements. When a wallpaper manufacturer, Warren, Fuller & Co., offered prizes worth $2,000 for designs, the firm won all four prizes: Candace Wheeler took first place with a design of bees, Dora another prize for a pattern of peonies and the other prizes went to Ida Clark and Caroline Townsend. Candace Wheeler then pushed home this success by arranging to supply designs for commercially produced fabrics for Cheney Brothers of Connecticut; these textile designs were among the first to use American motifs, drawing upon native flora and American literature and, in a quite different vein, to introduce modern motifs, such as a pattern of gold coins for a millionaire.

In 1883 the Wheelers had built themselves a house at Onteora, in a remote part of the Catskill Mountains, as a summer retreat. There they founded a village community for their friends along the lines of the pastoral relationship with the wild described by such writers as Ralph Waldo Emerson, Henry David Thoreau and Walt Whitman, who had imbued the pioneering spirit with a romanticism which echoed an earlier view of America as an earthly paradise. (Samuel Clemens was a frequent visitor, complaining that the walls were so thin that he could hear a lady in the next room changing her mind.) The lifestyle at Onteora reinforced Candace Wheeler's feeling for a specifically American culture; there she lived simply, much of the time outdoors, closely in touch with the flowers and plants which would later appear in her designs. She brought to her work a new sensibility directed towards American values, an appreciation of the vast landscape and a return to the close-knit community

Left: **Portière designed by Candace Wheeler in basket-weave silk** *Right:* **Printed velveteen cotton designed by Candace Wheeler for Cheney Bros, c. 1885**

life of her upbringing, which Thoreau and Whitman had described. It was at Onteora that she did much of her writing for, over the next twenty years, she wrote and lectured not only on art and design, but also on gardening, natural dyes, rug-making and other topics and even found time to write a story book for her grandchildren.

Unlike such American craftsmen as Gustav Stickley or Elbert Hubbard, who both actively promoted the socialist theories of William Morris, albeit without fully understanding their true political content, the women working in American crafts at that time had little interest in imbuing their work with either romantic medievalism or socialist content. Nevertheless, Mrs Wheeler's desire to establish a profession for women was programmatic in a way that the socialism of Morris and the British Arts and Crafts Movement, where the involvement of women was purely haphazard and pragmatic, never was and her ideal of the practical woman was the exact opposite of the contemporary European image of femininity. Her distinctively American belief in self-help had led her by a very different route to the simple belief that women should be practical in whatever ways they could.

In 1893 Candace Wheeler's contribution to the artistic life of her country was recognised when she was asked to become involved in the planning of the Woman's Building for the Columbian Exposition to be held in Chicago. The building was originally intended as a headquarters for those women involved in the Exposition, but it grew to encompass almost every aspect of working women's lives. The design of the building was chosen in an open competition which attracted thirteen entries: the winner was twenty-five-year-old Sophia Hayden, the first woman to complete the architecture course at the Massachusetts Institute of Technology. She designed a 'simple, light, classic' three-storey building looking out on to sky and water. Candace Wheeler was appointed Director of Color, with sole responsibility for the decoration of the library (which was to contain a collection of books written by women) and Director of the Bureau of Applied Arts, with the task of collecting exhibits.

The library was lit by one great window looking out on to the water and Mrs Wheeler decided to decorate it with drapery in shades of blue and green to reflect the colours outside and with a rich ceiling painted by her daughter, Dora. Oak panelling and furniture and the books themselves completed the scheme. Associated Artists also exhibited in the Bureau of Applied Arts section, with a huge 'needlewoven' tapestry which Mrs Wheeler had faithfully copied from Raphael's cartoon for the *Miraculous Draught of Fishes* that she had seen in the Victoria and Albert Museum in London. For the woman who had founded the first Society of Decorative Art, the Woman's Building represented a culmination of all that she had worked for. 'I felt,' she wrote later, 'that the women of all America would not be sorry to be women in the face of all that women had done besides living and fulfilling their recognised duties.'[13]

Two years after this accolade Candace Wheeler's husband, Thomas, died. He had supported her throughout her career and had taken pride in her success; his death seemed to deprive her of her previously unstoppable

momentum. In 1900, when she was seventy-three, Candace retired from Associated Artists and handed the business over to her son, Dunham, who was an architect. However, it failed seven years later, after Elsie de Wolfe had revolutionised ideas about interior decoration in 1905 with her light, airy trellis work and chintzes at New York's Colony Club. In 1909 Candace Wheeler retired to Georgia, devoting herself to gardening and writing. She lived there until her death, at the age of ninety-six, in 1923. Her contributions both to design and to the role of women within that profession had been enormous, showing the way forward for so many American women. As Elizabeth Custer once observed with pride, after lunching with Mrs Wheeler: 'Why . . . we are all working women: *not a lady among us*!'[14]

Following Candace Wheeler's example, American women were indeed to be far more forward than their European sisters in placing their artistic skills on a commercial footing. They set up successful textile, furniture and ceramics companies, applied for patents and marketed their work as effectively as they could a generation ahead of women in Britain or other European countries and, although some of them relied upon husbands or fathers for initial financial support, nearly all ran independent workshops under their own names, employing managers, salesmen and technicians when necessary. It is worth remembering that in Britain in the same years few women were able to liberate themselves from the conventional domination of their families. Significantly, while the majority of Victorian Englishwomen who found work under the aegis of the Arts and Crafts Movement tended to take up needlework, which could be done quietly and anonymously at home, the most popular craft in America was ceramics, which required workshops and equipment and which entered the market-place in greater quantity and from a clearly advertised source.

As with Candace Wheeler, it was again the Philadelphia Centennial Exposition of 1876 which inspired the pioneers of American ceramics. Two women returned from the Exposition to their home town of Cincinnati, Ohio, impressed by what they had seen. Louise McLaughlin, who had studied drawing, wood-carving and china-painting at the McMicken School of Design (later renamed the Cincinnati Art Academy), was struck by the slip-painted stoneware of the French ceramist Ernest Chaplet exhibited at the Exposition by the Haviland firm from Limoges. Already an accomplished china-painter, she admired the 'appearance of a painting in oil, to which a brilliant glaze has been applied'[15] achieved by the Limoges technique. In the autumn of the following year she began experimenting and in 1878 she produced the first 'Cincinnati Limoges'; a year later, she founded the Cincinnati Art Pottery Club with some fellow students from McMicken. Agnes Pitman (daughter of Benn Pitman who had pioneered a course in 'Ornamental Design' at McMicken), Clara Newton and Laura A. Fry were three of the original twelve 'accomplished, wealthy and influential' members.

Maria Longworth Nichols was equally captivated by the Japanese ceramics she saw at the Philadelphia Exposition, cementing an interest in Japanese

design aroused by some books a friend had earlier sent her from London. Unlike the ladies of the Art Pottery Club, she had no formal art training, having married at the age of nineteen in 1868 and borne two children. Her marriage to Colonel George Ward Nichols was apparently 'not a happy one' and it was perhaps as a diversion that she had turned to china-painting in 1873 and thence to pottery in 1879, eventually turning her hobby into a successful business. In the summer of 1880 Maria Nichols persuaded her wealthy father to let her use an old school house which he owned on the bank of the Ohio River and here she founded the Rookwood Pottery, named after her father's country estate; the first kiln was drawn on Thanksgiving Day that year. Initially she shared her facilities with the women of the Art Pottery Club with whom she had worked earlier, and, hoping to train women who could then be employed as decorators by the firm, she also founded the Rookwood School for Pottery Decoration. All the women who worked at Rookwood were decorators making ornamental pieces: the throwing and firing was supervised and carried out by Joseph Bailey Jr and later by his father as well. Maria Nichols, entranced by the insects, reptiles and marine monsters depicted in Japanese prints and books, copied her designs from them, whilst Louise McLaughlin, making use of her art training, drew her motifs from a direct observation of nature.

The whole Rookwood venture, however, was rather haphazardly run and, perhaps at the suggestion of Maria's father, Joseph Longworth, William Taylor was employed as manager in 1883. His first actions were to close the pottery school and to evict the Art Pottery Club. He then set about re-organising Rookwood's sales outlets and instituted a Shape Record Book, kept by Clara Newton, so that unsuccessful lines could be detected and discontinued.

Clara Newton and Laura Fry, with several other graduates from McMicken, were employed as decorators; they introduced the floral decorative motifs which Benn Pitman had advocated and Mrs Nichols's Japanese influence was incorporated into a simpler, less imitative idiom. In 1883, Laura Fry developed a method of spraying fine coloured slips on to the moist clay body with an atomiser, giving an even, delicate ground upon which the painted decoration stood out more finely. This technique was used for the 'Standard' Rookwood ware, using yellow, green, light brown and mahogany red backgrounds with Japanese-inspired grasses, flowers, blossoms, birds and butterflies. A second, more pastel 'Cameo' line, also decorated with plants and flowers, was introduced later.

Taylor recognised that Rookwood's success lay in the appeal of the decoration and he went to great lengths to ensure that the staff had access to journals, books, drawings and even specially commissioned photographs of flowers; when the pottery moved to new premises, a flower garden was planted to provide 'an ever-changing supply of specimens for the decorating department'[16] which, by this time, had a repertory of over two hundred floral subjects.

In 1885 Colonel George Ward Nichols died and the following year Maria

Nichols remarried. Her second husband, Bellamy Storer, was a Washington politician and she became increasingly involved in furthering his political career, although she remained in contact with the Rookwood Pottery.

William Taylor had meanwhile been made President of the Rookwood Pottery Company and under his direction the firm continued to grow from strength to strength. Although the throwing, firing and specialised chemistry required for glazing was undertaken by the male staff, many of the decorators were women and part of Rookwood's initial publicity derived from the interest in a firm run by a woman. New lines were introduced – 'Iris', 'Sea Green', 'Aerial Blue' and a series of matt glazes, the most successful of which was 'Vellum', often used for misty landscape scenes. Rookwood took part in various exhibitions which were held in these years, winning medals and prizes, but also became involved in acrimonious legal disputes over credits and patents for the techniques used. At the Chicago Columbian Exposition Taylor claimed that Louise McLaughlin's underglaze painting technique had been developed by Rookwood. As the author of several books on china decoration, Miss McLaughlin remonstrated with Maria Storer, but received little satisfaction. In the same year, Laura Fry, who had by this time left Rookwood, took a case to the Federal Court for a patent infringement on her atomising technique; the case was to drag on for several years. These disputes highlighted the distance that Rookwood had travelled since the early days of amateur experimentation by the wealthy, leisured ladies of Cincinnati and the company continued to dominate the art pottery market for many years before going into voluntary liquidation in 1941.

Other women were to extend their interest in china-painting to the more complicated aspects of ceramics; Louise McLaughlin experimented with porcelain clays to develop her 'Losanti' ware in 1898. Another graduate from Cincinnati, Mary Chase Perry, experimented with glaze recipes in emulation of French Art Nouveau ceramists at her Pewabic Pottery in Detroit. The greatest of them all, however, was Adelaide Alsop Robineau.

Born in Connecticut in 1865, she had an unsettled childhood because of her father's poor business sense and her parents' eventual separation. Adelaide, however, taught herself china-painting from books and in her early twenties taught the subject in Minnesota. In her thirties she went to New York to study painting under William Chase, while earning her living from china decoration; she was a member of the National League of Mineral Painters, founded by Susan Frackleton in 1892. In 1899, following her marriage to Samuel Robineau, a French-born naturalised American whom she had met in Minnesota, she began editing a magazine called *Keramic Studio* which published designs and information for china-painters and ceramists; it quickly became a success. Two years after their marriage the Robineaus settled in Syracuse, New York State. There Adelaide began to experiment with throwing and firing; frustrated by the limitations of mere decoration, she longed for control over the form of her work. In 1903 the Robineaus built a workshop and kiln and, the following year, a house next door. 'The Four Winds' was designed by

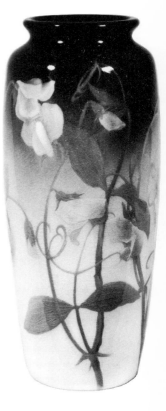

'Iris glaze' vase designed by Sara Sax for Rookwood in 1906

43

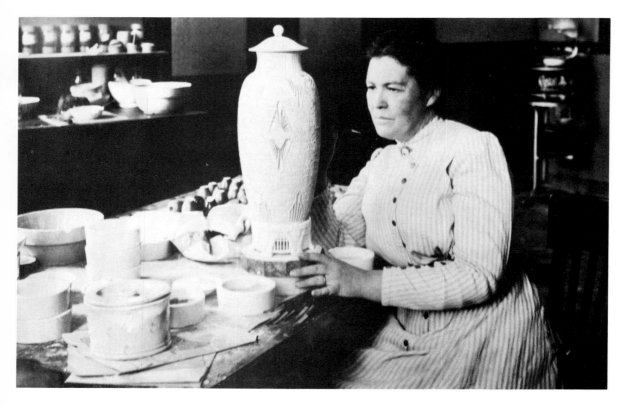

Mrs Robineau and an architect friend, Catherine Budd, who also wrote on household management and kitchen efficiency: the pottery was on three floors, the top floor eventually being used as an early crèche for the Robineau children.

In *Keramic Studio* Mrs Robineau constantly encouraged women to exploit their talents to the full. When she organised a summer school for her readers, she provided facilities for children; as she wrote, when her own children were aged between seven and thirteen:

> And now what are we going to do about the domestic problem, those of us who have homes and children and husbands and still feel called to follow the lure of art? For four long weeks the editor has been struggling with the mysteries of breakfast, lunch, dinner, sewing on buttons and darning, sweeping and dusting and otherwise trying to cling to some shreds of decency and order in her household while a two hundred and fifty dollar order stands, needing only a few hours to finish, and suspended ideas in porcelain are fading in the dim distance and others are crying to be put in execution . . . If only some good whole-souled woman with a love of art but talent only in the way of caring for a household and children would have the inspiration to take the home in charge and make it possible for the artist to devote her entire energies to doing something worthwhile in her art, heaven would come upon earth, and, between you and me, the honor of the artistic achievement would belong to her almost as much as to the artist herself.[17]

Despite her household cares, her gardening, photography and embroidery, Adelaide Alsop Robineau was to become one of the most notable American potters.

Samuel Robineau gave his wife his constant support in her endeavours and Adelaide herself appears to have had indefatigable confidence in her ability to ultimately succeed in the most difficult ventures. Frederick Rhead, a potter who worked with her at University City, described her as 'the possessor of a remarkably placid and tranquil mind together with a patient and gentle obstinacy which no influence could affect'. Mrs Robineau, he continued, 'decided to switch from china painting to porcelains. And this switch, I may add, is about as rational and as possible as a vocational change in the early thirties from dentistry to 'cello playing. But a little thing like this would not disturb Mrs Robineau.'[18]

She had begun working in porcelain in 1903, the year in which her husband began a series of translations of articles on 'Grand Feu Ceramics' by the Sèvres ceramist, Taxile Doat, for *Keramic Studio*. Mrs Robineau threw her own shapes and experimented with different glazes, fired at extremely high temperatures, to achieve her distinctive crystalline effects. Within two years she was exhibiting her work at international exhibitions and selling her porcelain through such famous stores as Tiffany & Co. in New York. One reviewer wrote of her work:

> The busy ceramist must spend at least as much time in the laboratory as in the studio. Colored glazes and glazes with a delicate kid-glove texture, glazes containing beautiful and uncommon crystallization, glazes which flow and mingle together under the caress of the flames: all these are the resources of the ceramic artist.

Such work, he concluded, 'is, in a word, precious and a fit companion of choice silver, rich draperies and dainty books'.[19]

Mrs Robineau was one of the most intellectual designers in her field and, indeed, among the women of her generation who applied themselves to any of the decorative arts. She never made the same piece twice; each pot was a further exploration within the science of ceramics and an additional expression of her aesthetic development. She constantly challenged her own limits and was able to live with the failures that inevitably accompanied her attempts because each trial was a further step towards the perfection she sought. One of her assistants spoke of 'her inexhaustible patience and superhuman courage'[20] and, despite her devotion to her art, she, like Candace Wheeler, was warmly remembered by those whom she helped and supported. Her aims for her work were 'guided simply by the desire of producing something good, something unusual, different from the work of others'.[21]

In 1909 Mrs Robineau's prestige brought her into contact with one of the strangest enterprises. An entrepreneur named Edward Gardner Lewis had founded the American Women's League in St Louis, Missouri; if women in outlying rural communities sold $52 worth of subscriptions to the *American*

Woman's Magazine they received free instruction at University City and, from 1910, at the league's Academy of Fine Arts. Lewis, who had arrived in St Louis with 50 cents in his pocket, had built the league into a million-dollar enterprise and hoped to make University City into the cultural centre of the Midwest.

In 1903 porcelain clay had been discovered in St Louis and Lewis and his wife, Mabel, experimented with it with the help of Samuel Robineau's translation of Doat's treatise. Lewis then decided to found a pottery in University City which would be 'the finest in the world' and persuaded Taxile Doat to leave Sèvres for Missouri and for the Robineaus to join him at the league. Two other ceramists, Frederick Rhead and Kathryn Cherry, also came to University City. The first kiln was fired in April 1910 and during the next two years Mrs Robineau produced some of her finest work, including the Scarab Vase, which took 1,000 hours of painstaking work and won the Grand Prize at the Turin International Exhibition.

In 1911, however, Lewis came under investigation for mail fraud concerning the league's correspondence course. The league foundered the following year and Lewis fled to California, where he was eventually imprisoned. The Robineaus also left and returned to Syracuse where, in 1919, Mrs Robineau joined the faculty of Syracuse University. She died of cancer in 1929.

In general, ceramics had by the 1890s become an established field in which women could earn a living. (Adelaide Alsop Robineau never made a great deal of money from her pottery because of the many trials she had to make to achieve her results and because her favourite form of decoration – incising into the body of the vase – was extremely time-consuming.) In 1885 Mrs Julia Ward Howe, from Boston, a prominent supporter of women's suffrage and a friend of Candace Wheeler's, organised the Women's Department of the World's Industrial and Cotton Centennial in New Orleans. She invited Ellsworth Woodward to give practical art classes which proved to be enormously popular and developed into the Ladies' Decorative Art League. Many of its members became interested in pottery and when, in 1895, a pottery department was opened at the H. Sophie Newcomb College for Women in New Orleans, founded nine years earlier by Josephine Newcomb 'for the education of young white girls in the south' in memory of her only daughter, many members of the league enrolled as students. The art classes, run by Woodward, had always been popular, but pottery, the first craft to be taught, became one of the most important departments within the college.

In 1895 the students were given their own kiln and equipment and, from the beginning, the pottery was run on commercial lines. The throwing and firing was carried out by two professional potters, Joseph Meyer and George Ohr, and the decoration was supervised by Mary Given Sheerer, who came to Newcomb in 1894 when she was twenty-nine. She had studied art at the Cincinnati Art Academy and had worked briefly for Rookwood as a decorator. Her students in the pottery department had already taken courses in drawing and she insisted that they freely explore their own ideas, with the condition

**Photograph of women walking towards the
'Women's Magazine Building' in University City,
probably taken during the First Convention of the
American Women's League in 1910**

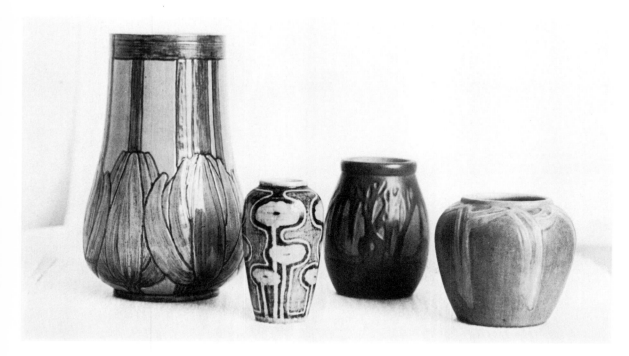

Four pieces of Newcomb College pottery. *Left to right:* vase with incised motif of magnolia with underglaze painting, decorated by Sabina E. Wells, *c.* 1905; vase with abstract floral design with underglaze painting, decorated by Emily Hon LeBlanc, *c.* 1900–05; vase with moulded relief tree design and matt glaze, decorated by Sadie Irvine, *c.* 1920–30; vase with moulded relief abstract plant pattern and matt glaze, decorated by Sadie Irvine, *c.* 1930–35

that each finished piece should be unique. With Joseph Meyer she experimented with different glazes and firing temperatures and it was she who sketched designs for the shapes he threw.

The distinctive feature of Newcomb College pottery was the motifs, which were drawn exclusively from local colours, flora and fauna. 'Each decorator,' wrote Sadie Irvine, who later headed the pottery department, 'had her own portfolio, pencil studies of various plant forms, trees, etc., that she knew well and probably grew in her own garden: wild iris, Cherokee rose, Confederate jasmin, oak, pine, or cypress trees.'[22] Designs of magnolias, poinsettia, rice or cotton were incised in the clay and coloured in bright blues, greens, yellows and blacks; the bold, confident, stylised motifs of the Newcomb pottery were among the most joyful products of the American art pottery movement.

The Newcomb Guild was formed to market the work of the students, which also included jewellery, bookbinding, calligraphy and embroidery; half the proceeds went to the individual artist, the rest to the college. The pottery especially was enormously popular and, as *The Craftsman* reported in 1903, 'within seven years of its active existence, the pottery has sent out a number of students who have gained both profitable employment and reputation'.[23] The college was at the forefront of a new, distinctively American style of crafts which owed nothing whatsoever to European models; it had something of the simplicity and directness of Candace Wheeler's fabric designs for Cheney Brothers, which seemed to exult in the fresh discovery of American nature, in the freedom from the burden of historical cultures which sometimes dogged European design. It is perhaps no coincidence that such spontaneity, and even

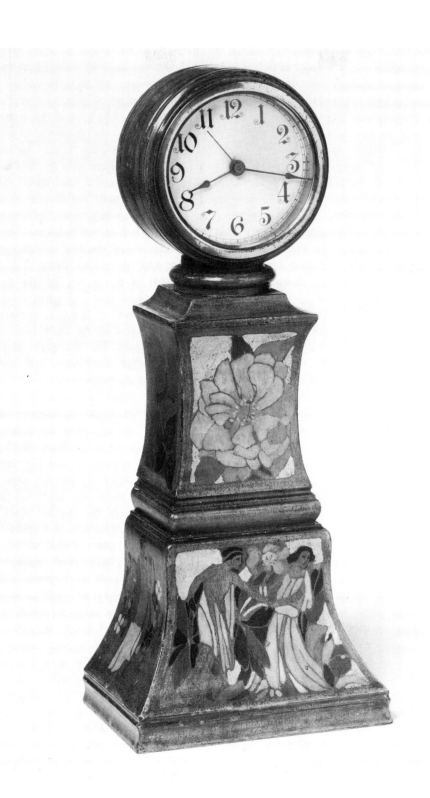

Clock in painted wood with gold-leafed decoration, by Lucia Mathews

innocence, was expressed by young women who were eager to earn their independence in a society which was less hide-bound than Victorian Britain.

Another woman who drew solely on local landscape and flora to create a colourful and original decorative style was Lucia Kleinhans Mathews. Born in San Francisco in 1870, she enrolled at the Mark Hopkins Institute of Art when she was twenty-three. Her talents quickly brought her to the attention of her teacher, Arthur Mathews: they were married the following June. Arthur Mathews had studied painting at the Académie Julien in Paris and in 1898 he took his wife to visit the city which had so deeply influenced him; there she studied briefly with J. M. Whistler at the Académie Carmen. Yet despite such formidable mentors, she retained her own clear and striking style. In 1906, following the earthquake and fire which destroyed much of San Francisco, the Mathewses opened the Furniture Shop, which undertook interior decoration and murals and produced a range of furniture and decorative items. Lucia supervised the carving, design and colour of many of the pieces; in this she excelled, bringing a bright but harmonious eye for colour and a sprightly sense of line and form. Only Californian motifs were used – oranges, grapes, peaches, plums, poppies, pine and cypress trees – with a strong awareness of the bright sunlight and sudden shadows in the colours. The furniture itself was well, but simply, made according to craftsman traditions, and the Furniture Shop thrived during the fourteen years of its existence.

Candace Wheeler, Lucia Kleinhans Mathews and the many decorators of Newcomb College all contributed to the creation of an American decorative style which shared none of the sombre medieval colours of the William Morris tradition, but set a new, optimistic tone. Louise McLaughlin, Laura Fry and Adelaide Alsop Robineau demonstrated that women were technically innovative, while Mrs Wheeler, Maria Longworth, Nichols Storer and Mary Given Sheerer proved that women could stake their claims in the market-place. Their work shows a confidence and vitality which was a landmark in women's attitudes not only to their own creations but also to their place within society. No such record could be claimed for European women in these years, hobbled as they were by notions of gentility and by social pressures to conform and with the complexities of a developed iconography of women to confront and overcome. Only in America could Candace Wheeler have done so much to establish a professional self-help network before going on to devote herself so successfully to her own career in decorative arts. In nineteenth-century America attention was not focused on women in the same way as it was in Europe; women were expected to be practical, and many nineteenth-century American novels condemned those women who did affect a European abstention from a practical interest in the home in favour of a regime of visiting, leaving cards and indulging in too great an interest in clothes or European travel. The image of American women within the mythology of frontier idealism and the 'rags-to-riches' ideology was essentially active, where the iconography that enshrined and trapped Janey Morris was passive.

3. Two Laughing, Comely Girls

By the 1890s the broad concerns of the British Arts and Crafts Movement, which had looked for a national soul amid the wastes of industrial expansion, had narrowed to a personal introspection and a nostalgic search for some lost secret of human life: poets looked to the cycles of nature and symbols of legend to discover this hidden knowledge while painters sought to express their intuition of some netherworld by reference to the hidden realities of fable. One of the most enduring emblems of their search was a wraithlike female figure with flowing hair and trailing clothes, her arms outstretched towards the ineffable substance of a dream, a chimera.

When this new style first appeared in the work of a group of artists from the Glasgow School of Art who exhibited posters, metalwork, stained glass and gesso at the 1896 Arts and Crafts Exhibition Society in London, it was labelled 'spooky' and eccentric and roundly criticised for employing a wilful distortion of the human figure. However, the editor of *The Studio* magazine, J. W. Gleeson White, himself a designer and a perceptive art critic, who had published some of the young Aubrey Beardsley's illustrations and was clearly no stranger to 'decadent' art, decided to discover more about this group of young designers. He travelled up to Glasgow where he found the 'Glasgow Four' – the architect Charles Rennie Mackintosh, the designer J. Herbert MacNair and two 'clever sisters', Margaret and Frances Macdonald. In 1897 *The Studio* published two articles on these Glasgow School designers, in which Gleeson White wrote of the 'two laughing, comely girls' who had contributed some of the offending work to the 1896 exhibition: 'These young ladies are not unaccustomed to receive the first missiles which are so liberally hurled at the côterie of artists of which they are a part. Such attacks they suffer not merely stoically, but apparently with a keen sense of the humorous attitude which folk in a bad temper usually fall into.'[1]

The Macdonald sisters, the daughters of a solicitor from Newcastle-under-Lyme who had settled in Glasgow in the mid-1880s, had begun attending classes at Glasgow School of Art around 1891. Margaret Macdonald was then a serene, elegant woman of twenty-six, quite tall with thick red-gold hair. Her

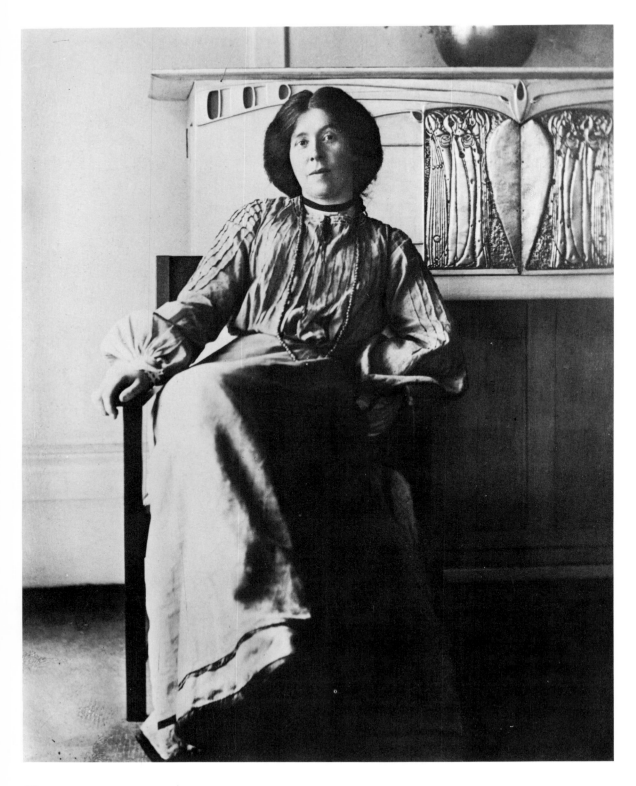

sister, Frances, was only seventeen and, in comparison with Margaret, small and fair with curly hair, 'twittery like a bird', as a friend recalled. By 1893 they were producing striking watercolours of spectral women; their mood is conveyed by the title of one of Frances's works, *Ill Omen,* or *Girl in the East Wind with Ravens Passing the Moon.*

The sisters were introduced to Charles Rennie Mackintosh and Herbert MacNair, who both attended evening classes at the school, by Francis Newbery, the new young Principal, who had trained at the South Kensington Schools in London and was a keen supporter of Arts and Crafts Movement ideals. In 1893 Newbery organised a series of lectures on the Arts and Crafts and the following spring Mackintosh put together an exhibition of furniture, metalwork and embroidery by some of his fellow students. It drew attention to the similarities between his own work and that of the Macdonald sisters and marked an immediate departure from the established idiom of the Arts and Crafts Movement, showing in many ways a closer affinity with Continental styles, especially that of the Symbolist artists.

In 1896 the sisters opened their own studio at 128 Hope Street in Glasgow, producing book illustrations, embroidery, gesso, leaded glass and repoussé metalwork, which they made themselves. It was Charles Rennie Mackintosh, however, who was the undisputed leader of the Glasgow group and Margaret began collaborating with him in 1899, making beaten metal panels which he incorporated in his furniture. A rather silent, but extremely observant man, especially of plants and flowers – a trait inherited from his father, who was a keen gardener – he nevertheless had a dry, sardonic sense of humour and, as a friend described it, 'a twinkle in his eye'. Margaret shared Mackintosh's sense of humour and their friendship blossomed.

In 1896 Mackintosh won a competition to design a new building for the Glasgow School of Art and also began working with the architect George Walton on a project for the Misses Cranston, a series of tea-rooms which, it was hoped, would help combat drunkenness in the city. Other commissions followed, including, in 1899, a drawing-room at Dunglass Castle, the new Macdonald family home outside Glasgow; Mackintosh's salary nevertheless remained less than £20 a month. In August the following year he and Margaret were married, despite her parents' disapproval that she was marrying the son of a lowly superintendent of police.

The couple moved into a flat at 120 Mains Street, Glasgow, which Mackintosh had been decorating since the spring. Although there were traces of the style of such Arts and Crafts designers as C. F. A. Voysey and M. H. Baillie Scott in the decorative scheme, the overall effect was light, refined and totally new. He had subtly altered the proportions of the room to suit his needs by running a wide rail right around it, even across the windows, at the height of the top of the door. With dark grey or white walls, grey carpets, Mackintosh's distinctive white or black furniture, simple curtains with occasional motifs embroidered by Margaret and Mackintosh's strange, woven-twig flower arrangements, the interior was pure and uncluttered. The popular

Margaret Macdonald Mackintosh photographed about the time of her marriage in 1900, possibly in her Mains Street flat

53

Cover designed by Margaret Macdonald Mackintosh for the Darmstadt art magazine, *Deutsche Kunst und Dekoration,* **1902**

Arts and Crafts idiom of plain oak, or cottage-like windows or fireplaces, was completely ignored and no patterning of any kind was admitted, only the stylised leaded glass, metalwork and embroidered cushions which the Mackintoshes designed themselves. The flat became a centre for their friends and, as they never had any children, it easily retained a quality of peace complementary to Margaret's own serenity and elegance.

In 1899 Frances had married Herbert MacNair and moved with him to Liverpool where he had recently become an instructor in design at the School of Applied Arts. The Liverpool School was only a few years old and the staff included several Arts and Crafts Movement designers. In 1901 the painter Augustus John joined the school for a year to teach drawing and it has been said that it was his influence which led MacNair, always a rather weak man, to begin drinking.

During these years Glasgow enjoyed a love affair with Europe and in particular with Vienna, where a group of artists who had belonged to the Academy there had broken away from the conservative traditions of the official school and in 1896 founded a splinter group which called itself the Vienna Secession. It included the architects Josef Hoffmann and J. M. Olbrich and the painters Gustav Klimt, Koloman Moser and Felician von Myrbach. To find other kindred spirits and to demonstrate to the Academicians that the Secession was part of an international movement, they naturally looked to the new avant-garde art magazines which were springing up elsewhere – *The Studio*, and two German magazines, *Deutsche Kunst und Dekoration* and *Dekorative Kunst*, which had featured the work of Mackintosh in 1898 and 1899; he also designed a dining-room for Herr Brückmann, the publisher. In the early summer of 1900 a supporter of the Secession, the banker Fritz Wärndorfer, visited Glasgow with his wife in order to meet the 'Glasgow Four' and was sufficiently impressed by the modernity of their work to invite them to exhibit at the Eighth Secession Exhibition to be held that winter. In October Charles and Margaret arrived in Vienna to spend six weeks preparing their display; the MacNairs' son, Sylvan, had just been born, so they were unable to join them. The Mackintoshes brought furniture from their flat, some embroidery and a beaten metal firescreen by Margaret, together with a clock and watercolours by Margaret and Frances and two gesso panels from Mackintosh's Ingram Street tea-rooms – *The May Queen* by Margaret and *The Wassail* by Charles – all of which were shown in J. M. Olbrich's newly built Secession House, the Secessionists' own exhibition hall. The MacNairs sent a wall cabinet, metalwork and some framed book illustrations.

Other British designers had also been invited to exhibit, but Charles and Margaret were delighted to find that their work was more enthusiastically received than that by older, established artists such as C. R. Ashbee, Walter Crane and William de Morgan, thus turning the tables on the reception their work had been given at the 1896 Arts and Crafts Exhibition Society. Margaret found herself particularly fêted; as a Viennese newspaper reported, 'a young

lady with reddish hair, dressed elegantly in an unusual manner, attracted general attention'.[2] One report even claimed that students from the Vienna Kunstgewerbeschule (School of Arts and Crafts) carried Charles and Margaret in triumph through the streets of the city.

During their time in Vienna Charles and Margaret met the leading painters, architects and designers of the Secession and became particularly friendly with the young architect Josef Hoffmann, who had already begun to design furniture and metalwork himself. Hoffmann found the idealistic basis, if not the actual style, of the English Arts and Crafts Movement inspiring and the young couple were ready and willing to discuss the means of finding a new way forward, out of the medievalism which was already beginning to date the older generation of designers.

Charles and Margaret returned to Glasgow exhilarated by their experiences in Vienna and the next few years were busy and successful for them both. In 1901 Margaret's designs were included in Charles's plans for a competition to design a 'house for an art lover' held by the German publisher, Alexander Koch; the scheme was well received by the judges and certainly aroused more interest than any of the other plans. In their partnership the Mackintoshes refined the concept of the complete artistic interior, in which the lines of the furniture were extended into the art work – Margaret's gesso panels – and complementarily, the art work was echoed by motifs in metal panels or panes of leaded glass inset into the furniture. The result was an organic coherence of design combined with a narrative, illustrative decoration, enhanced by Margaret's light touches of colour.

Margaret remained close to her sister and MacNair frequently brought Frances and their son to visit in Glasgow. But while Margaret increasingly collaborated with her husband on his commissions, adapting the strangeness of her earlier work to a more formal, decorative idiom of far greater confidence and strength, Frances's early promise failed to fulfil itself. The Mackintoshes' harmony of intention was lacking in the MacNairs' style; Herbert MacNair never approached Charles's stature as a designer and his rather solid forms shared little with his wife's misty, twilight world. She continued to paint her haunting watercolours, images of eerie, melancholy women mourning some lost or unattainable goal, which reflected the difficulties of her marriage. Later paintings, showing girlish figures caught in the toils of their own unfulfilled hopes and desires, surely convey her own feelings of entrapment. The poignant wraithlike images that had attracted Frances as a student had been prophetic and the women she now depicted seemed to be looking out beyond the frame to the happier lives which other women had found, rather than inward to some unseen mystery.

In the spring of 1902 the Glasgow School designers exhibited in the Glasgow Pavilion at the Turin International Exhibition. The School of Art was well represented, with bookbindings and embroideries, and Frances MacNair contributed beaten metal panels, jewellery, and curtains and cushions embroidered with a motif of young birds in the nest. The MacNairs also

Two embroidered linen panels designed by **Margaret Macdonald Mackintosh** and exhibited in the 'Rose Boudoir' at the Turin International Exhibition in 1902. Glass beads, silk and metal threads, silk braid, ribbon, green, purple, white, black and cream silk appliqué have been used to form the design

contributed a writing room, decorated in shades of grey, gold and white, with a green and pink frieze around the walls. However, the furniture, which came from their flat in Liverpool, was slightly cumbersome and contrasted poorly with the delicacy of the Mackintoshes' 'Rose Boudoir'. This represented the fullest development of the ideas that Charles and Margaret had explored together in their design for a 'house for an art lover' and was perhaps their most complete collaboration. Its theme was based on three gesso panels by Margaret, entitled *The Flowery Path, Heart of the Rose* and *The White and the Red Rose*, which showed female figures wearing wide, flowing dresses whose lines suggested stylised roses, and also included a silvered metal panel, *The Dew*, originally made for the Ingram Street tea-rooms. The room was painted in white, silver and rose pink, with touches of purple, pink, green and white in Margaret's appliqué embroideries and gesso panels. Her imaginative images created a story-book setting for Charles's elegant black and white furniture and the different elements combined to create an effect of enchanted fantasy.

Mackintosh had accompanied his former tutor, Francis Newbery, to Turin to install the Pavilion and while he was there he again met the banker and patron Fritz Wärndorfer from Vienna. Wärndorfer purchased several pieces from their display and commissioned the Mackintoshes to design a music salon for his Viennese home. Their scheme again included a series of gesso panels by Margaret, illustrating a story by Maurice Maeterlinck called 'The Seven Princesses', a theme which Gustav Klimt was also to explore.

That year both Wärndorfer and the Mackintoshes' friend Josef Hoffmann visited Glasgow. Hoffmann was keen to discuss with them his plans for the foundation of a decorative arts workshop, which Wärndorfer had promised to finance and which several of the Secessionist artists supported. The Wiener Werkstätte, as it was called, was formed the following year and Mackintosh wrote to Hoffmann enthusiastically, applauding his decision. 'Later on,' he wrote,

> when the high quality of your work and financial success have strengthened your hand and your position, you can walk boldly in the full light of the world, compete with commercial production on its own ground and achieve the greatest accomplishment that can be achieved in this century, namely the production of all objects for everyday use in beautiful form and at a price that is within the reach of the poorest, and in such quantities that the ordinary man on the street is forced to buy them because there is nothing else available and because soon he will not want to buy anything else.[3]

In fact Hoffmann and Mackintosh were never to serve the needs of any but their own kind; their ideal of a democratic art could enfranchise only the middle classes. Since 'the poorest' were cast in the image of the middle classes, the actual needs of those who existed in tenements, back-to-backs or worse could never even be considered.

It is possible that Mackintosh flirted with the idea of moving to Vienna and collaborating with Hoffmann at this time, but he had several commissions to occupy him in Glasgow. In 1903 he designed, decorated and furnished 'Hill

House' for the publisher Walter Blackie. Blackie wanted a practical house and Mackintosh, perhaps encouraged to follow his ideas to their logical conclusion by his conversations with Hoffmann, abandoned the romantic elements of his earlier schemes. Margaret's contribution was limited to embroidered panels and curtains for the bedroom, a gesso panel above the drawing-room fireplace and appliqué covers for the sofa there. She also made panels for a matching lampshade, using ribbon, braid and beads to emphasise the lines which formed the design. Her work now stressed her husband's geometric ornamentation, adding a touch of luxury which was nevertheless disciplined to the requirements of the surrounding architecture. Thus, for example, the sofa covers were appliquéd with black and cream ribbon, but were enhanced with green, blue, red and purple satin, silk and velvet.

That year Miss Catherine Cranston commissioned Mackintosh to decorate his fourth tea-room, the Willow Tea-Rooms in Sauchiehall Street, and to build her a house, 'Hous'hill'. Margaret worked with him on both commissions, contributing embroideries and four gesso panels, *The Four Queens*, to 'Hous'hill' and a gesso panel based on a poem by D. G. Rossetti for the Room de Luxe at the Willow Tea-Rooms. In these commissions, Mackintosh refined the idea of the complete interior towards a total geometric scheme, doing away with figurative or stylised organic forms altogether. The relation of straight line to curve, of horizontal to vertical, became the dominant theme and Margaret's contribution was necessarily curtailed. However, she greatly admired her husband's work and supported his innovations.

In 1904 Charles became a partner in Honeyman and Keppie, the architectural firm where he worked, and in 1906 he and Margaret were able to leave their Mains Street flat for a terraced house in Glasgow's more fashionable Southpark Avenue, which they converted to suit the furniture from their former home. However, over the next few years, little new work came their way. Despite their popularity abroad, the British continued to find the Glasgow style too divorced from the cosy interiors, with oak furniture and patterned wallpapers and fabrics, which English Arts and Crafts designers were creating, and Charles and Margaret spent their time putting the finishing touches to earlier commissions. Eventually, in 1913, Mackintosh resigned from Honeyman and Keppie where he had begun to view his work extremely half-heartedly. He was increasingly unwilling to adapt his style to the desires of the firm's more conservative clients and possibly his success in Europe had convinced him that he was right to insist on his own vision of domestic architecture; in any case, his working relationship with John Keppie had always been strained after he had jilted Jessie Keppie, John's sister, in the 1890s (her later failure to marry had embarrassed the family).

The MacNairs were faring little better than the Mackintoshes. Although Herbert MacNair was extremely popular among his students, he received few commissions for interiors and he and Frances were mainly designing tableware, book plates and illustrations, jewellery and other minor items, although Frances continued to paint. When the University School was closed in 1905

Herbert went to teach at the newly founded independent Sandon Studios in Liverpool and Frances gave instruction there in embroidery. The Sandon Studios were a lively centre – Augustus John, Mackintosh and Henry Tonks from the Slade were all honorary members – but the masters did not receive a full salary. MacNair came from a wealthy military family and had a small private income, but by 1908 this was no longer sufficient and the couple returned, penniless, to Glasgow where they stayed with Charles and Margaret at Southpark Avenue until they found themselves a small flat around the corner.

For three years Frances taught embroidery, enamelling and metalwork at Glasgow School of Art, but she was asthmatic and, with a young child and an alcoholic husband to care for, she found the work very tiring. Her parents' reaction to a plea for help was to pay Herbert's fare out to Canada; when he returned after only a few months, they disowned him entirely. The fortunes of the 'Glasgow Four' had always been tied to Charles Rennie Mackintosh, the most successful of the group and, as he became increasingly unwilling to discipline himself to the reality of the lack of interest in his work at home, they shared his unpopularity. Although Margaret and Frances had opened a workshop together in Glasgow in the 1890s, on marrying both had then collaborated with their husbands and, even if a market had existed for their work, the ideological pressures on women not to work independently were too great for them to consider this course again, despite their economic difficulties. For Margaret especially, Charles was too well known in Glasgow for her to find independent work without evoking the stigma that she was supporting her husband.

In 1914 Charles and Margaret left Glasgow, supposedly for a recuperative holiday in Suffolk. They rented rooms by the river in Walberswick, a village where the Newberys went each summer to paint, and spent their days painting watercolours. In the evenings they walked in the countryside. Margaret also completed a frieze for the last of Miss Cranston's tea-rooms. With the outbreak of war, the locals began to view the unconventional couple with suspicion and eventually the police were called in to search their lodgings. Letters were found from the Mackintoshes' friends in Vienna and the prevailing mood of jingoism was such that Charles was summoned before a tribunal to prove that he was not in collaboration with enemy agents. Although he was cleared, the peaceful seclusion of the countryside was destroyed.

In 1915 the couple moved again, this time to the more congenial atmosphere of Chelsea, where they took lodgings and studios in Glebe Place. Over the next few years Charles received a few small architectural commissions, despite the restrictions of the war, and both he and Margaret designed textiles for two manufacturers, Foxton's and Sefton's. These brightly coloured, geometric and stylised flower patterns, marketed anonymously, helped to introduce other English designers to the bold Continental idiom which the Mackintoshes understood so well. They became friendly with the

The Queen of Hearts by **Margaret Macdonald Mackintosh, one of a set of four painted and gilt gesso panels in blue, red, black, buff and gold, entitled** *The Four Queens***, made for the cardroom at 'Hous'hill'**

artistic circle who frequented the Chelsea restaurants, including Augustus John, the young painter Allan Walton and the playwright G. B. Shaw, and they joined several local art societies, exhibiting their work at the newly founded London Salon of the Independents and at a show of 'things of everyday life' organised by the Friday Club, where their work was displayed alongside textile designs by Paul Nash and posters by E. McKnight Kauffer. Charles had hoped to earn some money from the sale of his watercolours, but in the circle of such well-established artists his work received little notice. In any case, few people were paying much attention to art during the war.

Despite Margaret's devoted support, Charles became gradually more depressed at his failure as an architect and in 1923 they sublet their Chelsea studios and left for France. Undoubtedly their remaining reason for staying in Britain had disappeared with Frances's death of a cerebral haemorrhage in 1921 at the age of forty-seven. Although the MacNairs had just begun to find their feet once more, Herbert never worked as a designer again, but opened a garage with his son. Charles and Margaret eventually settled at Port Vendres on the Mediterranean coast, a few miles from the Spanish border. Charles devoted himself to painting flower studies and landscapes in watercolour and Margaret must also have done some painting; she contributed a miniature watercolour to the 'Queen's Dolls' House', designed by Sir Edwin Lutyens and unveiled at the British Empire Exhibition at Wembley in 1924. They lived quietly and cheaply and friends say that these were happy years for the couple. In 1927, however, Charles developed cancer of the tongue and they returned to a series of lodgings in London while he underwent radium treatment. He died in December the following year. Margaret spent the last few years of her life living quietly in Chelsea, where she died in 1933 at the age of sixty-eight.

Critics today tend to decry Margaret Macdonald Mackintosh's contribution to Charles's work, saying that she added a detracting femininity to his bolder style, but it was, in fact, their collaborative projects which received the most flattering reviews at the time, in both Britain and Europe. It is difficult to assess what direction Margaret's own work would have taken had she not married Mackintosh, but she undoubtedly had the critical instinct to recognise and successfully integrate her style with his. In an age when it was considered unladylike to promote one's own business, she worked professionally to make a name for herself and was accepted on equal terms by artists such as Gustav Klimt and fellow designers such as Hoffmann. In contrast, Frances, although she was able to use her painting as an escape route to express her anxieties and difficulties and also to earn money to keep her family together, never achieved a style cogent enough to convey the intensity of her feelings to a public who did not take women's art seriously and who would have regarded her work as merely fashionable and mannered. Nevertheless, the 'Glasgow Four', especially through their innovative early work, had established a style which was followed by several generations of Glasgow School students.

One student who adapted the romantic, fairy-tale style of the Macdonald sisters was the illustrator Jessie M. King. In many ways less ambitious

artistically than the Macdonalds, her career was nevertheless markedly more successful. She had enrolled at Glasgow School of Art in 1894, when she was nineteen, and by 1905 was teaching there and supplying designs for jewellery, wallpapers and textiles to Liberty & Co. in London. Three years later she married a fellow student, Ernest A. Taylor, and moved with him to Manchester, where their daughter Merle was born. In 1911 the couple moved to Paris where Jessie discovered the startling new colours introduced by Leon Bakst in his costume and set designs for Diaghilev's Ballets Russes. Bakst's bold and garish greens, oranges, purples and blues banished the more muted, mysterious colours of the Glasgow School from Jessie's palette and she even sought out the man who dyed Bakst's costumes, using his dyes for batiks. In 1915 she and her husband returned to Scotland, where they ran a summer sketching school on the Isle of Arran.

Jessie M. King illustrated over seventy books, many of them for children. Her range was small, which was perhaps the secret of her success, but her imagination roamed the same fables and stories which had captivated the Macdonald sisters – thus returning their imagery from whence it came – and her happier outlook lacked the threatening undertones of Frances Macdonald's watercolours.

At Glasgow School of Art the work of the female students went from strength to strength under the exceptional tutelage of Jessie Newbery; a former student and wife of Francis Newbery, she was accomplished in metalwork, enamelling, mosaic, bookbinding and stained-glass design. Her embroidery classes, started in 1894, which were open to people outside the school and to women studying for a certificate to teach embroidery in primary and secondary schools, were totally innovative in terms both of the designs and techniques she used and the philosophy behind them. She was one of the few designers who appreciated the realities of the ideals which the Arts and Crafts Movement espoused, giving ordinary women the chance to enhance the work which they undertook as a necessity, not as the exercise in skill which much late nineteenth-century embroidery represented. 'I believe,' she told the editor of *The Studio*, 'that nothing is common or unclean: that the design and decoration of a pepper pot is as important, in its degree, as the conception of a cathedral.'[4] Such a belief was a central tenet of the Movement, but most designers then designed pepper pots with all the majesty of cathedrals, using precious metals and complex finishes. Thus, although their aim was the regeneration of traditional craft skills and the protection of a craft-based lifestyle from the encroachment of industrialisation, their achievement, as C. R. Ashbee wrote, was almost inevitably to make 'of a great social movement a narrow and tiresome aristocracy working with high skill for the very rich'.[5]

Jessie Newbery realised that in order to capture the interest of those who had neither the time nor the skill to execute designs by Burne-Jones or Walter Crane and who could never afford to work in expensive materials, it was necessary to interpret the Arts and Crafts doctrine in a new way. In her

classes, she employed relatively cheap fabrics, such as flannel, linen, un-
bleached calico and hessian, and introduced outmoded techniques, such as
appliqué or needleweaving (the removal of rows of either warp or weft
threads), which, because of their very simplicity, would have been frowned
upon by the Royal School of Art Needlework at South Kensington. Her
designs were not only simple in execution, but also in style, acknowledging
that a more ornate idiom would no doubt be out of place on the clothes and
furnishings of her pupils. She encouraged her students to make items for
everyday use, such as bedspreads, fire screens, tea cosies or clothes.

In her classes for full-time students, who had already taken courses in
drawing, painting and modelling, Jessie Newbery drew primarily on their
experience as artists, teaching them the techniques necessary to communicate
their ideas. She was a very fine designer and her example inspired her pupils.
An enthusiastic and knowledgeable gardener, she adapted plant forms for a
decorative vocabulary of stylised flowers, stems and leaves, especially the
'Glasgow Rose', a circle intersected by a simple pattern of lines suggesting
petals, which became a trademark of the Glasgow style. She also had a keen
interest in lettering, inspired by William Morris's typography, and developed
an elegant, unfussy calligraphy which she used to embroider inscriptions on
cushions, banners and book covers. Her colour sense, however, was opposed
to the dark, sombre medieval colours used by Morris; she preferred pale
greens and blues, pink, yellow, grey and purple and often added coloured glass
beads to her work. All her designs were balanced and well spaced, drawing the
eye to the graphic effect rather than to the complexity of the stitching. 'I like
the opposition of straight lines to curved; of horizontal to vertical,' she said. 'I
specially aim at beautifully shaped spaces and try to make them as important
as the patterns . . . I try to make the most appearance with least effort, but
insist that what work is ventured on is as perfect as may be.'[6] Her daughter
Mary says that her mother often found the work of teaching hard and difficult,
for she had a home to run and official entertaining to organise, yet even after
she had retired as head of the Needlework Department in 1908 friends would
still call at the house for advice on a design or help with the pattern of a dress.
She herself loved Russian peasant clothes and made most of her own dresses,
with embroidered cuffs, belts, collars or yokes and wide sleeves with loose
bodices and skirts; photographs show a gentle, gracious lady, who expressed
her artistic nature through the individuality of her clothes.

Perhaps because Jessie Newbery's influence was focused on embroidery,
traditionally held to be a female activity, her contribution to the Arts and
Crafts ideal has been almost entirely overlooked; it has also been over-
shadowed by the glamour of Charles and Margaret Mackintosh's work and by
the poignancy of their fate. In fact, Jessie Newbery and her students succeeded
where so many of the leading Arts and Crafts designers had signally failed, in
bridging the chasm which lay between the theory and practice of the
Movement. If acknowledged at all, her successful application of the ideal was
easily dismissed by contemporaries – as was the achievement of so many

Detail of linen cushion cover, designed and embroidered by Jessie Newbery *c.* 1900 in green, cream and pink silks

women of that time – as invalid or unimportant, on the grounds that it was easier for women to retain the integrity of their aims because they had no need to be professional. Yet ultimately the women who benefited from her work, although unpaid, were undertaking labour that was vital for their households. There is no reason to accept such a view of her contribution: Jessie Newbery was one of the very few Arts and Crafts designers to keep before her the reality of the movement's aims and to accommodate her own taste and ambition as a designer to them. At the same time, she set a standard of design which ranked with any of her contemporaries.

Jessie Newbery was succeeded at the School of Art by her assistant Ann Macbeth, a forthright, energetic and outgoing woman. The daughter of an engineer from Bolton in Lancashire, she had enrolled as a student in 1897

Silk embroidered picture by Ann Macbeth with added seed pearls and coloured glass beads

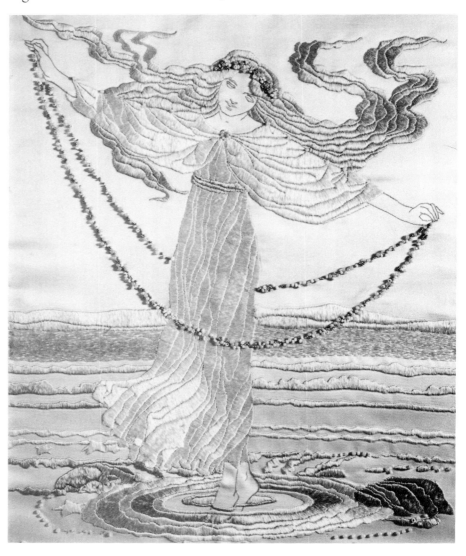

when she was twenty-two; her style was more detailed and pictorial than Mrs Newbery's sparse elegance and she favoured images of romantic nymphs with flowing hair and robes. In 1901 she had become Mrs Newbery's assistant and later she was also to teach metalwork, bookbinding and ceramic decoration. However, her most important contribution to the development of embroidery was the book *Educational Needlecraft*, which she wrote with her assistant Margaret Swanson and published in 1911. It publicised Mrs Newbery's approach for the first time, applied her principles to the teaching of embroidery in schools and was instrumental in introducing new ways of teaching needlework to primary-school children. The authors suggested using big needles and brightly coloured wools and demonstrating to the children the connection between drawing and stitching, so that they could execute their own designs rather than learn different stitches by rote. The book had an enormous impact and the two women lectured throughout Britain, published further books, organised summer classes, helped make needlework an employment for wounded soldiers during the First World War and introduced a loan scheme, sending examples of the work described in the book all over the world. As a result, the embroidery department became one of the most important sections of Glasgow School of Art. Ann Macbeth's far-sighted attitude brought women into the educational debates on the teaching of handicrafts in schools, giving women the confidence to base their opinions on their own practical achievements rather than allowing men to talk for them.

Seen within a wider perspective, Glasgow School of Art, along with the other two art schools – Birmingham and London's Central School – which pioneered Arts and Crafts teaching methods, was of major importance at a national level; they produced the necessary training for the first generations of British women students who were able to make a living from teaching, book illustrations or design work and therefore allowed younger women to develop their potential and to succeed where Margaret and Frances Macdonald had so poignantly failed. While in America it was individuals such as Candace Wheeler who paved the way for women decorative artists to find professional work, in Britain it was the development of these leading art schools which provided the infrastructure on which so many women built original and successful careers for themselves in the 1920s and later years. Nevertheless, the schools themselves must be seen within a more general context, since their contribution was reinforced by a more general change in attitude towards women in the first decades of this century, as the First World War brought new working opportunities and the granting of the vote to women gave them increased confidence and awareness.

The contrast between the experiences of Frances Macdonald and of Jessie M. King or Ann Macbeth was aptly symbolised by the images which they portrayed: in only a few years the wraithlike figures of the Macdonald sisters' early paintings had become prettier, more robust and cheerful. Few women of the later generation were to identify themselves with the haunting, sombre chimeras from the turn of the century.

4. The Heyday of the Decorators

The manner in which a room could be made to express the refinement or some other intimate aspect of the inhabitant's personality had, by the late nineteenth century, become a matter of status. An American or English lady was judged by her sensibility in much the same way as fifty years earlier her moral scrupulousness had been seen as a measure of her value. Oscar Wilde's ridicule of the cult of sensibility played upon the fear that a woman's surroundings were no longer a refuge, but had become yet another yardstick by which, together with her clothes, hairstyle and behaviour, she could be judged and possibly condemned. As Elsie de Wolfe, the New Yorker who became the first lady of interior decoration, wrote:

> A house is a dead-give-away . . . We are sure to judge a woman in whose house we find ourselves for the first time, by her surroundings. We judge her temperament, her habits, her inclinations, by the interior of her home. We may talk of the weather, but we are looking at the furniture.[1]

The earlier Victorians had furnished their homes to last a lifetime – especially in the 1850s and 1860s when style dictated the use of the most expensive materials and finishes, such as carved and inlaid wood, gilt decoration on tea services, cut glass and damask, which could not be lightly discarded and replaced. Mrs J. E. Panton, the daughter of the popular Victorian painter, W. P. Frith, observed in 1919 that,

> Fifty years ago, if carpets and curtains were bought at all, it was after high and long debates in the family, and heavens how they wore! At this moment I could put my hand on amber coloured damask curtains bought more than sixty years ago [about the year that Frith's *Derby Day* was exhibited], and pieces of carpet bought more than eighty years since [when Frith first settled in London].[2]

By the end of the century the relaxation of conventions regarding visiting and entertainment had led to a slightly more flexible use of the home. The Arts and Crafts Movement had encouraged women to extend their sphere of management within the home to include its decoration and some women now

went further, putting their taste and practical expertise on a professional footing. This happened first in America, where the Puritan ethic of self-sufficiency made it more acceptable for a woman to find independent work, and only later in England, where women such as Syrie Maugham and Sibyl Colefax made a profession out of placing their taste at the service of their wealthy and fashionable friends.

From the start, the personalities of the pioneers of interior decoration ensured that it was a fashionable profession. Elsie de Wolfe, Syrie Maugham and Sibyl Colefax were all larger-than-life figures who lived boldly in the public eye and who found in their profession a vital outlet for the expression of their own strong personalities. As such, they were welcomed for their flamboyance and for their open challenge to conventional female roles. Well-travelled and sophisticated women, they also had many friends among the artistic, political and aristocratic circles of their day: that they counted such celebrities as Sarah Bernhardt, the Vanderbilts, Noel Coward or King Edward VIII among their friends (and in some cases also their clients) meant that less worldly-wise women, especially among the *nouveaux riches*, were delighted to employ them and so buy into the world they represented. Most of the decorators' clients were the daughters of middle-class Victorian mothers, yet now they could not only daringly transform their environments – and their lives – but have that transformation sanctioned by the highest levels of society. The emergence of this new class, first in America and later in Europe, created the need for the twentieth-century decorator.

The first book on interior decoration, published in America in 1897, was written not by Elsie de Wolfe or Syrie Maugham, but by the novelist Edith Wharton with Ogden Codman, an architect. *The Decoration of Houses* was Edith Wharton's first book, written, as she said in her autobiography, to alleviate the boredom and frustration of an unsuccessful marriage. She was delighted to find it a success. The 'simple elegance' which she recommended was based on seventeenth- and eighteenth-century European styles, but although she despised the sumptuousness of the Vanderbilt château on New York's Fifth Avenue, the schemes she envisaged must have seemed to many readers to belong in a similar world of fantastic wealth. However, the popularity of *The Decoration of Houses* and her subsequent book, *Italian Villas and Their Gardens*, demonstrated the appeal of such grandeur even to those who could themselves never afford to live in such a style.

Elsie de Wolfe, the woman who blazed a trail for so many others and revolutionised the wealthy American interior, turned to decoration in 1904, when she was almost forty. The daughter of a New York doctor, she had had a brief career as an actress, first as an amateur and then as a professional, setting up her own company after her father died. From 1887 she had lived with her intimate friend, Elisabeth Marbury, a literary and dramatic agent, in an elegant little house in Irving Place, New York, where, on Sunday evenings, they entertained: actresses such as Sarah Bernhardt and Ellen Terry and writers such as Oscar Wilde, Robert de Montesquieu and Edith Wharton were among

those who found their way to their door. Elsie's friends also came to include such wealthy potential clients as the Vanderbilts, Morgans, Whitneys and Cooper Hewitts, who were able to help her in her new career: as she later said, 'friends have always been one of my greatest assets'.

The house in Irving Place gave Elsie her first chance to explore her philosophy of decoration, a philosophy which she later explained in her book, *The House in Good Taste* (1913):

> I . . . wish to trace briefly the development of the modern house, the woman's house, to show you that all that is intimate and charming in the home as we know it has come through the unmeasured influence of women. Man conceived the great house with its parade rooms, its *grands appartements* but woman found eternal parade tiresome, and planned for herself little retreats, rooms small enough for comfort and intimacy. In short, man made the house: woman went him one better and made of it a home.[3]

The house in Irving Place also acted as a showcase of her ideas to her friends, and in 1905 they gave her her first chance to put them into practice on a grand scale with the job of decorating the newly built Colony Club on Madison Avenue, the first women's club in New York.

The club, which had dining-rooms, a reading room, card room, gymnasium and swimming pool, attracted a great deal of publicity, most of it adverse. The newspapers declared it 'a menace to the American home', as women would be free to smoke and to drink there – it was only recently that the code of conduct in upper-class circles had permitted women to eat in public places. Newspaper headlines demanded 'Where Will This Lead?' and a jealous husband, as if inflamed by such coverage, shot dead the club's architect, Stanford White. Elsie was in England selecting furnishings at the time, but, undaunted, she set about her work.

Her decorative scheme for the club earned her the title 'the Chintz Lady' and established both her style and her business. In the entrance-hall, she echoed the elegant simplicity of a Virginian house, with polished mahogany furniture, English chairs and 'quaint old Colonial mirrors'. In the bedrooms and public rooms she totally abandoned the costly plush drapery and satin and damask upholstery of the period for a variety of cheap and cheerful European chintzes. With painted furniture she used hand-blocked linens of old French patterns in delicate creams, yellows, greys and blues or cottons in 'rose-sprigged and English posy designs', and 'an Oriental paper patterned with marvelous blue and green birds, birds of paradise and paroquets perched on flowering branches' was matched with black lacquer furniture and jade green hangings. On the ground floor there was a trellis room and on the roof a lattice-work garden in cool greens and white, both adapted from Roman frescoes, English gazebos and Moorish tracery. Elsie also contributed to the amenities by designing special dressing-tables.

The interiors of the Colony Club were a tremendous success; the wealthy ladies who patronised it rushed to commission Elsie and she was launched on

a busy and profitable career. Her clients were able to buy into her spirit of breezy confidence, briefly invigorating their lives as well as their drawing-rooms. She was indefatigable and she carried into her work and lifestyle the belief that women should express themselves freely and fearlessly. The range of her work and other activities over the next four years was extraordinary. In addition to her many commissions for private clients, in 1906 she and Elizabeth Marbury bought the almost ruined 'Villa Trianon' near Versailles, which they shared with Anne Pierpont Morgan, sister of the millionaire, and began to restore it. In London Elsie displayed her business acumen in managing to secure part of the Wallace Collection for one of her clients, the collector Henry C. Frick. Back in New York, in 1911, she and Miss Marbury moved house, to a renovated brownstone at 123 East Fifty-fifth Street. The following year she exhibited a modern labour-saving kitchen at the American Women's Industrial Exhibition and marched in support of the women's suffrage movement. She also took a test case to court, refusing to pay income tax because she did not have the vote. Although she lost, she said she never regretted her action, and obviously enjoyed the publicity. In whatever field, Elsie set an example of dauntless courage and pluck: in 1908 she had even gone flying with Wilbur Wright at Le Mans.

In *The House in Good Taste*, Elsie gave her own spirited account of her work

The private dining-room in the Colony Club, decorated by Elsie de Wolfe; the walls in 'a delicious color between yellow and tan', with grey panels painted in pinks yellows and browns, with rose-coloured carpet. Illustrated in *The House in Good Taste*, 1913

and aims, stressing the relationship between a woman's expression of personal taste and the power of an environment to promote a woman's personality. 'I believe,' she wrote, 'in plenty of optimism and white paint, comfortable chairs with lights beside them, open fires on the hearth and flowers wherever they "belong", mirrors and sunshine in all rooms.'[4] Suitability, simplicity and proportion were her watchwords as much as beauty, comfort and peace of mind. Elsie de Wolfe liked making women comfortable. 'We must,' she wrote, '. . . visualize our homes . . . as individual expressions of ourselves, of the future we plan, of our dreams for our children.'[5] She was ready with advice on planning a first bedroom for a young girl or a drawing-room for a society hostess, on devising a small apartment for a single woman on a tightly stretched income or a house for the mother of boisterous teenage boys. She made a speciality of dressing-rooms, bedroom-boudoirs and bathrooms – luxurious private apartments where women could pamper themselves, relax, write letters, read or simply apply their make-up in comfort.

Elsie also believed in using decor to enhance the personality of the woman of the house: 'We say that one woman is "so full of color", when she is alert and happy and vividly alive. We say another woman is "colorless", because she is bleak and chilling and unfriendly.'[6] Warm 'primitive' reds and golds could be used for the drawing-room of a timid woman, but a 'colorful' woman could get away with the 'tempting combination' of black and white, made so popular by Josef Hoffmann in Vienna, or Elsie's own favourite combination of ivory, dull blue, rose, dove grey and tan. 'If a woman has taste,' she wrote, 'she may be as human and feminine as she pleases, but she will never cause a scandal!'[7]

In later life, Elsie did much to promote her ideas in Europe. At the outbreak of the First World War, she was at the 'Villa Trianon' in France and she remained based there until the end of the war working with a special medical unit that treated burn casualties, for which she was awarded the Légion d'honneur and the Croix de Guerre. In 1918 she returned to New York, took new offices on Fifth Avenue and continued her flourishing business. Eight years later, at the age of sixty-one, she married a British diplomat, Sir Charles Mendl, and after her marriage divided her time between Paris and New York, with frequent visits to London where she continued to buy fabrics and wallpapers, discovering with an unerring eye such new and unusual shops as Modern Textiles, the Little Gallery and Dunbar Hay. Although as Lady Mendl Elsie took her place among the international set in Paris and at Cannes, where she donned a bathing suit and practised yoga, the British found her a little 'de trop'. In London, her forthright manners were criticised as vulgar. Elsie often stayed with Syrie Maugham, the interior decorator, yet the writer Beverley Nichols, a friend of Syrie's, observed that while 'Syrie and Elsie were often brought into contact, one might indeed say into collision . . . though they linked arms and pecked each other, and though the air around them vibrated with "darlings", they had little in common'. Of Elsie, he went on to say damningly: 'her favourite adjective was "chic", and it

was applied indiscriminately to objects varying from the reredos at Notre Dame to a pair of Boucheron cuff-links.'[8] She also now had increasing competition in London. In 1937 she closed her firm and during the war moved to Hollywood. She died at Versailles in 1950 at the age of eighty-five.

One house which Elsie de Wolfe greatly admired and for which, although it represented the antithesis of her own philosophy and style of decoration, she would never have dared to offer any advice on its arrangement, was that of Isabella Stewart Gardner. Born in New York, the daughter of a wealthy businessman, she married Jack Gardner of Boston in 1860 when she was twenty. After the death of their only child, they began travelling and over the next two decades visited Europe, Egypt, India, China, Japan and Thailand. In England she met such figures as Oscar Wilde, J. M. Whistler, Henry James, with whom she corresponded for many years (she may well have supplied him with the character of Adam Verver, in *The Golden Bowl*, or Adela Gereth, in *The Spoils of Poynton*) and J. S. Sargent, who painted a rather dashing portrait of her; 'for years,' wrote her biographer, 'her wardrobe contained a close-fitting, plain black dress, copied from the one in the picture.'[9] In the 1880s she began buying European art and antiques for her Boston home in Beacon Street, making it a centre for the leading social and intellectual life of the city.

In 1886 Mrs Gardner met the young Harvard undergraduate Bernard Berenson, to whom she gave money for a trip to Europe. By the time they met again eight years later, this time in London, her father had died, leaving her almost three million dollars, and she had begun to buy art in a determined and dedicated manner. Berenson now became her adviser, establishing his reputation as an art scholar at her considerable expense; he bought for her on commission and at greatly inflated prices, although she would never admit that he had the better part of the bargain. She now started to plan a house in Boston which would be worthy of her expanding collection and when Jack Gardner died in 1898 she was able to give full reign to her flamboyant and despotic ambitions, unhindered by his gentle circumspection.

'Fenway Court', built under her strict supervision, is an extraordinary monument to one woman's desire to create a type of self-made nobility by bringing culture, wholesale, to America. The house, redolent of Walter Pater or Henry James, is built around a central open courtyard, on to which open windows and balconies which were purchased and shipped from European palaces. The grand, high-ceilinged, beamed rooms are named after their themes – the Gothic room, Tapestry room, Spanish cloister, Titian room, Dutch room – and are filled with precious furniture, glass, majolica, lace, armour, ecclesiastical embroideries and paintings, including canvases by, or attributed to, Botticelli, Rembrandt, Rubens, Titian and Velazquez.

Mrs Gardner opened 'Fenway Court' with a private party on New Year's Day, 1903; after a concert her guests were admitted to the central court to find it lit by candles and lanterns, the fountains plashing amid hothouse summer flowers. Henry Adams, the historian, wrote to her tellingly, and surprisingly frankly, after his first visit to the house: 'I feel as though you must

Left: **The central court-yard at 'Fenway Court', Boston, laid out by Isabella Stewart Gardner, and first opened to the public in 1903**

need something – not exactly help or flattery or even admiration – but subjects.'[10] And her motto, *'C'est mon plaisir'*, inscribed on the seal she designed for the house, was perhaps the most accurate reflection of the philosophy which lay behind her work. While in no way a professional, her decoration and arrangement of the house were a powerful expression of a personality which had, at that time, no other tangible outlet. Although Mrs Gardner eventually intended 'Fenway Court' to become a museum, she lived there until her death in 1924.

It was only after the First World War, around 1920, that interior decoration became a fashionable profession for women in England, although even then it was not considered entirely respectable. *Vogue* reported in 1921 that 'someone

Interior of 'Wilsford Manor', Stephen Tennant's house near Amesbury, decorated by Syrie Maugham and Cecil Beaton in 1939

once said that a woman is either happily married or an Interior Decorator' and by 1932 it could be observed that 'usually in our crowd when a girl gets hard hit she either takes to dissipation or else has a nervous breakdown and goes in for interior decoration as an after-cure'.[11] Previously the English interior decorator was an expert in the restoration and valuation of antique furniture, adviser to men such as J. P. Morgan, Joseph Duveen or the owners of stately homes. Mr Thornton-Smith, head of Fortnum & Mason's antiques department, or Francis Lenygon, a restorer and author of two books on seventeenth- and eighteenth-century English furniture, typified the earlier type of decorator who had catered for their more conservative Edwardian clients.

It is impossible to say which came first, the female decorators or their women clients, but in the 1920s interior decoration became a world led and dominated by women. The first and perhaps most gifted of the English decorators, Syrie Maugham, was born in 1879, daughter of the famous British philanthropist, Dr Barnardo, who founded the 'Homes for Boys and Girls', and she was strictly brought up as a member of the Plymouth Brethren. At the age of twenty-one she saw and seized her chance to escape from her restricted world, marrying Henry Wellcome, founder of the pharmaceutical company, who was twenty-six years her senior. They travelled widely together and she bore him a son, who later became mentally ill. After ten years of marriage, they separated in 1910.

In 1913 Syrie bought herself a house in Regent's Park in London and, financed by her lover, Gordon Selfridge, founder of the famous London department store, called in Thornton-Smith to help her renovate and redecorate it. Fascinated by his skills, she asked to be allowed to work with him to learn his techniques and did so on an informal basis, without pay, for several years, learning about restoration, *faux* finishes, pickling, gilding and the history of antique furniture. Syrie's first professional commission came from the young Earl of Lathom, who was rebuilding his family seat. She decorated his drawing-room with antique red lacquer furniture set against pale yellow walls and curtains. By 1924 she had become successful enough to move her original showroom in Baker Street to a large house on the corner of Grosvenor Square with workshops in Chelsea and by 1930 she was employing up to twenty people, with shops in New York and Chicago.

As though bearing out the pundits' view of an interior decorator, Syrie's emotional life had grown more complicated as her business expanded. In 1914, Somerset Maugham, the successful playwright and novelist, had become her lover and in September 1915 she gave birth to his daughter, Liza, in Rome, where she had gone in the hope of hiding the child's illegitimacy. Wellcome, however, discovered and sued for divorce, citing Maugham as co-respondent. Meanwhile, Maugham, while serving as an ambulance driver in France, had met a young American, Gerald Haxton, and had begun an affair with him. Driven by his desire to camouflage his homosexuality behind a respectable marriage and his wish to acknowledge his daughter, Maugham acceded to Syrie's demands and in May 1917 married her in Jersey City, New Jersey.

The drawing room at 'Wilsford Manor'

The marriage was doomed from the start. Maugham spent half the year travelling with Haxton, gathering material for his writing, and spent less and less time with Syrie. She adored her husband and fought hard to keep him, but he found her snobbish, pleasure-seeking gregariousness and her readiness to sell anything in the house to an admiring client distasteful. Syrie, for her part, could not comprehend Maugham's sexual obsession with Haxton nor his unfailing loyalty to his unpleasant lover, who was frequently drunk and appallingly rude. By the mid-1920s the couple were beginning to think of a divorce. It was at this time that Syrie, frustrated in her marriage, threw all her energies into her work, which, in turn, she tried to use to cajole Maugham to stay with her.

In 1926 Syrie bought a house in the King's Road, Chelsea, converting it so that Maugham had his own private rooms and separate entrance, where he could work undisturbed. She also built the 'Villa Eliza' at Le Touquet on the Channel coast north of Paris, designed to enchant Maugham and his guests and, she hoped, to supply that touch of grace which Haxton could never give.

It was to become one of her finest interiors. Beverley Nichols recalled

breakfast at the housewarming weekend which Syrie organised there as a last-ditch attempt at reconciliation. The food was,

> set on a long Provençal sideboard of bleached pinewood . . . I can clearly recall such charming details as . . . trays of fresh white currants, a mound of pale-yellow raspberries on a white Sèvres plate, and a tangle of white grapes in a coarse wooden bowl. Behind these were bowls of white roses . . . Syrie touched nothing that she did not adorn.[12]

Syrie's pathetic appeal to her husband's sensibility failed – unsurprisingly – after Maugham accused her of running a boarding-house when she handed him a bill for his laundry. The Maughams were finally divorced in 1929; Haxton remained with Maugham until his death.

Syrie understood the importance of cutting a dash socially and knew that it was part of her job to get her client talked about – a very different role from the discretion of the pre-war expert. Maugham's literary success had given Syrie the opportunity to establish herself as a society hostess and she drew mercilessly on her social contacts in the effort to promote her business. In April 1927 she unveiled her 'all-white' room at a midnight party at 213 King's Road to which she invited all her fashionable friends and clients.

Syrie's drawing-room was decorated in every tone of white and cream – indeed, new names such as parchment, pearl, ivory and oyster had to be found for the different shades. White upholstered furniture was reflected in rather severe mirrored screens and the whole room lit indirectly. She had commissioned abstract rugs, the pile cut at varying lengths to obtain a slightly sculptural look, and to echo this she went to the extreme of dipping her canvas curtains in white cement. Constance Spry, whose ideas for flower arrangement Syrie greatly admired, may well have supplied the white lilies, camellias, stocks, gardenias and chrysanthemums which filled the room. The total effect was stunning and those who saw it never forgot it. The scheme put Syrie's name on the map; other French and English decorators had already experimented with the same look, but it was she who had the business acumen to seize it for herself and so link her name inextricably with the avant-garde. Another decorator, Ronald Fleming, described Syrie's party:

> The effect was sensational, and, as a setting, filled with pretty women in coloured dresses, it was most effective; but as a scheme for permanent decoration it was obviously less successful or practical. As propaganda the idea was certainly brilliantly conceived, and the firm of 'Syrie' was launched in a big way.[13]

Syrie's social instinct led her to be daring and clients came to her for distinctive and idiosyncratic settings. Noel Coward, Gertrude Lawrence, Tallulah Bankhead, Mrs Wallis Simpson and the Prince of Wales were among those for whom she worked.

By 1930, however, Syrie no longer had the floor to herself. Unsurprisingly, her closest rival, her Chelsea neighbour Lady Sibyl Colefax, was one of the great society hostesses of her day. She had turned to interior decoration only

Sibyl Colefax's Bruton Street showroom in London, 1940

out of financial necessity at the age of fifty-five. A grand-daughter of the founder of *The Economist*, she married a barrister, Arthur Colefax, in 1901 and they travelled a great deal over the next ten years before settling in London. By the end of the war their home, 'Argyll House', had become a centre of social and political life, but in 1928 Arthur Colefax became deaf and in the following year Sibyl lost most of her own money in the Wall Street Crash.

Virginia Woolf, whose friendship Sibyl had cultivated during the 1920s, described how the society hostess turned to business, showing tremendous spirit and losing 'almost all her glitter and suavity' in the process:

> She said, I will not be beaten; and promptly turned house-decorator; ran up a sign in Ebury Street, sold her Rolls Royce, and is now, literally, at work, in sinks, behind desks, running her fingers along wainscots and whipping out yard measures from 9.30 to 7. So I said, Come and dine, and she came ... All ease, hunger, shabbiness, tiredness even; no red on her nails and merely lying in an armchair gossiping and

telling stories of this sale and that millionaire, from the professional working class standard, as might be any woman behind a counter.[14]

Sibyl initially went to work with Dolly Mann, a decorator who had a shop in Bennet Street near Piccadilly. Dolly, who had divorced her husband, the portrait painter Harrington Mann, had worked for the firm of antique dealers Lenygon and Morant for two years before breaking away to open a shop specialising in English Regency furniture (which Francis Lenygon considered to be in extremely bad taste). She combined rather whimsical and ornate pieces with fresh Regency stripes in a light, fanciful style. After working there for several months, Sibyl opened her own business, first in Bruton Street, then in Ebury Street, near Victoria. Sibyl, who, unlike Syrie Maugham or Elsie de Wolfe, had turned to interior decoration out of financial need rather than an innate desire to express her own taste, never attempted to rival Syrie's reputation for originality and instead concentrated on an elegant style typified by the English country-house tradition of good eighteenth-century furniture with pastel Adam shades of pale green, blue, lilac and yellow. She regularly visited France and Italy, returning with lamps, pottery, glass and fabrics and made a speciality of chintzes. Her clients came to her for prettiness and restrained good taste – and, of course, for the social value of her name.

In February 1936 Arthur Colefax died. Sibyl was forced to sell 'Argyll House', the setting for so many brilliant lunches and dinner parties, where she had entertained eminent friends such as Neville Chamberlain, Winston Churchill, Charlie Chaplin, Maynard Keynes and H. G. Wells, and to move into a small flat in Lord North Street, Westminster. In 1938 she took on a partner, John Fowler, and at the end of the war sold her portion of the business to Lady Astor's niece, Nancy Lancaster, who introduced a charming element of American colonial sparseness to Sibyl's very English taste.

Although Sibyl Colefax contributed little in the way of an original style, she had proved that a woman with no preparation for such a way of life could go into business and survive. And far from being socially ostracised because of her need to earn her living, she gained the admiration of her friends for her unabashed commercialism. Indeed, when she gave a final party, her swan song for 'Argyll House', in June 1936, Edward VIII, accompanied by Mrs Wallis Simpson, had attended, listening to Artur Rubinstein play Chopin and Noel Coward sing 'Mad Dogs and Englishmen', while Sibyl sat on the floor talking to Diana Cooper – proof indeed that attitudes not only to commerce but also to professional women had changed dramatically in half a century.

One woman whose defiance of the conventions of her Victorian childhood was pungently expressed through her surroundings and lifestyle, although outside the tradition of the professional decorators, was the painter Vanessa Bell. In 1904, after their father's death, she and her sister Virginia had set up their own unconventional house in Bloomsbury and in 1906 she had married the art critic Clive Bell. However, later, when her marriage threatened to

suffocate her in a world of entertaining, smart clothes and wifely behaviour, so preventing her from painting, Vanessa broke away and through her affair with the art critic Roger Fry became enthusiastically involved in the foundation of the Omega Workshops in 1913. The Omega was created to provide work for struggling young artists and to proselytise Post-Impressionism and it introduced the idea of applying abstraction and a Fauvist use of colour to furnishings. Students from the Slade School of Art joined Fry's group of painters and helped to design fabrics and carpets, paint furniture and decorate pottery, tiles, boxes, fans and silk scarves, which were sold from the gallery in Fitzroy Square. The Omega also offered an interior decoration service, which consisted of painting murals or abstract patterns on walls, doors and fireplaces.

During the next two years Vanessa grew increasingly close to the painter Duncan Grant, a co-director of the Omega, and in 1916 she moved with him to 'Charleston', a house in Sussex which they immediately began to decorate; after the Omega closed in 1919, Vanessa and Duncan continued to develop their idiosyncratic style of interior decoration. Working in partnership, they embellished houses and London flats for several of their family and friends; their style was easy and colourful, reflecting very different values from Syrie Maugham's opulence. Books, paintings, decorative panels and comfortable armchairs placed around the tiled fireplace were the order of the day, creating rooms where people could sit and talk. These interiors were never overtly smart or fashionable, but their visitors – some of whom belonged to Sibyl Colefax's social milieu – frequently were, presenting a contrast with the impression of slightly studied bohemianism evoked by the rooms themselves.

Once Vanessa began to live with Duncan Grant, she never again achieved the intensity of effect which had marked her painting before the war. His art was easy and flippant, snatching images to communicate charming, decorative observations and, under his spell, her painting became less austere. By the late 1920s Duncan and Vanessa had established themselves as decorators and designers. One of their most successful interiors was the dining-room of 'Penns-in-the-Rocks', the house of the poet, Lady Dorothy Wellesley, near Tunbridge Wells. Delicate pastel shades were used against large appliquéd, sequined curtains, mirrors and painted furniture, with six large panels showing classically posed figures, some of which were based on photographs of Vanessa's sons playing in a garden, taken almost twenty years earlier. Their style was, however, generally more robust, with stronger colours and a confident, carefree calligraphy. Decorative work became a major part of Vanessa's life at this time, as she used it to create a cherished and hospitable home for the people she cared for, combining her painting and looking after children with gardening, painting murals, designing carpets, decorating teacups or working cross-stitch cushions. The result was that 'Charleston' became a chaotic but untrammelled expression of the freedom she sought for her art and her way of life. A room would be crammed with objects she, her family and friends had designed and decorated: fabrics produced by the

Vanessa Bell in her garden at 'Charleston', Sussex, 1925–26

decorator Allan Walton, pottery thrown by Vanessa's son Quentin, book jackets designed for Leonard and Virginia Woolf's Hogarth Press, carpets woven by Wilton Royal. Although Vanessa might possibly have been a finer painter had she not lived a life 'packed like a cabinet of drawers', as her sister Virginia described it, she never sacrificed her art, continuing to paint until her death in 1961 at the age of eighty-one.

A tragic contrast to Vanessa Bell's fulfilled existence, but one perhaps influenced by it, is offered by the circumscribed life of the painter Dora

Carrington, one of the Slade students connected with the Omega. She, too, decorated furniture and rooms for friends and took proud delight in the embellishment of the two houses she shared with the writer Lytton Strachey, 'Tidmarsh Mill' in Berkshire and 'Ham Spray' on the Newbury Downs. Although she admired Duncan and Vanessa's decorations at 'Charleston', where Lytton often stayed, her decorative style was more formal and restrained than the tumbled disarray of 'Charleston'. By the 1920s she was doing less and less serious work, willingly sublimating her painting to her obsession with Lytton's comfort, and her decorative work became her only artistic outlet. Strachey was her entire world and when he died of cancer in January 1932 she found herself unable to live without him; she shot herself a few weeks later.

'Charleston' and 'Tidmarsh' represented a rejection of the Victorian values which still pervaded the world of the decorators. The lavish schemes of Elsie de Wolfe, Syrie Maugham and Sibyl Colefax continued to find a market until the Second World War, but their ideas were essentially aimed at a diminishing section of society and their ornate luxury relied on the employment of servants as much as the drab, heavy Victorian furnishing schemes they had thrown out. Charles Darwin's grand-daughter, Gwen Raverat, wrote of one of her great-aunts:

> She told me, when she was eighty-six, that she had never made a pot of tea in her life . . . she asked me once to give her a bit of the dark meat of a chicken, because she had never tasted anything but the breast . . . Once she wrote when her maid . . . was away for a day or two: *I am very busy answering my own bell.*[15]

Yet by the late 1920s there were many people who had grown up in large houses built on the assumption that there would be servants to lay, light and clear the coal fires every day; fill, clean and lead the boilers and kitchen ranges and move the heavy sideboards and wardrobes for spring-cleaning, who no longer had the income – or the desire – to live with servants. At the same time, life had not changed radically enough in the three generations since the mid-nineteenth century for every middle-class woman to have mastered the household arts; Gwen Raverat admitted that,

> Even when I was first married it would never have occurred to me that I could possibly be the cook myself, or that I could care for my baby alone, though we were not at all well off at that time. It was not that I was too proud to work – I would not have minded in the least what I did – it was simply that I had not the faintest idea how to begin to run a house by myself, and would not have thought it possible that I could do it, in spite of all my mother's efforts to train us in housework.[16]

For these homes, the answer lay not in the decorators' elaborate schemes, but, on the one hand, in the revolution in household technology and, on the other, in the trim lines and built-in convenience of English modernism. In the transition from large house with servants to manageable apartment, with

perhaps a part-time maid, new glass and tile bathrooms, new heating systems, which included white-enamel stoves and electric fires, and new methods of cleaning went hand in hand with the fashionable abolition of dust-catching mouldings, picture rails and skirting boards and with wall-to-wall carpets and smooth, veneered, built-in cupboards and shelves. The new look was clean, simple and 'easy'. It was an idiom that made the decorators' work look fussy and mannered.

Although in the 1920s the idea that the furnishings and decoration of one's home could be altered every few years was still relatively recent, by 1930 a new type of shop, where the intrepid could order extrovert furnishings for a simple, modern interior in scarlet and silver, or black and jade green, came into being. These galleries supplied a style of furnishing reminiscent of the luxury depicted in Hollywood films and, indeed, several supplied sets for the British film industry. In 1929 an American, Curtis Moffat, opened a design studio in Fitzroy Square in Bloomsbury selling antiques, modern art and contemporary French and English furniture. Married to Iris Tree, who was a close friend of Nancy Cunard and Diana Cooper, he belonged to the same social set as Sibyl and Syrie and had close ties with Paris, where he had worked as a photographer with Man Ray. He held the English agency for the French firm Décorations Interieures Modernes (DIM) and also sold primitive African art, then all the rage in Paris. Another fashionable decorator, thought to be extremely smart and modern, was Arundell Clarke, who had a gallery in Mayfair. He specialised in plain, functional 'cocktail party' rooms with indirect lighting and built-in furniture and is credited with the first 'all-white' room to be shown in London, although it clearly had less obvious panache than that of Syrie. These shops flourished in the period leading up to the war. In 1930 Arundell Clarke's protégé Denham MacLaren opened his own gallery and in 1934 J. Duncan Miller, a designer who had worked for Curtis Moffat, and his wife Madeleine also opened a gallery selling modern French furniture.

It was through the gradual acceptance of European modernism and the revolution in household technology in the 1920s and 1930s, rather than the grandiose schemes of the decorators, that the Victorian values of the earlier generation really gave way to an almost self-conscious love of the new. The avant-garde in architecture, design, art and fashion was, although often hotly debated, welcomed as an escape from the conventions and ideals which, it was believed, had contributed to the First World War. The heyday of the great decorators had long passed, and their idiom was to find only a limited place in society after the Second World War. In fact their contribution to the way in which people lived was largely ephemeral, for they had influenced only the fashion which reigned among a small exclusive group and it was a more classless type of interior – pioneered in Europe – which pointed the way forward to the interiors of today. Where they had contributed was in encouraging their women clients to express themselves and their aspirations through their domestic environments and in a manner which had little to do with such images of women as the Victorian ideal of the chatelaine.

5. From Icon to Machine

In 1861, the year in which William Morris founded his decorating firm in London, Tsar Alexander II freed the serfs in Russia and, for the first time, gave them land of their own. While the members of the Arts and Crafts Movement acted in response to industrial unrest, their contemporaries in Russia who held similar liberal beliefs were concerned by the very different problems of a dispossessed rural peasantry and the stagnant political and economic organisation of a nation which, despite her vast expanses and rich resources of coal, iron and oil, lagged far behind the rest of Europe. This concern was expressed most directly in renewed interest in the management of estates and in the education and emancipation of the peasants, and led, by the closing years of the nineteenth century, to a fresh artistic awareness of Russian landscape and traditional Russian arts.

Through art, the liberals within the middle and upper classes were able to show their support of social reform as the successive governments of the tsars became increasingly reactionary. Folklore, myth, peasant art and the art of the Russian Church came to symbolise a new spirituality centred on a fresh relationship with the ancient traditions of rural village life. Artists drew upon religious art and peasant culture in their work, creating a sense of national identity in their appeal to Eastern European traditions and the peasant was increasingly depicted as their hero within a new realist style.

The artistic adoption of myth and religion within this context cultivated the view of women as repositories of wholeness and wisdom through the association with the Virgin Mary and the powerful women of legend, and it was to be women who led the resurgence of interest among artistic circles in peasant traditions. The two major centres where peasant arts were revived were established by aristocratic ladies: both existed within the nineteenth-century tradition of enlightened estate management. The first of these, at Abramtsevo, near Moscow, developed out of the rural colony for artists founded by Savva Mamontov, a railway magnate, on his estate in the 1870s. His wife, Elizaveta, set up a wood-carving school to give young peasants a regular winter occupation which, with the help of her artist friends, developed

into a craft community. The greatest contribution to the artistic development of the school was made by the painter Elena Polenova – sister of Vassily Polenov, a friend of Tolstoy and Turgenev and one of the first painters to depict the Russian landscape in a realist style – who, encouraged by Elizaveta Mamontova, began a study of the decorative motifs used in peasant art and, with another artist, Maria Yakunchikova, collected fairy tales and legends, which Yakunchikova then used as the themes of her paintings and embroideries. Yakunchikova also later founded a carpet and dye factory on her own estates. These two women gradually took over the running of the wood-carving school, introducing other traditional peasant crafts, such as embroidery and painted decoration, and encouraged the peasants to make use of the wide range of motifs they were collecting themselves.

It was Elena Polenova's studies that inspired the establishment of the second Russian workshop for peasant crafts, set up in 1893 by the painter Princess Maria Tenisheva. Princess Tenisheva was described by one writer as 'one of the most unusual women I have ever met. Unstable, even rather cranky, with an all-round education and widely-read, imperious, exacting and imbued with a genuine and sincere love of art.'[1] She had already taken over an existing school for peasant children on her husband's estate, Talashkino, near Smolensk, and here embroidery and design, singing and traditional music played upon such instruments as the balalaika were taught. The workshops employed peasants trained at the school to make carved and decorated furniture, embroidery and ceramics which were sold in Moscow at a shop called Rodnik. Solidly built and liberally decorated with deep carvings, occasionally painted in bright colours, of stylised birds, fish, flowers and religious motifs, the Talashkino furniture owed little to European influences. It lacked sophistication, but had great charm, and the designs focused attention on rural Russian culture which was in danger of disappearing in an age of industrial expansion.

Princess Tenisheva was herself a designer and a fine enamellist as well as a great patron. Artists, writers and musicians were welcomed at Talashkino, which was a lively centre for information on the latest news from artistic circles in Russia and Europe. The Princess was also interested in French Art Nouveau and owned a collection of ancient Russian art and modern decorative pieces which she donated for the establishment of a museum in Smolensk; there visitors could see work by Emile Gallé and René Lalique, the French Art Nouveau designers, and by the American L. C. Tiffany. In 1898 she gave financial support to *World of Art*, a new magazine founded by Serge Diaghilev with the help of Alexander Benois and Leon Bakst which lent its support to the development of distinctively Russian arts. Diaghilev knew and admired the workshops at both Talashkino and Abramtsevo and he devoted one issue of the magazine to the products of Princess Tenisheva's workshops.

While Diaghilev and his circle championed an aesthetic based upon Russian and Eastern European forms, colours and themes, both Russian artists and

their patrons – including Princess Tenisheva and Savva Mamontov – paid close attention to the development of new artistic theories and styles in Europe. Many Russian artists went to study in Paris, but, as they returned to their homeland with news of Fauvism, Cubism and Futurism, a theoretical split developed between those – such as Alexandra Exter or Luibov Popova – who welcomed the European innovations and those – such as Natalia Goncharova and Mikhail Larionov – who came to believe that only by reference to their own cultural traditions could Russian artists express ideas of any importance. Yet although almost every exhibition held in Russian cities in the years around 1910 sought to establish some new law which was henceforth to govern art and to disclaim all that had gone before, and although new 'isms' – such as Neo-Primitivism, Cubo-Futurism, Rayonism or Suprematism – abounded, many of the artists experimenting with new theories about representation, form, colour or the psychological content of art – such as Natalia Goncharova the Neo-Primitivist painter, Wassily Kandinsky who believed that colour and form had a direct influence on the psychology of the onlooker, and later the Suprematist painter Kazimir Malevich and the Constructivist artist Vladimir Tatlin – in fact followed zigzag paths in their exploration of the exciting new developments in art, each borrowing from Europe, from the nineteenth-century interest in rural Russian culture and from their contemporaries in order to take their own creations and ideas forward. Throughout this period women artists, partly as a result of their nineteenth-century inheritance, were regarded as equals by their male colleagues. Indeed, many of the leading painters of the day were women: they trained at the same schools, were free to travel and study abroad, shared in various exhibitions and established their own studios while at the same time marrying and having children.

The painter who, perhaps more than any other, identified her career with the spirituality of Eastern Europe was Natalia Goncharova. Born in 1881 into a cultured family in central Russia, Goncharova studied at the Moscow Institute of Painting, Sculpture and Architecture, where, in 1900, she met Mikhail Larionov, a fellow student, who became her lifelong companion. At this time she abandoned sculpture for painting and stage design, always working closely with Larionov, and was influenced by French painting, especially the work of the Fauves. In 1906 Diaghilev included work by Goncharova and Larionov in the *World of Art* show at the Salon d'Automne in Paris; by 1908, however, she began to turn increasingly to the themes of peasant and religious art, and in December 1910 she and Larionov organised the controversial *Jack of Diamonds* exhibition in Moscow. The first of several exhibitions to be organised by Larionov, it brought together contemporary works by French, German and Russian artists, but also established the Russian Neo-Primitivists in firm opposition to those painters who drew their inspiration from European styles. Goncharova declared her allegiance to the roots of her own culture in the catalogue to a one-woman show held in 1913:

At the beginning of my development I learned most of all from my French

contemporaries . . . Now I shake the dust from my feet and leave the West, considering its vulgarizing significance trivial and insignificant – my path is toward the source of all arts, the East. The art of my country is incomparably more profound and important than anything that I know in the West.[2]

She found an immediacy and an energy drawn from her identification with an imaginative world far larger than her own personal concerns. While she, a rather solemn, although extremely energetic woman, admired Russian icons and Byzantine art, Larionov drew upon the more light-hearted motifs of *lubki* (a type of hand-painted peasant woodcut), painted trays, signboards and other such items. One of Goncharova's main objectives was 'to fight against the debased and decomposing doctrine of individualism, which is now in a period of agony'.[3] Ironically, however, despite her identification with the Russian artistic concerns of the nineteenth century, Goncharova was to have far greater success in France, where the Rayonist style which she and Larionov developed in 1913 had affinities with Robert and Sonia Delaunay's work, than in her native Russia. In 1914 Diaghilev asked her to design the drop curtain and costumes for the Paris production of *Le Coq d'Or*, which opened in May that year, with music by Rimsky-Korsakov and choreography by Fokine. She produced a riot of colour, of large, primitive designs, national costumes and head-dresses. It was the first of many successes that Goncharova was to achieve with the Ballets Russes. While there had been theatres at both Abramtsevo and Talashkino where artists and craftsmen combined to produce plays and concerts, Goncharova developed the style of these amateur theatricals to new heights, celebrating the arts and ceremonies of traditional peasant life and combining her visual homage to Mother Russia with music by such composers as Stravinsky, Mussorgsky and Rimsky-Korsakov.

In 1917 Goncharova and Larionov accompanied Diaghilev to Italy and Spain, where, like her compatriot Sonia Delaunay, Goncharova found further inspiration in the costumes of Spanish dancers. At the end of that year the couple settled in Paris and Goncharova continued to paint, depicting themes such as nature, fertility, motherhood and sanctity in strong colours and primitive, almost naive, forms. She also undertook embroidery, book design and further theatre designs for Diaghilev. In 1923 she produced austere, elegant costumes for Bronislava Nijinsky's choreography in *Les Noces*, a ballet based on the rites of a traditional peasant wedding, but in 1926 she returned to her more gorgeous idiom for two more ballets, *L'Oiseau de Feu* and *La Foire de Sorotchinsky*. The tremendous popularity of the Ballets Russes increased the esteem in which the Russian émigré artists were held in Paris.

With the outbreak of the First World War, the Russian artists who had been experimenting with French Cubism and Italian Futurism became increasingly isolated and so began to develop their own theories. Malevich represented one school, Suprematism, which upheld an aesthetic based upon pure form and pure colour, and Tatlin the other, named Constructivism, in 1921, which supported an exploration of form as dictated by the properties of specific materials. The avant-garde painters enjoyed their freedom, becoming

Costume design in
watercolour by Natalia
Goncharova for *Le Coq
d'Or*, 1914: Russian
woman in a red dress
with yellow sleeves

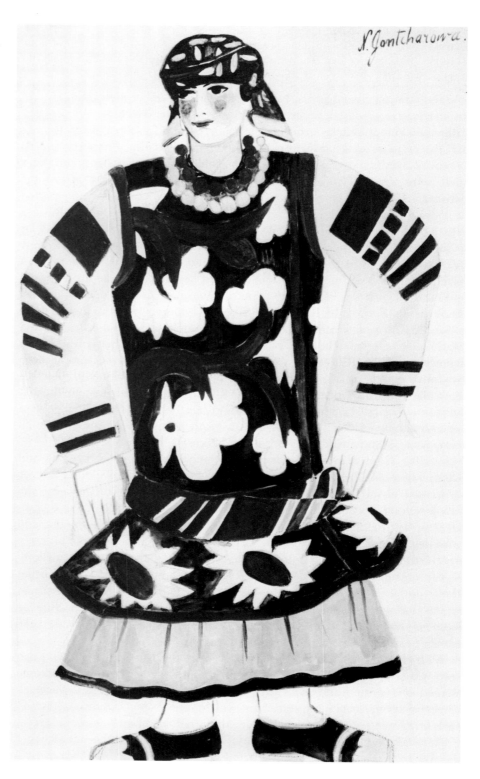

more and more radical in their approach to art and turning away from the European abstract painting which contained reference to a figurative tradition, disliked by the avant-garde as the type of art collected by the bourgeoisie. In their exploration of the formal implications of abstraction, these painters wished to free art from its associations with the patronage and culture of the wealthy and to create a revolutionary art free from all conventions but the demands of art itself. The October Revolution of 1917 gave these revolutionary theories a new cohesion and purpose and many of the avant-garde artists were taken up by the Revolutionary government. Nevertheless, fresh manifestos, especially those of Productivism, continued to refine the approach to a socialist art.

After the Revolution, responsibility for the art schools rested with Anatoly Lunarcharsky, the Soviet Minister for Enlightenment. Lunarcharsky integrated the Moscow Institute of Painting, Sculpture and Architecture with the Stroganov Art School to form the Svomas (Free State Art Studios) and set up a separate Visual Arts Section (IZO). Although Lunarcharsky had no great admiration for the work of the avant-garde, their anti-bourgeois protest provided the most convenient form of propaganda for Lenin's government. The painters who held the top posts in the art academies were opposed to the Revolution, and since the focus of art had to move from the peasant traditions and culture depicted by the Neo-Primitivists, the jobs in the re-organised schools were given to the young avant-garde artists. Women were included not only among the teaching staff of the new schools, but also among the administrative staff who decided on the future course of Soviet culture. Lunarcharsky was supported by several women close to the Government, including Lenin's wife, Krupskaya, who was, for some time, his deputy and also head of the film section, Trotsky's wife, who was head of the museum department and her sister-in-law, who headed the theatre section.

One of the women who helped to establish the IZO was Olga Rozanova, wife of the poet, Aleksai Kruchenykh, who was a friend of the painter Malevich and the poet Vladimir Mayakovsky. In 1918 Rozanova initiated the Industrial Art Section of the IZO, which she headed with the Constructivist artist Alexander Rodchenko. Despite the chaotic conditions which prevailed in the country during the Civil War, she travelled extensively throughout Russia, establishing Svomas in several towns and re-organising museums to take account of industrial art. She also supplied designs for embroidery and clothes for peasant workshops, always stressing practicality rather than traditional motifs.

Rozanova was to die suddenly of diphtheria in November 1918. Her work, however, set the tone for what was to follow. She believed that art belonged to the proletariat and should reflect the essential elements of industrial and urban life. She wanted 'a creative, not a reproductive, art' freed from the bourgeois chains of 'style'.

In the spring of 1920 the Inkhuk (Institute of Artistic Culture), essentially a theoretical and research-oriented group, was formed in Moscow under

Varvara Stepanova, photographed by her husband Alexander Rodchenko in 1924

Wassily Kandinsky with Rodchenko, his wife Varvara Stepanova, Liubov Popova – all painters – and the architect Alexander Vesnin as co-directors. The following November the Svomas were re-organised as the Vkhutemas (Higher Technical Artistic Studios), intended to train artists for the benefit of the ailing national economy. The Vkhutemas trained about 1,500 students. For their first year they studied graphics, colour and spatial studies in the Basic Section or Workers' Faculty, before moving on to train in a chosen subject (architecture, sculpture, graphics, typography, wood and metalwork, ceramics, textiles, painting or theatre design) and to spend some time working in industry. At the Vkhutemas the theory developed at the Inkhuk was put

into practice and the traditional study of the history or psychology of art or of aesthetics was rejected in favour of a study of form and materials.

At the end of 1920 Kandinsky resigned from Inkhuk under pressure from his colleagues, who disapproved of his psychological approach to art. He was replaced by those who, like Stepanova and Rodchenko, were more interested in exploring Tatlin's Constructivist ideas about materials and form. Among themselves, the Constructivists argued about the place of painting and sculpture within their theories: to begin with, they continued to paint, believing that a canvas, a composition, was a construction which could express the properties of paint and that such art still had a valid place in their researches. But gradually they came to feel that their constructions should have a utilitarian purpose in keeping with the future of Communism.

It was this move away from any form of purely conceptual art which led to Productivism, announced by the directors of Inkhuk at $5 \times 5 = 25$, an exhibition held in Moscow in September 1921. The Productivists believed that art should be practised as a trade and that the production of well-designed articles for everyday use was of far greater value than individual expression or experiment. They deplored the exploitation of paintings as an expression of culture by wealthy patrons, which meant that the intention of the painting ceased to exist over the passage of time, while its value, in aesthetic and financial terms, continued to increase.

The exhibition itself was organised under the auspices of Inkhuk, and four of the five artists involved – Rodchenko, Stepanova, Vesnin, Popova and Alexandra Exter (each of whom exhibited five works) – taught at the Vkhutemas. The Productivist manifesto, written by Stepanova and Rodchenko, called for artists to serve the public in the same way as a doctor or a scientist and described their creative actions as akin to the work of an engineer. The exhibition $5 \times 5 = 25$ was a valediction to painterly interests; as Stepanova wrote in the introduction to the catalogue, 'The sanctity of a work as a single entity is destroyed.'

The death of the easel painting was welcomed by the authorities, who were beginning to fear the artists' freedom and who now encouraged them to forge closer links with industrial production and the needs of agitprop. It was Productivism which, from 1921, formed the basis of the teaching at the Vkhutemas. Of the five artists who had exhibited in 1921, Stepanova and Popova turned to textile design, Exter to theatre design, Rodchenko to graphics and photography and Vesnin to architecture. Many of their plans were doomed to remain as theories, since the crippling shortages of raw materials which existed in this period of reconstruction after the Civil War meant that few projects could be realised. Moscow did, however, have a large textile industry and, not surprisingly, it was textile and theatre design, which served the needs of propaganda, which were most influenced by the vision of these artists and showed that the proletariat could benefit from the Productivist manifesto.

One of the major Constructivist artists who embraced Productivism was

Varvara Stepanova, who married, developed her artistic philosophy and worked with, Alexander Rodchenko. They both came from peasant origins and met at Kazan Art School. In the years before the Revolution they came to live in Moscow, sharing an apartment with Kandinsky, through whom they met Exter and Popova. It was perhaps because of their own humble origins that they so enthusiastically supported the demands made by socialism on art and were to play such a prominent role within Inkhuk and the Vkhutemas. In 1922 the Vkhutemas gave them a studio in Moscow and in this one large room, divided by a bookshelf into studio and living space, they lived, worked and, eventually, brought up their daughter: even a photographic darkroom was organised within the space.

The following year, Stepanova and Liubov Popova were invited to design textiles for the First State Textile Factory in Moscow; both Popova and Stepanova designed bright, simple, geometric patterns, freed from 'degenerate' bourgeois style and also small enough to save waste when cutting to match repeats. Stepanova had a professional training as a dress designer, yet her designs for clothing seem more closely related to her other artistic work than Popova's. In *The Dress of Today Is the Industrial Dress*, she wrote:

> Store windows with their dresses exhibited on wax mannequins are becoming an aesthetic leftover from the past. Today's dress must be seen in action – beyond this there is no dress, just as the machine cannot be conceived outside the work it is supposed to be doing . . . Aesthetic aspects must be replaced by the actual process of sewing. Let me explain: don't stick ornaments onto the dress, the seams themselves – which are essential to the cut – give the dress form. Expose the ways in which the dress is sewn, its fasteners, etc., just as such things are clearly visible in a machine.[4]

The clothes today still seem surprisingly modern. Their stark blocks of colour, abstract geometric patterns, short hemlines and sleeves and simple necklines presented a revolutionary image of practical dress. They were indeed worker clothes, befitting women who were equal partners in the creation of a new socialist state. The textile designs, too, are marked by the absence of overtly pretty motifs, although they are fresh, crisp and cheerful.

In 1924 Stepanova became the professor of textile design at the Vkhutemas, but she gradually abandoned textiles for typography and book design, collaborating with her husband and the poet Mayakovsky on the monthly magazine *Novyi LEF* and, later, on cinematic and photographic projects.

Liubov Popova, who worked with Stepanova at the First State Textile Factory, came from a very different background. Born in 1889, she came from a wealthy, cultured merchant family and was brought up near Moscow. Her husband was a connoisseur of ancient Russian art and architecture and, as a young woman, she visited many Russian cities studying religious art. In 1912 she and Nadezhda Udaltsova, a fellow artist with whom she had shared a studio in Moscow, went to Paris to study painting at the Académie La Palette and in 1914 she again visited France and also Italy, where she was influenced by the work of the Futurists. When the Revolution came, however, Popova

Varvara Stepanova, photographed by Alexander Rodchenko in 1925

was among the most innovative of the young avant-garde; and as Udaltsova wrote, 'A storm was in the air. My colleagues and I gladly accepted the October Revolution and, from the very beginning, we went to work for the Soviets and then for the People's Commissariat for Enlightenment.'[5]

In 1916 Popova and Udaltsova had first started designing textiles, rugs and other household items and in 1917 they collaborated with Vladimir Tatlin on the decoration of the Café Pittoresque in Moscow. The following year they became teachers at the Svomas and in 1920 joined Rodchenko and Stepanova in Inkhuk. In 1921, following the $5 \times 5 = 25$ exhibition, Popova rejected studio painting for productional art. She wrote the following year:

> Why do we still not have a precise formula that would once and for all cut short all those absurd polemics and, like the best vacuum-cleaner construction, would remove all this aesthetic trash from life and transfer it to the jurisdiction of those who protect antique monuments and items of luxury?[6]

This belief in the importance of the artist's role in helping to bring about the social changes wrought by the Revolution became the guiding principle behind every aspect of her work, which included designs for theatre sets and costumes, clothes, textiles, porcelain and books. Thus, for example, her stark and functional designs for the set and costumes of Meierkhold's production of *The Magnanimous Cuckold* (1922), with the actors depicted as workers, attempted to present a formal organisation rather than an aesthetic enhancement of life upon the stage. In her fashion designs – perhaps the most important area of her productional work – she created simple, functional smock dresses which could easily be made by women at home from the patterns and advice which were published in the various periodicals. Popova once said that 'no artistic success has given me such satisfaction as the sight of a peasant or worker buying a length of material designed by me'.[7] Despite the complex artistic theories which she explored throughout her career – her textile designs, for example, were executed according to an understanding of the body's movements – she, perhaps more than any other Productivist artist, succeeded in meeting the true needs of the proletariat in whose name their theories were developed. In 1924 Popova caught diphtheria from her child and died at the age of thirty-five.

A third woman who followed a similar path to her colleagues at the Vkhutemas, although she eventually chose to leave the Soviet Union, was Alexandra Exter. Born into a wealthy Ukrainian family in 1882, she had studied art in Kiev and had in 1907 exhibited with Goncharova and Larionov in Moscow, but had subsequently broken with their Primitivist approach in favour of Cubism. She had first visited Europe in 1908, following her marriage to her cousin, Nikolai Exter, a wealthy lawyer, and had met Picasso, Leger and Apollinaire in Paris. In the years leading up to 1917 she, like Popova, had frequently visited France and Italy and did much to help introduce other Russian artists to Cubism.

Top left: Plate decorated with a stylised yucca plant made at the Newcomb College Pottery, New Orleans, *c.* 1905. The choice of a local motif and the clear colours show a decisive independence from the Gothicism of the William Morris style which had initially inspired the American Arts and Crafts Movement

Top right: These pots by Katharine Pleydell Bouverie show the range and subtleties of the vegetable and wood ash glazes with which she has experimented since the 1920s

Left: Porcelain bowl by the Austrian-born potter Lucie Rie, *c.* 1978. Her post-war work marked a vital departure from the Oriental rhetoric of Bernard Leach's style

Facing page: Ill Omen, or *Girl in the East Wind with Ravens Passing the Moon,* 1893; one of Frances Macdonald's haunting watercolours and typical of the early Glasgow School style

Above: The drawing room at 'Charleston', the Sussex house which Vanessa Bell shared with Duncan Grant for forty-five years and which they began to decorate when they moved there in 1916

Ceramic figures by
the three leading
ceramists at the Wiener
Werkstätte in the 1920s.
Top left: Vally Wieselthier
Top right: Susi Singer
Left: Gudrun Baudisch

Facing page
Left: The 'stereotype'
dress, designed by
Alexandra Exter in
1922.
Right: Another simple,
geometric dress
designed by Luibov
Popova. Both were
made up in 1979 and
show the Construct-
ivists' approach to
fashion in revolutionary
Russia

Two hand-block-printed textiles designed by Phyllis Barron and Dorothy Larcher in the 1920s, using natural dyes.

Left: 'Scallop', linen dyed in indigo and printed with nitric acid to discharge the design
Below: 'Lines', positive print in red on natural linen.

Left: Composition Aubette, one of Sophie Taeuber-Arp's geometric embroideries, executed in 1928, which influenced the work of her husband, Jean Arp

Facing page: The 'Transat' chair, in leather and lacquer, designed by Eileen Gray in Paris, 1927

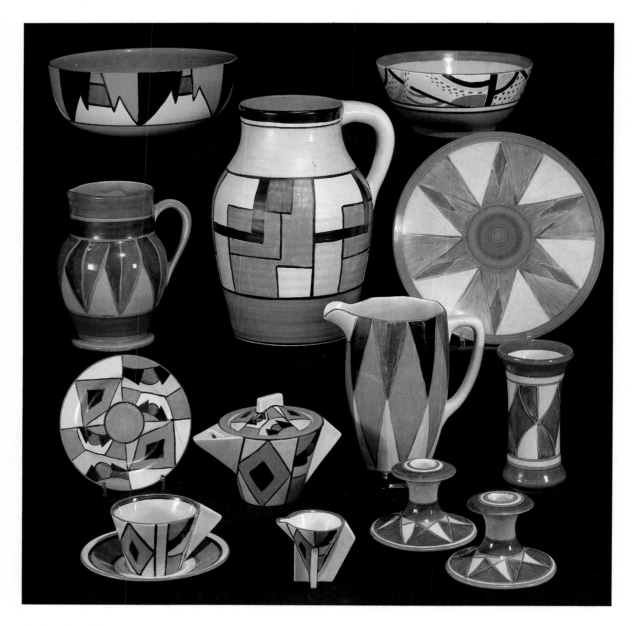

A selection of the decorated pottery designed by Clarice Cliff in the 1930s and marketed under her name

Exter's involvement with the theatre had begun during the First World War when she started designing for Alexander Tairov's Kamerney Theatre in Moscow. Like her contemporary Sonia Delaunay, she was influenced by the colours and motifs of her native Ukraine and in 1915 she had begun to exhibit decorative items embroidered to her designs by the peasant women of a village near Kiev. Following the Revolution, however, she began designing for the Moscow Fashion Studio, creating both utilitarian worker clothing which could be mass produced and also more luxurious, richly embroidered dresses. Her designs, with those of Stepanova and Popova, were published in a 'programme' for Soviet fashion by Lamonova, a celebrated contemporary dressmaker.

In 1924 Exter settled in Paris. Despite the success of her work for the Kamerney Theatre and for some early Soviet films, she found her imagination constrained by the increasingly stringent ideological and, indeed, material limits imposed in post-Revolutionary Russia; in Paris she felt able to create more freely. Until the early 1930s, she taught Constructivist theatre design at Fernand Leger's Académie d'Art Moderne, undertook fashion, interior and book design and also continued to design for the theatre and for films. She saw her theatre designs as the creation of stylised images, the actors as 'living sculptures', but her sets remained somewhat fanciful and more overtly decorative than the requirements demanded by agitprop. Exter remained in Paris, where so many Russian émigrés made their home, until her death in 1949.

It is only in recent years that the work of artists such as Stepanova, Popova and Exter has been rediscovered and placed within the context of better-known contemporary movements, due both to the fact that the work of the Russian avant-garde was never fully accepted in its own time (its non-figurative, non-realist canvases shocked even the most advanced collectors) and to historical events. In the 1920s the era of the Vkhutemas came to a close. Lenin died in 1924; at the beginning of 1929 Trotsky was exiled. Under Stalin, the Vkhutemas were disbanded in 1930 and in 1934 the proclamation of Socialist Realism led to the denouncement of the Constructivists' earlier abstract work as Formalist. The short-lived explosion of ideas, which had lasted less than fifteen years, then remained isolated by the doctrinal repressions in the Soviet Union. By 1930 many of the artists had lost faith not only in Communism but also in the theoretical ideals of their art. Under Stalin, they had either to turn to realistic subjects or to stop painting. Stepanova and Rodchenko continued to work in Moscow, but their days at the forefront of the avant-garde were over and, by the time of their deaths in the 1950s, they no longer believed that their work would ever be seen as important.

The teaching programme that had been pioneered at the Vkhutemas by the members of Inkhuk was revolutionary in its stress on materials and forms of construction, as was the close involvement of women in the pragmatic realisation of the Productivists' aims – particularly in the context of contemporary developments in other countries. These artists, especially Popova,

**Two textile designs
by Liubov Popova,
1923–24**

were among the most exciting painters of their time, yet they were nevertheless enthusiastic in their abandonment of painting in the cause of creating a new society and proved themselves to be the most pragmatic of all the Russian avant-garde artists. But it is often forgotten that one of the reasons that women could move swiftly to apply their ideas to the challenge of the Revolution and were unafraid of voicing their ideas was their acceptance within artistic circles since the previous century: the strength of women's contribution in post-Revolutionary Russia resulted from the intertwining of two traditions, not from the abandonment of an old order for one entirely new. Had they had the opportunity to put more of their designs into production, had the raw materials existed, their influence on contemporary design would reflect more truthfully the richness of their ideas and they would undoubtedly receive their due recognition.

6. Something Colourful, Something Joyful

The second half of the nineteenth century changed Vienna from a pleasant European capital, famed for its music and simple elegance, to the powerful administrative centre of the vast Hapsburg Empire. A new class of wealthy magnates, who owned steelworks, coal-mines and factories in Bohemia and Poland, settled in Vienna, where they built palatial townhouses on the Ring, a wide road encircling the centre of the city, flanked by newly built museums, a theatre and public buildings, all liberally garnished with sculptures, mouldings and mosaics. Yet ironically, the Hapsburg Empire was itself beginning to disintegrate: the various nationalities within its borders were clamouring for autonomy from a centralised system which was collapsing under its own weight.

In 1897 a group of avant-garde Austrian artists had founded the Vienna Secession in opposition to the established Academy painters and to the florid extravagance of the Ring and all that its officialdom stood for. They designed and built their own exhibition hall in Vienna and here they organised shows of contemporary European art and design, including work by such leading British Arts and Crafts Movement designers as C. R. Ashbee and William de Morgan; they supplied the visual counterpart to the intellectual ferment of the time produced by writers such as Freud and Wittgenstein, musicians such as Mahler and Schönberg and novelists such as Kafka and Musil and were part of the intellectual community which met in the coffee houses to discuss the issues of the day. All of them were agreed that the imperial system had to change before the entire edifice crumbled disastrously around their ears.

By the turn of the century the Kunstgewerbeschule (School of Arts and Crafts) established by the imperial government in 1867 was dominated by the artists of the Secession. In 1899, the painter Felician von Myrbach was appointed Principal of the school and he brought two fellow Secessionists, the architects Josef Hoffmann and Koloman Moser, on to the staff. These radical young professors talked about form and function, about reducing ornament to a rational system and even about doing away with it altogether, and their students designed articles such as plates, tea-pots or flower vases, for everyday

use. Inspired by the ideals of the British Arts and Crafts Movement whose work they saw at the Secession exhibitions, Hoffmann and Moser concentrated on linking the way people furnished their homes with the way in which they arranged their domestic lives and believed that the decoration of a house should no longer be a mere display of worldly possessions, but a mirror to one's thoughts and actions: a simple, functional dining-room might encourage dinner-table discussions on pertinent topics rather than encouraging social intrigues and flirtations; a clear, uncluttered living-room would proclaim the intention of a sensible and useful life. But although they shared the idealism of the British movement, they arrived at a quite different aesthetic.

In 1903, with the financial support of a Viennese banker, Hoffmann and Moser founded the Wiener Werkstätte (Vienna workshops). Hoping to revive the values and functional simplicity of the early nineteenth-century Bieder-meier style, Hoffmann and Moser set out to design furniture and metalwork which would be emblems of a revitalised and rational society, seeing their work as the vanguard of a social revolution. The first interiors of the Wiener Werkstätte introduced a geometric smartness with a cool effect of black and white, which, wrote Moser, 'seemed chilly at first', but which they soon felt to be 'a refreshing contrast to the false warmth of the upholsterer's art'. Nevertheless, although their schemes for the 'Palais Stoclet' – a private house in Brussels – and the Kabarett Fledermaus in Vienna's fashionable Kärntner-strasse were acclaimed by other European designers as the spearhead of the Modern Movement and presented issues that were more than merely aesthetic, the Wiener Werkstätte's products never approached Hoffmann's avowed aim of creating well-designed goods which could be mass produced at reasonable prices for 'the ordinary man on the street'.

Although women played no part in the formation of either the Secession or the Wiener Werkstätte, by the First World War they had come to dominate the work of the latter. Like the Arts and Crafts and Aesthetic movements, the Secession had linked women's domain – the home – to art, not only through its members' insistence that art extended to the design of furniture and other household items, but also through their paintings, in which the modern woman moved, serenely and harmoniously, through cool, spacious interiors, a symbol of the new modernity. The young middle-class women of Vienna were eager to make the most of their new image, and it quickly became acceptable for women to exploit their artistic talents.

In 1899 the Secessionist painter Adolf Böhm had founded a private art school for teenage girls, the Kunstschule für Frauen und Mädchen, three of whose pupils, Fritzi Löw, Maria Likarz and Susi Singer, were later to design for the Wiener Werkstätte. Design offered the means of entering a larger world and by 1900 about half the students at the Kunstgewerbeschule were women: committing themselves to the new modernity, they left behind the stuffy restrictions of their parents' world. Many such women joined Koloman Moser's ceramics class at the Kunstgewerbeschule. Therese Trethan and Jutta Sika, who attended the school from 1897 to 1902, were among Moser's most

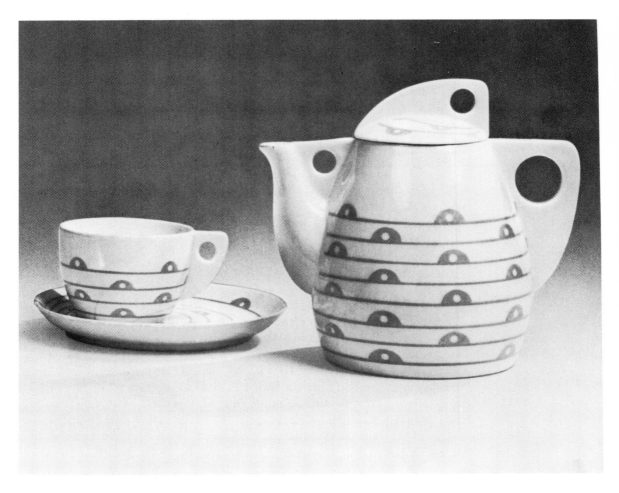

Breakfast set in white porcelain with yellow decoration designed by Jutta Sika, 1901–02, and made by Josef Böck

successful students. Jutta was then in her early twenties, but Therese was already in her forties when she graduated. They were at the centre of the debates on modern architecture, dress and design which led to the foundation of the Wiener Werkstätte and could have been among the students who welcomed Margaret Macdonald Mackintosh and her husband to Vienna. Both women designed a range of tea-sets with curving, organic shapes, the rounded handles, often carved out of the mass, forming part of the overall outline. Their decoration was simple, usually a monochrome geometric pattern or merely a band of indentations in the white porcelain. These asymmetrical tea-cups and saucers belonged in the smart interiors depicted in the paintings of the period, lending a freshness totally divorced from earlier, often pompous, ceramic designs, and they were successfully put into commercial production by the porcelain manufacturer Josef Böck. Hoffmann later included a tea service designed by Jutta Sika in the *Kunstschau* (art show) which he organised in 1908, where Klimt's paintings were also exhibited. Therese Trethan also contributed designs for painted furniture to the Wiener Werkstätte.

The modern woman became a symbol – though not yet a true participant – of the reform movement in Vienna and even her clothing became a matter for debate, especially among men. Throughout Europe at this time, the female figure dominated art and design, from the jewellery of René Lalique to the popular image of the actress Sarah Bernhardt. In 1900 the Belgian designer Henry van der Velde had unveiled his 'reform clothes' at Krefeld, the centre of the German textile industry. He explained that his high-waisted tea-gowns with short, embroidered jackets were designed according to architectural principles. Ignoring the fashion for a female silhouette contorted by corsets, he declared that rational principles of construction dictated dresses hanging loosely from the shoulders, thus liberating the waist, and that the wearer could express her own individuality through added embroidery. The extent to which the new fashion became accepted is suggested by one of the more fantastic pieces of propaganda designed to promote the local fashion industry – a rumour of 1914 that the constricted waists of the 'unnatural' Parisian fashions had been a fiendish French plot to kill the future Austrian army in the womb.

One of the most exciting influences on Viennese fashion was the painter Gustav Klimt. He not only painted women in exotic and startling dresses but also designed clothes – dresses which were based on a workman's loose smock with a flat embroidered yoke, using the expanse of fabric to introduce a mass of colour and detail inspired by both Japanese prints and Byzantine mosaics. His designs were made by his lover, Emilie Flöge, who, together with her sisters Helene (the widow of Klimt's younger brother) and Pauline, obtained the master diploma in dressmaking and set up a dress salon, called Schwestern Flöge, above a coffee house on Mariahilferstrasse. The reception room there was decorated by the Wiener Werkstätte. Klimt painted Emilie in 1902 wearing one of his dresses; as in Rossetti's paintings of Janey Morris, she is transformed into an object of desire. She appears as an elegant and mysterious figure, but it is the dress, not her clear and kindly eyes – which assert a modern rationality – that suggests a Salome-like power and sensuality. Fashionable women flocked to both the salon of the Flöge sisters and Klimt's studio to commission dresses and full-length portraits depicting themselves in this new and alluring light.

Hoffmann and Moser also designed dresses and in 1910 the Wiener Werkstätte opened a fashion department selling fabrics, dresses, millinery, leather goods, bead bags and accessories. In 1915 a fashion show, held at the Museum of Art and Industry in Vienna to promote trade, included dresses and designs by the new young Wiener Werkstätte designer Dagobert Peche and by Hoffmann's students, including Fritzi Löw, Mathilde Flögl, Mela Köhler, Hilda Jesser and Vally Wieselthier. For all the women associated with the Wiener Werkstätte, their clothes and hairstyles were a vital means of self-expression; indeed, the portrait photographs of the designers which appeared in a German art magazine in the 1920s show that they were well aware of the publicity value of their style of dress.

In 1909 Myrbach had been succeeded at the Kunstgewerbeschule by Alfred Roller, who reformed it radically along the British lines admired by Myrbach, introducing workshop experience in preference to drawing-board design and encouraging self-expression, even at the expense of technical expertise. Michael Powolny began teaching ceramics, with a more practical orientation which led his students to experiment with a free, naturalistic modelling of the clay. To a large extent, the course pursued by the Wiener Werkstätte from this time on inevitably reflected the results of this new slant in design education. While the early years of the Wiener Werkstätte had been dominated by Hoffmann's architectural commissions, by 1913 a new system based on the Kunstgewerbeschule's reforms had evolved. Hoffmann followed the school's emphasis on free expression, creating the Kunstlerwerkstätte (artists' workshops) where graduate students had free access to materials and equipment under the supervision of the Wiener Werkstätte's master crafts-men (who were required by law to supervise a workshop) and chief designers. The reformed structure considerably strengthened the workshops, not only giving young artists and designers the opportunity to experiment with materials and equipment at a time when few could afford to set up their own studios, but also encouraging them to develop a more professional attitude to their work.

Most of the artists who worked in the Kunstlerwerkstätte were chosen by Hoffmann from among the brightest students at the Kunstgewerbeschule and it was not easy to gain entrance. They were unpaid, unless a design was passed for production by a member of the Wiener Werkstätte, in which case they were paid a fee, plus a royalty if a limited edition was made. The Wiener Werkstätte had first refusal on all designs, but, if they waived their option, the artist was free to sell elsewhere and several local firms apparently thrived on the pickings.

About sixty people worked in the Kunstlerwerkstätte. Hoffmann regularly visited the workshops, generally in the afternoons on his way from the school to his favourite coffee house, the Café Kremser, on the Ring. He demanded the highest standards, but encouraged experimentation and freely applauded originality. Each year a lottery for a free study trip to Germany or elsewhere in Europe was held. Hoffmann enjoyed his contact with the artists and at the end of the day they would sometimes join him at the Café Kremser where they had the advantage of meeting his friends and foreign visitors, like the couturier Paul Poiret from Paris, or Alexander Koch, the editor of the Darmstadt art magazine *Deutsche Kunst und Dekoration*. Koch frequently featured Viennese work in his magazine, giving the young artists much-needed publicity.

The Wiener Werkstätte changed its artistic direction radically as a result of the First World War, especially in regard to the position of the women designers who worked there. Inevitably, most of Hoffmann's students at the Kunstgewerbeschule during the war were women, as were nearly all the artists associated with the Wiener Werkstätte. They were almost all from

**Vally Wieselthier
photographed in the
1920s**

prosperous middle-class families, born in the 1890s and in their early twenties when they began working professionally. They worked extremely hard and some also had their own studios, specialising in ceramics, textiles, or fashion and theatre design. They sported short hair, posed for photographs with cigarette in hand and often stayed out until midnight talking or playing skittles in the coffee houses; several were married.

After the war and the collapse of the Hapsburg Empire – Austria was declared a republic in November 1918 after the Emperor was forced to abdicate – the Wiener Werkstätte continued to be run by this group of more than a dozen women. The experiences in the trenches of the men who had trained at the Kunstgewerbeschule led many of them to wish for something more lasting than the creation of decorative schemes for the wealthy. Of those

who continued as designers, several left Vienna for the newly created Weimar Bauhaus. Hoffmann himself remained in Vienna, but the Spanish influenza epidemic of 1918 killed many of his friends – Moser, Klimt, the architect Otto Wagner, his former mentor, and the young painter Egon Schiele all died – and it was left to the women to find the direction the Wiener Werkstätte would take in the new post-war order. They went on to develop a progressively lighter, more witty style and the workshops now came to rely heavily on the sale of fashionable and witty fripperies, designed to amuse and charm, with frankly decorative motifs. An awareness of the political claims of the Slav minorities raised by the peace treaties at the end of the war had brought with it a new appreciation of their cultures. Folk art was thought to be expressive of primitive natural feelings and the objects venerated in peasant art and folk-lore – a bird, a sheaf of corn, a butterfly or a full bunch of grapes – now appeared as motifs in ceramics, enamels or delicately made lace, rendered naively in the Secessionist manner. Stylised flowers in the warm reds, purples and greens of Eastern Europe replaced the cool geometry of earlier years. Such motifs had first been introduced by Berthold Löffler who, in 1905, had founded the Wiener Keramik with Michael Powolny. His playful style, based on peasant motifs, had reached the students at the Kunstgewerbeschule through Powolny's classes there and, by the end of the war, had been successfully combined with the school's stress on personal expression to create a sophisticated new design idiom.

The essential lightness of this new style, which may at first sight appear retrogressive after the earlier functional work of the Wiener Werkstätte and particularly in comparison to contemporary work at the Bauhaus, was in part a reaction to the privations of the war, a deliberate break from all that had gone before and in any way been attached to the old order and the carnage of the war, and partly an absorption of contemporary European decorative styles. It was also a practical necessity. The women who now developed the Wiener Werkstätte's post-war designs were intimately familiar with their market and appreciated the appeal of a smart handbag or pretty scarf, concentrating on what would sell rather than on creating prototypes for furniture or metalwork when many raw materials were still in short supply after the war. Perhaps also they revelled in creating piquant, elegant accessories which they themselves enjoyed using. The domestic market was strong at this time, as people consciously sought something new and exotic, and the Viennese women who added their own style to the European resurgence of figurative art, cheering the spirits of those who could afford an extravagance from the Kärntnerstrasse showroom, showed a strong commercial sense.

Undoubtedly, the ethnic origins of several of the Wiener Werkstätte designers also played an important part in the adoption of peasant motifs. Mathilde Flögl, who joined the Kunstlerwerkstätte in 1916 when she was twenty-three and became Hoffmann's chief collaborator, especially on mural decorations, was born in what is now the border area between Austria and Czechoslovakia; she took local traditions as a basis for a whimsical, pretty style

**Textile design by
Maria Likarz**

which she applied to sophisticated luxury goods, such as cigarette cases or decorative cushions. She and Fritzi Löw, who joined the Kunstlerwerkstätte in 1916 and specialised in fashion design and graphics, became the most versatile designers of the Wiener Werkstätte during the war, turning their hands to a wide range of products, from enamels, glass, ceramics, metalwork, carpets, wallpapers and graphics, to lace, embroidery, leather goods, bead bags, hand-painted cushions, fashion accessories and hand-coloured papers. Fritzi Löw also worked as a book illustrator; they both supplied local commercial firms

with designs and Mathilde Flögl wallpapers for a Swiss manufacturer.

Maria Likarz, who had worked for the Wiener Werkstätte before the war, returned to Vienna in 1920 and joined the Kunstlerwerkstätte. She was born in what is now Poland, near the Ukrainian border and, like Mathilde Flögl, adapted her local traditions to an extremely wide range of goods, including murals: she also decorated the Wiener Werkstätte's Kärntnerstrasse showroom.

In 1920 two influential ceramists, Susi Singer and Vally Wieselthier, had joined the Kunstlerwerkstätte. They rejected the smooth, reflective surface of porcelain in favour of rougher, glazed clay, modelling female heads and figures and also a range of vases. Although some of their creations had some ostensible use – as candlesticks or plant holders – they made no attempt to produce functional objects. They employed an almost jerky style of decoration – with short connecting perpendicular lines, diagonals and semi-circles all jostled together with stylised flowers and leaves in a variety of colours – which was also used by other Wiener Werkstätte ceramists. There is a confident assertion of femininity in their work which seems centuries, rather than decades, away from the rather dour passivity with which Rossetti had depicted Janey Morris. That Singer and Wieselthier chose to concentrate on female images was itself an expression of their excitement in their new-found freedom.

Vally Wieselthier's and Susi Singer's female figures are wonderfully evocative of their period and of their creators' outlook on life. It is not surprising that it was women, revelling in their own freedom, who were able to ignore the aesthetic boundaries that constrained others. Vally Wieselthier was twenty-five when she joined the Kunstlerwerkstätte, having spent six years at the Kunstgewerbeschule where she studied under Hoffmann, Moser and Powolny. She became the leading exponent of the new expressionistic ceramics; she designed all kinds of ceramics, but her best pieces were her female heads and figurines. They are crudely modelled, in stark contrast to the immaculate surface of porcelain, and are frequently painted in harsh blues and orange, roughly applied. Whether she modelled them on herself, or whether she came to mimic her own creations, they undoubtedly resemble her: sparkling and cheeky with perhaps a long, narrow scarf or a bead necklace around their necks, neat little heads, pouting lips and long, shapely legs. Vally herself was slim and bright-eyed, wore pretty clothes with small hats perched aslant her short hair and, like her figurines, she too wore circles of rouge on her cheeks. As one reviewer put it: 'Her art has a naive joy of living . . . enticing as a bunch of flowers, careless as a butterfly and as merry as a child's smile . . . here is a grace without inhibitions, without pose and without affectation.'[1]

Vally Wieselthier's ideas about her work were greatly influenced by the style of teaching at the Kunstgewerbeschule, with its emphasis on free expression. She considered that art and craft were inextricably linked – that art was to do with taste, something that arose spontaneously in the making,

Vase by Vally Wieselthier, *c.* **1927**

so that it was useless to design on paper, hoping that someone else could then create what you had in mind. Her portrayal of women was immediate and well observed: a stance, a gesture, a flirtatious toss of the head, captured and communicated. In 1922 she wrote that,

> Clay has something serious, perhaps even grand, about it, but what I love are the glazes, maybe because most of all I want something colourful, something joyful . . . In this respect I work primitively. I think it is of absolutely no importance to obtain a smooth, monochrome glaze which is free of hair-line cracks; instead I mix up together tones of every possible shade and then let the fire sort it all out. But this unruliness and lack of certainty results in a fascinating kind of beauty that only ceramics can achieve . . . [2]

Wieselthier's figurines represent a fusion of technique, artistic intention and content which, in the 1920s, was a revolution in ceramics. The artist-craftsman of the Victorian age, who had achieved perfection of finish and technique, had given way to a new generation who used the medium to communicate ideas. In later years Wieselthier explained her ideas about pottery:

> There are arts which have no deep message to give the world save that of their own beauty and the artist's joy in making, intimate arts that make life gayer, and yet have all the seriousness of a thing that is felt intensely and worked out with the utmost care . . . Good pottery . . . expresses attitudes and moments of life which to the great poet or prophet may seem almost superficial but are, for the ordinary people, of the very stuff of life itself, the delight of the true *Lebenskunstler* [life's artist].[3]

Susi Singer's female portraits are softer and gentler than Wieselthier's, with more rounded, motherly faces and figures, always with beautifully painted clothes. She decorated her figurines with small Chinese topknots and coolie hats and hid their coquettish faces behind little fans. Susi Singer had herself been crippled by a childhood bone disease caused by the malnutrition she suffered during the First World War. Nothing is known about how she coped with her disability in Vienna, and very little about her personal life, although, according to one source, after she had moved with her husband, a miner, from Vienna to Grünbach, she founded her own pottery, the Grünbacher Keramik, and her husband used to carry her up the hill to her pottery in the mornings and fetched her back at night. In the 1930s, however, he died and Susi Singer and her young son emigrated to California, sponsored by two women who owned an art gallery in Pasadena. They found her a house in Hollywood and helped her to sell her work; she also taught occasional classes at Claremont College. She died in 1949, at the early age of fifty-four. One friend described her as 'a brave, gallant woman, and a unique and joyous artist'.

In August 1926 another ceramist, Gudrun Baudisch, took Singer's place when she moved to Grünbach. She had studied ceramics and sculpture at Graz and although she was only nineteen (the youngest person in the Kunstler-werkstätte) she swiftly established herself as one of the top ceramic designers

in the Wiener Werkstätte, introducing a sterner, bolder note to their productions. She, too, made heads and figurines, but in a more sculptural style: the heads were smooth and unadorned, the eyes pulled sideways, the faces elegantly elongated and painted almost disturbingly with the colours of eye-shadow, lipstick and mascara. Her figures were generally nude – she seldom bothered with dresses, hats or beads – and were draped merely with a simple fold of fabric across the belly, sometimes brought up and around the neck as a scarf, revealing lean, androgynous bodies. The image of women she portrayed was languorous and powerful, with a far more striking sense of sexuality than Wieselthier's. A contemporary reviewer wrote of her figures:

> The fine strong eyebrows on these female heads are arched, the almond-shaped eyes have an Oriental sultriness, the groomed hair denotes a worldly type of woman and the fierce red lips produce an effect of blatant sin. Lastly, the coqueterie, which accidently drapes the chemise so that one breast is exposed, tells us that there is refinement in the work, that the natural beauty of women is above any amount of unnecessary enticements.[4]

Gudrun Baudisch also designed vases and even there her style was close and plain compared with Wieselthier's. While Wieselthier began using a kind of beribboned handle, made of loops of thick clay, to decorate her vases, Baudisch added solid rectangles in place of the curling loops. The use of colour and the overall modelling was in the same seemingly crude style, but the impression was more purposeful.

In 1928 work by Wieselthier, Singer, Baudisch and others was included in the International Exhibition of Ceramic Art, organised at the Metropolitan Museum in New York by the American Federation of Arts, which went on tour to seven American cities. The freedom of expression shown in their work was a revelation to the Americans; indeed, several young Americans enrolled in the ceramics course at the Vienna Kunstgewerbeschule as a result. Others hated it, thinking it clumsy and crude, but those who appreciated its immediacy learnt a lesson they never forgot.

Despite their local sales and international critical acclaim for their ceramics, the Wiener Werkstätte was not a financial success and relied heavily on private backers. In 1917 Dagobert Peche, who had joined the Wiener Werkstätte two years earlier and who also developed Berthold Löffler's decorative idiom, had been sent to Zürich to open a showroom there. Shops were also opened in Marienbad and Breslau, but none of them met with any success, and Peche had returned to Vienna in 1919. In 1922 there was an attempt to open a showroom on Fifth Avenue in New York, partly as an effort to aid post-war Austrian commerce organised by Joseph Urban at the Metropolitan Opera, but it too failed. In Vienna, the tradition of the fey, the unreal, was indulged when done with wit and charm, but it was too inbred a style to export successfully to cities where its finesse was read as a lack of sophistication or even as kitsch and where, perhaps, anti-German feelings still ran high after the war. By 1928, when the Wiener Werkstätte celebrated their

twenty-fifth anniversary, those who had been the avant-garde of the 1890s were in danger of becoming – and were increasingly seen as – reactionaries. The Wiener Werkstätte had been instrumental in ridding the middle-class parlour of the ostentation of the nineteenth century and Hoffmann had successfully encouraged local firms to adopt his designs and to turn to his students for their wallpapers, fabrics and china. But by the 1920s his belief in the exploration of personal expression had usurped his original aim of designing useful objects for daily life: despite his continued association with the workshops, his initial ideals had evaporated and the boldness and clarity of the Wiener Werkstätte's early designs gave way completely (with the exception of the ceramics) to a sophisticated frivolity which had little connection with the preoccupations of younger post-war artists – the search for a new equality among the classes, better conditions for workers and outright rejection of the old order.

One of the Wiener Werkstätte's sharpest critics, Adolf Loos – a contemporary of Hoffmann's and something of a cult figure in Vienna where he lectured on cooking or shopping as well as architecture and design – related what he regarded as the post-war degeneration of the Wiener Werkstätte style to the failings of the specifically 'feminine' aesthetic of its designers. He argued that style, or fashion, was a destructive, 'feminine' force within art because it was the means by which the bourgeois consumer imposed her will on production rather than consenting to submit to a universally agreed standard of design – along the lines explored by the Bauhaus artists in Germany – that would place control in the hands of the workers. Loos led an outright attack on the Wiener Werkstätte, writing,

> Whenever I interpret the object of daily use by decorating it, I shorten its life, because since it then is subject to fashion, it dies sooner. Guilty of this murder performed on the material is, it must be said, feminine whim and ambition – and ornamentation at the service of woman will surely live forever.[5]

Loos's notion of eternal female culpability was, in the light of the work women were doing at the Bauhaus and elsewhere, self-contradictory and not widely shared. But his politically barbed views on the role of the consumer and, in particular, his belief that the Wiener Werkstätte had provided merely another style, another fashion, were gradually accepted. Austria was in political turmoil; there were serious riots in Vienna in 1927 and both the Socialists and the bourgeoisie formed private armies to patrol the streets. Architects and designers, in their commitment to either worker housing or private commissions, were increasingly drawn up along political lines.

The women of the Wiener Werkstätte did not entirely ignore this political debate. In the spring of 1929 an exhibition named *Bild im Raum* (Painting in the Room) showed an uncharacteristic range of work by Wiener Werkstätte designers. *Bild im Raum* was the second exhibition organised by Wiener-frauenkunst (Viennese Women in Art), which had been founded around 1910 in support of women's suffrage. Its president, Fanny Harlfinger, was a painter

whose husband taught at the Kunstschule für Frauen und Mädchen; Fritzi Löw and Susi Singer were both members and most of the Wiener Werkstätte designers joined in its exhibitions. The exhibition, held at the Museum of Art and Industry, stressed the idea of simple, bright interiors which would be relatively cheap to furnish and easy to maintain, but the overall style was comfortable and rather folksy. The exhibits included a dining-room and a child's room by Fanny Harlfinger, a dress salon by Mathilde Flögl and Felice Rix, a tea-room by Hilda Jesser and a room called *Keramik und Möbel* (Ceramics and Furniture) by Hertha Bucher, all of whom designed for the Wiener Werkstätte. There was also a special show of paintings and graphics by women artists from Berlin. Several of the designers taking part were also members of the Austrian Werkbund, a designers' guild associated with the German Werkbund, and would have been familiar with the debates over mass production, standardisation and the use of new technology.

But Vienna was not an industrial city and although the Wiener Werkstätte designers sold designs to manufacturers, they never became directly involved with industrial production. The Werkstätte's failure to adapt not only its aesthetic concerns but also the style of goods it produced to modern needs contributed to its demise. In 1929, a year of international financial collapse, the ceramic workshop was closed down. Many Viennese firms faced bankruptcy as the political situation worsened and in 1931 the Werkstätte went into liquidation and its stock was sold off at auction.

While the 1920s had been the heyday of luxury goods and extravagant furnishings, the 1930s were, throughout Europe, more sombre years. Several of the designers had always maintained separate workshops and Maria Likarz, Mathilde Flögl and Gudrun Baudisch now also opened their own studios in Vienna. However, those Austrian women who looked for work abroad in the 1930s found that a designer who had worked for the Wiener Werkstätte had a certain cachet; they found a ready market for their portfolios and were able to establish successful careers in their adopted countries. The early years of the Wiener Werkstätte had attracted international attention and even when Paris emerged in the 1920s as the leading light of the avant-garde, French designers still kept an attentive eye on the Viennese style. In 1929 Vally Wieselthier left for New York, where she continued to prosper. She had already begun making larger-than-life figures and these were now included in a show called *Contempora* organised in New York by Hoffmann's old friend Paul Poiret and the German designer Bruno Paul. Wieselthier never returned to Vienna, probably because she was Jewish, but spent several months a year in Paris, where she had a studio on the Avenue Montaigne, and the rest of her time in New York. She designed for the Sebring Pottery in Ohio and in 1944 held a one-woman show at the Orrefors Gallery in New York. The following year she died, but the influence of her work continued and in 1948 her contribution to ceramics was celebrated in a retrospective exhibition. The impact her joyful attitude to ceramics had on American work can still be traced today, especially among those who had a sculptural approach to their

work, for example, Elie Nadelman or the various artists who worked at the Cowan Pottery Studio in Ohio. Their influence has led, in turn, to the funk movement in American ceramics, which owes much to the expressionistic freedom first seen at the Wiener Werkstätte.

In 1938 came the *Anschluss* with Hitler's Germany and many of the women left Vienna for good. Maria Likarz went to Rome, Fritzi Löw to Brazil and Felice Rix to Japan. Hilda Jesser was one of the few to remain in Vienna where, after the war, she continued to teach at the Kunstgewerbeschule.

Gudrun Baudisch moved to Berlin where she began working with the architect Clemens Holzmeister; they received commissions during the war to design architectural faience for churches and public buildings in Turkey, Austria and Germany. In 1946 she settled in Hallstatt in Austria with her second husband, Karl Wittke, and together they set up a pottery, the Keramic Hallstatt, of which he was business manager. Her early days of statement and revolt were past and her later work, while still sculptural, was calmer, more decorative and symbolic. She organised a group of young ceramists, 'Gruppe H', in Hallstatt, with a shop in Salzburg, and on her retirement in 1977 handed the pottery over to them. Gudrun Baudisch died in 1982.

Despite the criticism and financial disarray of the post-war Wiener Werkstätte, its light, expressive style – developed and refined by such women as Mathilde Flögl and Maria Likarz – has percolated throughout Europe and America in the decades since the Second World War, adding a welcome wittiness to the earnest ideals of the Arts and Crafts Movement. Jacqueline Groag, who had worked for the Wiener Werkstätte, designed fabrics for the leading Paris fashion houses before settling in England where, in the 1950s, she was constantly in demand for designs for a huge range of products, from laminates to wrapping papers. She was taught by Franz Cizek, who developed the Kunstgewerbeschule's stress on free expression into a theoretical approach to art, and, especially, to children's art, which was widely influential. The training course developed at the Kunstgewerbeschule and the workshop methods of Hoffmann's Kunstlerwerkstätte were recognised as the most effective way of training designers, and art schools all over the world began to encourage practical experimentation.

But while the artefacts produced by the Wiener Werkstätte show the results of academic developments, they also proclaim the exhilaration of the women who made them. The women of the Wiener Werkstätte had escaped socially from the Victorian image of women; in their work they rejected the materials, colours and surface qualities preferred by their teacher, Josef Hoffmann, and in the objects they made they felt totally free to create a distinctively female aesthetic, an image of women according to their own beliefs. Unlike their Victorian forebears who worked in the shadow of father, husband or brother, they had, as a result of their training and the universal rejection of nineteenth-century values, the confidence to face the attacks of Adolf Loos and his followers and to stand by their own ideas. There was no conclusive revolution in Europe, but nevertheless, the mould had cracked.

7. Equipment and Couture

Paris in the 1920s was the mecca for anyone interested in any aspect of fashion, art, the theatre or interior decoration. In the years before the First World War, every aspect of the visual arts had been subject to a fresh examination of form, style and content. There had been break-throughs in every field: Picasso and Braque developed Cubism, Diaghilev brought the astounding new colours and designs of the Ballets Russes from Moscow, Paul Poiret introduced a new style of dress for women and the over-stylised whiplash curves of Art Nouveau were rejected in favour of the more refined style, which, in the wake of the 1925 Paris *Exposition des Arts Décoratifs et Industriels*, became known as Art Deco. Between the aftermath of the Russian Revolution and the early 1920s, émigrés and exiles flooded the city. To Paris came the Dadaists from Switzerland, the Neo-Primitivists such as Goncharova and Larionov and Constructivists such as Alexandra Exter from Russia, and the strength and vitality of the community they created attracted others from England, Italy and America who found in Paris an artistic and social freedom lacking in their own countries. In return they contributed enormously to the visual vitality and variety of their surroundings.

The great salons and ateliers which had flourished in the 1870s and 1880s gave way to the more casual life of the cafés and the studios, although expatriates such as Gertrude Stein and Natalie Barney, both Americans and both lesbians, continued something of the old spirit. A soirée at Gertrude Stein's might bring together Picasso, Apollinaire, Robert Delaunay, Ernest Hemingway and Man Ray; at Natalie Barney's there might be Colette, Marie Laurençin, Ezra Pound, Romaine Brooks and Paul Poiret and both the Swiss architect Le Corbusier and the American designer Eyre de Lanux lived nearby. The artists shared their ideas with each other, and with couturiers, writers, photographers and film stars.

The existence of such a milieu – not unlike the coffee-house society of Vienna – created an environment, like that deliberately formed in Revolutionary Russia or at Hoffmann's Kunstlerwerkstätte, which led to an extraordinarily rich interplay of ideas and, in the early years after the war, there

were numerous collaborations on cabarets, illustrated books, ballets and schemes for interior decoration. It also created an unusually wide and receptive market for the work of the avant-garde artists and designers: there was money to be earned among the fashionably wealthy who aspired to display their appreciation of the latest artistic developments, or among the manufacturers who realised the importance of keeping up with the latest styles. In fashion, Paul Poiret, Elsa Schiaparelli and Sonia Delaunay were able to exploit the social cachet of their modernity; in portraiture, Marie Laurençin found wealthy clients; and, in interior decoration, Eileen Gray or Eyre de Lanux and her English collaborator, Evelyn Wyld, none of whom had any previous experience, found commercial success.

Within this environment, many of the women who designed in the applied arts in Paris were to prove more adept (or perhaps more willing) than their male colleagues at relating their artistic theories to living environments. Their work in fashion, textile design and interior decoration redefined the boundaries of the fine arts. By the late 1920s the former male bastions of couture had been taken over by the new women fashion designers such as Chanel and Schiaparelli, who introduced a new approach to fashion with their casual sportswear. During these years Eileen Gray, Marie Laurençin, Sonia Delaunay and Sophie Taeuber-Arp all succeeded in bringing a highly individual sense of form and colour to their designs for furniture, textiles, wallpapers, rugs or walls, avoiding arid theoretical exercises and creating comfortable, practical designs. While today we associate their names with interior decoration, it should not be forgotten that they came to the decorative arts through painting and that they themselves drew no clear parameters for the boundaries of their work. Unlike so much of the work by twentieth-century women designers, the textiles designed by Sonia Delaunay and Sophie Taeuber-Arp have been claimed as an extension of the boundaries of fine art rather than relegated to the domain of domesticity and have led to a more widespread understanding that artistic expression is equally valid whether executed through canvas and paint, tapestry or printed textile, or even the more ephemeral medium of interior decoration.

Again, the crucial factor in this artistic achievement and the recognition it received appears to have been the existence of a milieu which allowed women social freedom and professional respect and encouraged this interplay of different artistic media; it was a milieu that women of earlier movements had signally lacked.

The fruits of that interplay can be seen most clearly in the cross-fertilisation of ideas between haute couture and interior decoration. In 1911 the couturier Paul Poiret, inspired by a visit to the Wiener Werkstätte, had opened a decorating workshop, the Atelier Martine, in his couture house in the rue de Faubourg-Saint-Honoré. It first established the tradition in France of not only bringing fashion closer to the fine arts, but also allowing fashion to flow outwards into the decorative environment. Perhaps influenced also by the teaching methods pioneered by Franz Cizek at the Vienna Kunstgewerbeschule,

where the students were encouraged to work freely from their imagination rather than follow a strict rule of study, Poiret gathered a group of young teenage girls from working-class backgrounds who would not only be cheap, but also, hopefully, untutored, and set them to work without a teacher. 'Whenever it was possible,' he wrote,

> I had them taken into the country or the Zoological Gardens, or into conservatories, where each would do a picture according to her own idea, according to whatever motive pleased her best, and they used to bring back the most charming things. There would be fields of ripe corn, starred with marguerites, poppies and cornflowers; there were baskets of begonias, masses of hortensias, virgin forests through which sped leaping tigers, all done with an untamed naturalness that I wish I could describe in words . . . My role consisted in stimulating their activity and their taste, without ever influencing them or criticising, so that the source of their inspiration should be kept pure and intact.[1]

Poiret used the girls' designs for fabrics, but they also learnt to execute tapestries and murals themselves and the Martine later developed into a complete interior decoration workshop. Many of Poiret's artist friends visited the workshop, and its products inspired Raoul Dufy to design fabrics, leading eventually to his collaboration with the textile firm Bianchini et Ferrier. The designs were large, crude and bright, using the colour range of the Ballets Russes which Poiret first made popular for fashion design.

The Italian designer Elsa Schiaparelli was 'moonstruck' when she visited Poiret's establishment in the early 1920s soon after she first arrived in Paris; it was the first couture house that she had ever been to. 'Schiap' and Poiret became great friends: she always admired him and, like him, she knew many of the artists, musicians and theatre people in Paris, including Dali, Cocteau, Chaplin, Garbo and Sartre, for whom she designed theatre costumes for a production of *Le Diable et le Bon Dieu*.

'Schiap's' first fashion design was a sweater and it was her sports clothes that made her name. She believed that her clothes were shown to best advantage against bizarre, exotic settings – just as Poiret threw extravagant parties to promote his clothes – and in her gallery and her home she combined the most unexpected elements. Where Coco Chanel believed that décor should create a neutral, elegant backdrop for women, Schiap could mix black and yellow tartan, Russian silver and enamel, or throw together orange leather with a Bedouin rug, a Peruvian donkey bag and 'an ash-tray of broken pottery brought in by the sea from the never-never-land'[2], with an assurance which guaranteed its successful effect. Although she never undertook decorative schemes professionally, 'Schiap' was never content for her creativity to end with fashion and believed that the way in which a woman expressed herself through her clothes should be extended to her surroundings. That belief was a vital influence on her fashion designs.

Marie Laurençin, better known as one of the most fashionable society portrait painters of the 1920s, also designed fabrics, carpets and wallpapers as

Wallpaper designed by Marie Laurençin for André Groult, c. 1915–30

well as book illustrations and theatre costumes. Born in 1885, in her early twenties she was a member of the circle of avant-garde painters that included Picasso, Braque and Matisse. For six years, until 1913, she maintained a liaison with Guillaume Apollinaire, one of the most important critics of modern painting, and his highly flattering reviews of her work ensured her early success.

Her portraits, depicting young, sleek-headed and delicate women, owe more to her own idiosyncratic view of women than to any likeness to her subjects and stand in stark contrast to the lively, confident portrayal of women

by Vally Wieselthier or Gudrun Baudisch. Indeed, she charged 'more for work which bored her, double in the case of men . . . and something extra in the case of brunettes, whom she found less inspiring than pale blond women'.[3] Although the large dark eyes, rosebud mouths, flowing hair and bead necklaces of her portraits reflect something of Marie's own looks, the formula by which she depicted women presented them as merely decorative, women without experience or aspiration, innocent of any external world.

Marie Laurençin first became involved in interior decoration in 1911, when she collaborated with André Mare, and after the war she worked with André Groult, Poiret's brother-in-law, whose wife, Nicole, was her closest friend. Her sets and costumes for Diaghilev's ballet, *Les Biches* (1924), which portrayed 'the cynical grace and witty frivolity of the week-end party' in 'the refined simplicity of the women's neat short dresses in which they frisk like antelopes', have been described as 'the quintessence of the 1920s'.[4]

A complete contrast to Marie Laurençin's pastel world can be found in the bold colours, geometric designs and swirling patterns of Sonia Delaunay's paintings, textiles, book illustrations and interior designs. Born in Russia in 1885 into a cultured Ukrainian family, she had settled in Paris at the age of twenty after coming to study painting at the Académie La Palette. In the next few years she, like Marie Laurençin, joined the group of painters that included Picasso, Braque, Derain, Vlaminck and Robert Delaunay, who in 1910 became her second husband. She worked originally in the direct, bold and colourful style of the Fauves, but after her marriage she and Robert Delaunay evolved together their theory of simultaneous contrasts, using blocks of pure, juxtaposed colours to create abstract harmonies and dissonances of tone. The Delaunays spent the war years in Spain and Portugal, where they met Diaghilev, Goncharova and other Russian exiles, and in Madrid Sonia designed costumes for Diaghilev's production of *Cléopatra*. On their return to Paris in 1920 they had to support themselves and their young son entirely from their art, as Sonia's income had been wiped out by the Russian Revolution. They settled in a studio in the Boulevard Malesherbes and mixed with a new group of friends that included André Breton, Louis Aragon, Jean Cocteau and the young Romanian poet Tristan Tzara, who had been a founder member of the Dadaists in Zürich.

Sonia Delaunay's first textile design had been a colourful patchwork quilt for her son's cot, made in 1911. Inspired by Tzara, Sonia now began to apply her colour compositions in a series of abstract dress designs entitled *Robes-Poèmes*, which combined lines of poetry by Tzara with geometrically placed blocks of colour. She also illustrated three books by Tzara and created the outlandish costumes for his short-lived play *Le Coeur à Gaz*, which was shown as part of a Dadaist evening, with music by Satie, sets by Theo van Doesburg and films by Man Ray. The event, deliberately broken up first by André Breton, as a Surrealist rejection of all that Dada represented and then eventually by the police, was not a success, but, for Sonia Delaunay, the collaboration with Tzara led to a new departure. She had never intended her

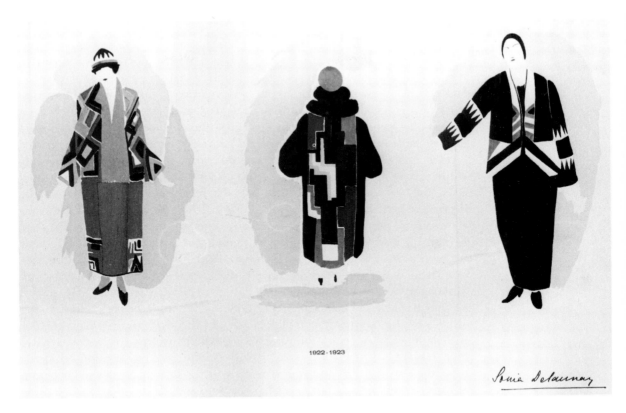

1922-1923

Sonia Delaunay

1922 designs for the *Robes-Poèmes* to be made, but was invited by a Lyons textile firm to design fifty patterns for fabrics. She hesitated before accepting the invitation, but the Delaunays needed the money and the chance to use her designs proved too attractive to turn down. When the textiles appeared in 1923 they were rapturously acclaimed. Sonia Delaunay then began to collaborate with the couturier Jacques Heim, designing not only clothes – especially sports clothes, from motoring coats to swimwear – but also handbags, hats and scarves. Their display of these fashions, the *Boutique Simultanée*, was one of the great successes of the 1925 Paris *Exposition*.

Sonia Delaunay used mathematical precision in working out the colour relationships in her work, and her paintings and those of her husband contributed an important perspective on the theories of colour, form and line then also being explored by artists in Germany and Russia. She went on to extend her theories to every aspect of design, decorating their Boulevard Malesherbes apartment with plain square armchairs upholstered in hand-embroidered geometric materials and matching rugs set against walls hung with printed linen in different shades of beige. For a publicity photograph she even painted a Citroën car to match the geometric woven fabric of the motoring coats she designed for Jacques Heim and her clothes themselves were practical, chic and highly individual.

By the late 1920s the European modernists who preferred to follow the

Fashion designs by Sonia Delaunay, 1922–23

119

functional dictates of such architects and designers as Walter Gropius in Germany, Adolf Loos in Vienna or Le Corbusier in France itself had condemned the Parisian avant-garde as degenerate and decadent, catering to the wealthy and ignoring the claims of industry. Artists such as Dufy, Cocteau and Sonia Delaunay were singled out for pandering to luxury and commercialism, yet, as she herself saw, their designs had a far greater influence on commercial production than the work of those who remained aloof from fashion. '*Si la peinture est entrée dans la vie,*' she later wrote, '*c'est que les femmes la portaient sur elles!*'[5] (If painting has become part of our lives, it is because women have been wearing it!) In the 1930s Sonia Delaunay concentrated again on her painting, but in old age she returned enthusiastically to the decorative arts. By the time of her death in 1980 she had been acclaimed as the woman who, perhaps more than any other twentieth-century artist, had irrevocably bridged the gap between the fine and applied arts, although those who wore her clothes never needed to know that the lovely colours of a scarf or coat in fact represented one aspect of the great exploration of abstraction during the period 1905 to 1925.

One friend of Sonia Delaunay's, Sophie Taeuber-Arp, also followed the same path in applying complex aesthetic theories to everyday objects. Although her work is now far less known (possibly because she died aged fifty-four, leaving a very small corpus of work behind) and had less impact at the time, the few paintings and embroideries which remain show her to have been a highly sophisticated artist. It is her husband, Jean Arp, who is now remembered as the artist who developed the rational, geometric abstraction of the De Stijl movement, despite the fact that he himself always claimed that his inspiration came from her. Born in Switzerland in 1889, Sophie Taeuber studied textile design in Germany before going to teach at summer school at the Zürich Kunstgewerbeschule (School of Arts and Crafts), where she became Professor of Textile Design in 1916. At this time, she was making small abstract embroideries, using planes and mathematical subdivisions of colour not unlike the work of the Dutch De Stijl painter Piet Mondrian. Her work had a decisive influence on the paintings of Jean Arp, whom Sophie met in November 1915 through her friends in the Dadaist Cabaret Voltaire in Zürich. They were married in 1921, but, as she could not afford to give up her job in Zürich, they did not settle together until they moved to Paris in 1926.

That year Sophie joined her husband and the Dutch writer Theo van Doesburg, editor of the magazine *De Stijl* which championed a functional approach to design, in Strasbourg to plan a scheme of interior decoration for an eighteenth-century building, the Café l'Aubette. Van Doesburg had been closely associated with Mondrian and the furniture designer Gerrit Rietveld and based his approach to design on the recognition of certain absolutes in form and structure. He believed the diagonal represented the dynamic of human movement and vitality, without which any scheme lacked relevance to modern life.

The interior of the Café l'Aubette, to which Sophie contributed stained-

glass designs for the *salon de thé* and further schemes for the billiard room, was calm, pure and cool, with geometric blocks of colour placed in relation to an unadorned architectural style of plain walls, windows and staircases. The three designers saw their scheme as expressive of movement and tactile and spiritual qualities which established a rhythm and cohesion, a balance and harmony conducive to the activities of the Café, where there were also bars and dance floors. For their own house near Paris, which Sophie conceived and decorated in 1928, she designed furniture in square or rectangular forms in plain wood, or painted in a pale grey-blue, which provided the perfect setting for their paintings and her embroidery. In 1943 Sophie Taeuber-Arp died: such had been the closeness of their artistic association that, for several years after her death, Jean Arp was completely unable to work.

While Marie Laurençin, Sonia Delaunay and Sophie Taeuber-Arp had all devised decorative schemes which reflected and extended their aesthetic theories, three women who succeeded as interior decorators in Paris in the 1920s – Eileen Gray, Evelyn Wyld and Eyre de Lanux – were all expatriates, none of whom had any training as designers. The spirit of experimentation in Paris in these years and the pool of skilled craft workers who could carry out any decorative brief meant that even those with no direct experience of design were encouraged to express their taste, to try their hand and to compete with the professionals. As expatriates who had settled in Paris because they wanted freedom from some restriction at home, they welcomed the challenge that the artistic circles in Paris held out to anyone who wanted to join them.

All three created a style of decoration which, in comparison to the luxurious schemes of Elsie de Wolfe or Syrie Maugham, was radical in its stress on surface qualities, bareness and elegant comfort. They appreciated that ostentation and a display of wealth had little to do with the creation of a beautiful living environment: indeed, Eyre de Lanux says that the most important influence on her own and Evelyn Wyld's work was a house in St Tropez belonging to a friend which was simply painted in different shades of white with pebbles and driftwood from the beach as decoration. Their work, while not now acclaimed or as widely known as that of Pierre Chareau or Jean Michel Frank, introduced a lasting idiom of great comfort and sophistication.

Eileen Gray, who was born in Ireland in 1879, went to study painting at the Slade School of Art in London when she was nineteen. It was there, in a small workshop in Soho, that she first discovered lacquer, the Oriental art of building up a lustrous surface with many layers of resin and fine earth. The painstaking and time-consuming technique – pigments, crushed eggshell, mother-of-pearl or silver or gold leaf can be added to obtain further decorative effects only after the eighteenth coat of resin – suited Eileen Gray's temperament, for throughout her life she was a perfectionist in her work, constantly refining her designs. In 1902 she went to Paris to continue her studies at the Académie Colarossi and the Académie Julien and five years later decided to settle there permanently. By this time Eileen Gray had begun to

work with a Japanese lacquer craftsman, Sougawara, and by 1913 she was sufficiently adept to be employed by the couturier and art connoisseur Jacques Doucet, who had sold a collection of eighteenth-century treasures and had started to collect paintings and furnishings by the most original of his contemporaries. Eileen Gray began by making picture frames for his collection, but later also supplied furniture, such as decorated lacquered tables. One lacquered screen that she made for him is an extraordinarily dramatic work, demonstrating her ability to synthesise her training as a painter with her obsession with such a demanding craft. Known as *Le Destin*, it is made of four panels in deep red lacquer, one side showing an abstract design of silver-grey lines, the other depicting the symbolic figures of two men against a totally plain background.

It was only after the First World War, during which she spent some time driving an ambulance in France and a spell in London where she set up a studio in Chelsea with Sougawara, that Eileen Gray became fully involved in interior decoration. When she returned to Paris after the Armistice she received further commissions, including one for the decoration of an apartment for the modiste Suzanne Talbot (Madame Mathieu Levy). For this she designed furniture, rugs, lighting fixtures and complete walls of lacquer panels and bricks. The interlocking bricks supplied the basis for a screen made of juxtaposed lacquered bricks of which she later made several variations.

In 1922 Eileen Gray opened a gallery in the rue de Faubourg-Saint-Honoré, which offered lacquered furniture, lamps, mirrors and a decoration service and also hangings and rugs designed by Eileen Gray and made under the supervision of an old family friend, Evelyn Wyld. Eileen Gray named the gallery Jean Désert; it was undoubtedly useful to have a name which was both French and male. Prospective clients were told that a visit to the gallery was

an adventure: an experience with the unheard-of, a sojourn into the never-before-seen. Eileen Gray's designs adhere neither to the rules established by the creators of classic periods, nor do they attempt to achieve sensational novelty by imitation of the primitive.[6]

From the brief notes made in the stock books, it appears that the majority of Jean Désert's customers were women, despite the fact that a great deal of the gallery's correspondence was addressed to 'Monsieur Désert'! Eileen Gray's output was always small and from the beginning the abstract, geometric rugs made by Evelyn Wyld sold better than the other items on offer.

In 1923 Eileen Gray exhibited a scheme for a *chambre à coucher-boudoir pour Monte Carlo* at the annual exhibition of the Artistes-Décorateurs, a society founded in 1901, which by the 1920s showed lavish and expensive schemes for interior decoration. A wide, abstract lacquer screen, flanked by two white 'brick' screens, hid the back wall, rugs from Evelyn Wyld's atelier covered the floor and simple but detailed and impeccably finished lacquer furniture completed the scheme. The French press hated it: it was '*cocasse et . . . anormal*'

Black lacquer 'brick' screen, one of several variations designed by Eileen Gray for Jean Désert from a design developed in 1923

(laughable and abnormal), '*affolante*' (demented), suitable only for the daughter of Doctor Caligari. It is difficult to see what the French found so ugly about the scheme and it may well have been that part of the abuse was aimed at its designer – not only a woman, but also a foreigner who showed little desire to join in the social life of her peers. Certainly the colour schemes – dark browns and blues matched with grey, white, red and dull gold – and the irregular forms of the furniture were very different from the bright colours and the move towards an eighteenth-century refinement favoured by her contemporaries.

The room did, however, excite the admiration of Dutch designers associated with the De Stijl movement. Their encouragement, and the development of a friendship with Le Corbusier, tempted Eileen Gray to move away from such opulent decorative schemes and towards architecture and a new design idiom. Soon afterwards, she met a Romanian architect and journalist, Jean Badovici, who encouraged her to develop her interest in architecture. She rented a place in St Raphael in the south of France and in 1927 began to plan a house for herself, with Badovici's active help. The house, which stood on rocks by the sea at Roquebrune, was called, quite simply, 'E- 1027'. Everything in it was planned with meticulous detail, with built-in furniture, special adjustable tables and chests and cabinets with pivoting drawers, all of different shape and size, as though designed with specific contents in mind. The rooms in the house were very small, reinforcing the concept of carefully used space.

By the 1930s Eileen Gray was completely disenchanted with the silken tassels and exotic finishes of her earlier furniture, preferring the new aesthetic of an essentially functional approach to design, which singled out the basic uses of furniture. She paid enormous attention to the proportions of her furniture and to the light and ventilation in her houses and any kind of new material excited her. Many of the designs Eileen Gray developed for 'E-1027', like the pivoting chests and the low-slung 'Transat' chair, were refined and extended for her later architectural schemes, such as an apartment in Paris she designed for Jean Badovici or the second house she built for herself at Castellar, near Menton, in the early 1930s, where she lived until the Second World War when it was commandeered by the Nazis. Although the careful planning of fitments and space were an expression of Le Corbusier's dictum that a house should be a '*machine à habiter*', the precise attention to detail and finish which she showed in the design of drawer handles or light fittings in fact meant that her work could never be produced on a large or cost-effective scale. She would have been delighted if her work could have been available to a mass audience – after the war she worked on various projects, including an ambitious plan for a leisure centre – but she never had the training to know how to work to the limitations of a production line. Even after she had abandoned lacquer, her designs continued, in terms of how they were produced, to cater for the wealthy. Indeed, in London her work was sold by Duncan Miller, one of the avant-garde gallery owners who sold to decorators and their clients.

Evelyn Wyld
(foreground) with her
lifelong friend Kate
Weatherby, at 'La
Bastide'. It was Kate
Weatherby's house at
St Tropez which
greatly influenced
Evelyn Wyld and Eyre
de Lanux's ideas

As Eileen Gray began to devote herself to architectural projects, Evelyn Wyld also went her own way. Evelyn came from a family of strong-willed and determined women; her two aunts, Etta (Henrietta) and Eva Burdon-Muller were both on the executive committee of the London Society for Women's Suffrage in the 1880s and Etta, under the pseudonym Helena B. Temple, edited the *Woman's Penny Paper*. Evelyn had a similar 'will of steel'; according to her family, she was a woman who always set her own style, dressing in beautifully cut trousers, Byronic silk shirts and wide embroidered belts, with her hair cut short. In the evenings she often smoked a cigar. Originally trained as a 'cellist, she had first come to France from England after the outbreak of the First World War as secretary of the French War Emergency Fund. At the

125

Eyre de Lanux, photographed in Paris by Arnold Genthe in the late 1920s, wearing a coat made for her by Sonia Delaunay

end of the war she had contracted bronchitis while helping to resettle French peasants in the south of France, taken a house named 'La Bastide Caillenco' near Cannes and decided to stay on in France. When Eileen had invited Evelyn to join her in making rugs at a studio which she had taken in the rue Visconti before the war, Evelyn had returned to England where she visited carpet manufacturers, learning about materials and techniques, and had then run the studio alone, making rugs and fabrics to Eileen Gray's designs.

Soon after leaving Jean Désert she began to collaborate with a young American painter, Elizabeth de Lanux, who had come to Paris at the end of the First World War with her French husband and who worked under the name Eyre de Lanux – Eyre being her maiden name – contributing a monthly account of Parisian life to an American magazine. Eyre knew many people; she had studied fresco with Brancusi, been photographed by Man Ray, figured as a character in one of Aragon's novels, had taken tea with Gertrude Stein and was admired by Natalie Barney. She had first visited the rue Visconti atelier in order to write about the French artistes-décorateurs, but Evelyn suggested that Eyre herself turn to designing and offered to work with her. With Eyre's flair and contacts, Evelyn's knowledge of the workshops which executed commissions for decorators and a well-established atelier, the new partnership had an auspicious start.

They worked from Evelyn's studio. In these large rooms, the walls hung

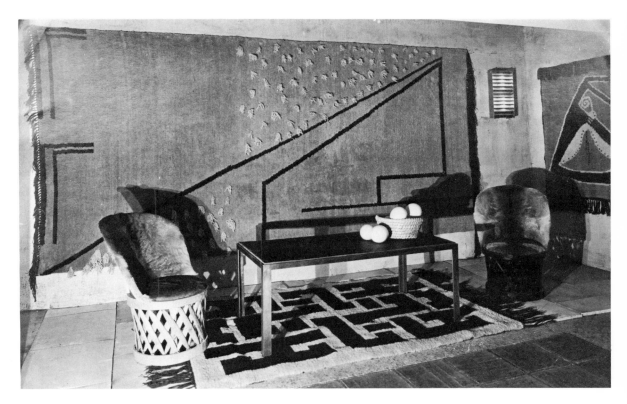

with rugs, all in natural shades from cream through to brown, were the looms and space to work; the only decoration was a fossilised fish on a grey-green slab on the mantelpiece. Through their contacts, they soon found new clients among the wealthy Americans in Paris, one of whom was a Mrs Forsythe Sherfesee, whose apartment was the subject of an article in *Town and Country*. It reveals their taste succinctly: Eyre is quoted as saying that 'the chic of . . . [the] apartment is hoped to be its "simple extravagance" – you know what I mean. There is almost nothing, but it is the very best.' The article continues to describe the 'large and serene forms balanced by areas of superalert patterns . . . There is practically no color . . . The result is a cool and disciplined smartness . . . expensive bareness.' The key-notes of their ensembles were texture – tiles, cow-hide, pony-skin, wood, steel, slate, lacquer, terracotta, ostrich eggs, silk – and Evelyn's vanilla, grey or African brown wool rugs, with varying lengths of pile in geometric forms and with distinctive fringes, all hand-woven in the atelier. Eyre was solely responsible for the furniture and décor, and her colours echoed Evelyn's use of natural undyed fleeces.

The two women also contributed to the annual exhibitions held in Paris. Their first display was at the Salon des Artistes-Décorateurs, where they showed a glass table against a montage of a postcard of the Manhattan skyline at night, lit from floor level and reflected in mirrored side walls. In 1929 they exhibited again at the Salon and also at the Salon d'Automne; they named their display

Evelyn Wyld and Eyre de Lanux's exhibit at the Salon des Artistes-Décorateurs in Paris, 1929. The havana, steel-grey and white rug on the wall and the black and white rug on the floor are by Evelyn Wyld; the steel and slate table and natural oak barrel chairs, upholstered in pony-skin, are by Eyre de Lanux

Terrasse du Midi and used blue lights hidden on the floor, shining upwards to give the impression of a blue sky behind a hammock. The following year they showed work at the exhibition of the newly formed Union des Artistes Modernes, a break-away group from the Société des Artistes-Décorateurs, formed to promote new materials and progressive ideas in contrast to the more traditional style of the Société, their display showing Eyre's increasing interest in American Indian design.

In the early 1930s when money was tight after the Wall Street Crash, Eyre and Evelyn gave up their business in Paris, moved to Evelyn's house in the south of France and opened a studio on the sea front in Cannes. But it was short-lived. Eyre then moved on to Rome and returned to painting and Evelyn remained at 'La Bastide' where she became a market gardener. Both Eileen Gray and Evelyn remained in France for the rest of their lives, while Eyre de Lanux returned to – and now lives in – New York. Although for Evelyn Wyld and Eyre de Lanux decoration was only a small part of their lives, the interiors they created were nevertheless a radical departure from the kind of homes that they themselves had grown up in and were among the most sophisticated but practical of their day. Their very lack of training enabled them simply to put the best current ideas of their day into practice.

One woman who did train as a furniture designer was Charlotte Perriand. Although her name is little known, she went on to collaborate with Le Corbusier on a range of chairs that are now regarded as 'classics'. Born in 1903, Charlotte Perriand followed the example of her aunt in enrolling at the Ecole de l'Union Centrale des Arts Décoratifs in Paris, where she took courses under the traditional Art Deco designers Maurice Dufrêne and Paul Follot. She, too, produced designs in this essentially derivative style, working in wood, which she exhibited at both the Salon des Artistes-Décorateurs and the Salon d'Automne. In 1927, however, she changed her approach, influenced by contemporary car design. As she later said: 'There's no doubt, it was much less demoralising to walk along the Champs-Elysées looking at car bodies than among the furniture makers of the Faubourg Saint-Antoine.'[7]

That year, Charlotte Perriand created an interior for the Salon d'Automne in metal, steel and aluminium, which she called *le bar sous le toit*. It received extremely good reviews, yet she still felt that there was no future for her in furniture design and intended to go and study agriculture instead. Then a friend, the jeweller Jean Fouquet, lent her two books by Le Corbusier, *Vers une Architecture Art* and *Décoratif d'Aujourd'hui,* which entirely changed her mind. Le Corbusier saw furniture as *équipement* (equipment), an extension of the architectural whole: he believed that not only traditional materials and methods of craftsmanship but even the accepted forms of furniture should be rejected. There was to be no expression of '*art décoratif*', only functional design. In Charlotte Perriand's own words, 'The French word for furniture, "MEUBLES", comes from the Latin "mobilis": meaning things that can be moved about. The only things that come into this category are chairs and

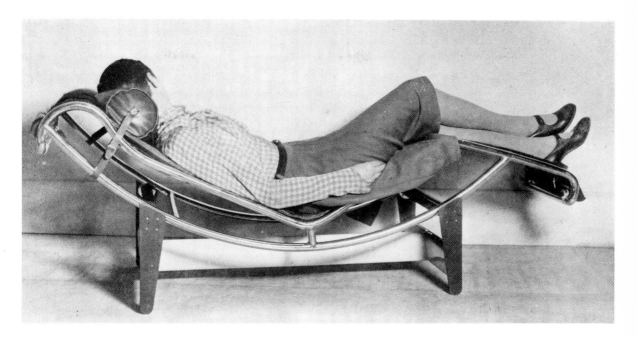

tables.'[8] All the other needs that furniture fulfils could be subordinated to standard built-in cupboards.

In 1927 she went to see Le Corbusier to ask if she could work with him; at first he showed no interest in her enthusiasm, but finally, after seeing her *bar sous le toit*, he agreed to take her into his office as an architectural student and a collaborator on *équipement*. She worked in Le Corbusier's office for ten years, later describing the organisation of the office:

> I would work on the elaboration of a general project with the office, then I took responsibility for doing the equipment. It was necessary to be on site, to watch the execution down to the smallest details. So I worked on the conception of putting together all the projects during that period, especially the domestic ones, as Le Corbusier was then concerned with those problems.[9]

Shortly after she joined the office of Le Corbusier he and his cousin, Pierre Jeanneret, exhibited their first suite of furniture, a metal table with a marble top and metal swivel chairs, at the Salon d'Automne. The following year, under the names of Charlotte Perriand, Le Corbusier and Pierre Jeanneret, the firm showed their definitive statement on *équipement* for a dwelling built of cement, metal and glass bricks. Three seats designed for the 'Ville d'Avray' and made by Thonet, the *Chaise Longue*, the *Basculant* and the *Grand Confort*, all employing chromium-nickel-plated tubular steel, leather or pony-skin, were shown. These famous chairs, which are still produced, are now described as designed solely by Le Corbusier, and Charlotte Perriand, who 'took responsibility for doing the equipment', is almost entirely forgotten.

That year Charlotte Perriand declared that 'metal plays the same part in

Charlotte Perriand on the chaise longue designed by herself and Le Corbusier, 1928–29

129

furniture as cement has done in architecture. IT IS A REVOLUTION.'[10] Metal, she said, was superior to wood because it could be mass produced and opened up new opportunities for design, providing maximum strength in return for minimum weight. In fact, the new opportunities it provided in design had already been seized a few years earlier by Marcel Breuer and Mies van der Rohe at the Bauhaus with their use of tubular steel in cantilevered designs, and the Perriand/Le Corbusier designs could not in reality be mass produced. 'If,' said Charlotte Perriand, all but echoing Eyre de Lanux, 'we use metal in conjunction with leather for chairs, with marble slabs, glass and india-rubber for tables, floor coverings, cement, vegetable substances, we get a range of wonderful combinations and new aesthetic effects.'[11] This was nearer the truth, for, when separated from the houses they were intended to equip, these designs had more in common with the interiors exhibited by Eileen Gray or Eyre de Lanux and Evelyn Wyld. Perriand and Le Corbusier's use of the 'confrontation' between natural and industrial materials was more for aesthetic than technical reasons. What was original about them was the new aesthetic of function they expressed, an aesthetic which relied on a complete coherence between architecture and *équipement*. These chairs were to be seen as performing specific functions, not as decorative features within a room. As Charlotte Perriand later said: 'It doesn't interest me to create an object for itself. I won't create something unless it is to be incorporated in an interior.'[12]

Artists and designers alike, none of the women who worked in Paris in the 1920s were content to focus on the object alone and all saw their work in the context of their daily lives. It was not that art should be subordinated to the demands of everyday life, but that it was something that sprang from life itself and could be utilised in every possible way. But the most important idea to emerge from their work was the widening of the very concept of art. Artists such as Sonia Delaunay or Sophie Taeuber-Arp showed that abstract theories of form and colour could validly be expressed in textiles and their work is now regarded, rightly, as a stepping-stone in the development of new attitudes to, and the redefinition of, the boundaries between fine and applied arts.

Yet even though the importance of this contribution is now accepted, the reputations of the individual artists have continued to suffer from the ambivalence haunting any evaluation of women's art. On the one hand, the acceptance of a supposedly 'female art' as art has allowed much that was previously dismissed as ephemera to be regarded in a new and more 'important' light, but, on the other, conventional art history has belittled such achievements and their revolutionary nature by insisting that they were a logical, almost inevitable, development within traditionally female fields. Both judgements derive from a traditional and misdirected critique of art history that ignores the true question raised by such work: whether, in art, men and women do share the same experiences and, therefore, whether the same critique should be applied to both. This was a question that was raised – and partly answered through the concept of the anonymous designer – at the Bauhaus in Germany.

8. The Rational Woman

Modern design was born at the Bauhaus; its innovative approach took all the former categories of craftsmanship, decorative or applied arts and interior decoration and linked them to a new approach to the practice of art and architecture and to a new attitude towards the teaching and development of good design. Many objects and materials we now take for granted were developed there: modern lighting, synthetic fibres in curtains or upholstery, stacking cups and bowls or well-proportioned office furniture are all derived from prototypes originated at the Bauhaus. To many, its products seem coldly theoretical, over-analytical and lacking in human comfort, yet it stood out in the memory of those who trained or worked there as a place of colour, excitement and youth. As Gunta Stölzl, one of the first women students, later realised,

> Dances and festivals played a big role in our activities . . . when Kandinsky came to the Bauhaus, he held a huge exhibition of his paintings in the studio and we danced there in the evening. What unforgettable parties, all the couples dancing before the large forms and glowing colours of his paintings . . . I believe today that our life there was the most important thing. It was, above all, discovery, experience, encounter, friendship: friendships which lasted for decades.[1]

For the women students especially, the informality of the Bauhaus was an extraordinary release from pre-war conventions.

The Bauhaus had been established in Weimar in Germany in 1919 as the successor to the former Kunstgewerbeschule (School of Arts and Crafts). The Director of the Kunstgewerbeschule, Henry van de Velde, a leading exponent of the European Arts and Crafts Movement, nominated the architect Walter Gropius as the head of the new school. In 1919 Gropius published a four-page *Programm* outlining the aims and principles of the Bauhaus. It was written during, and must be read in the context of, the violence and privations which followed the end of the First World War: much of Germany was starving and lacked the raw materials to rebuild, or even to replace basic household goods, while in Berlin and Munich revolts of the left were suppressed with cruel

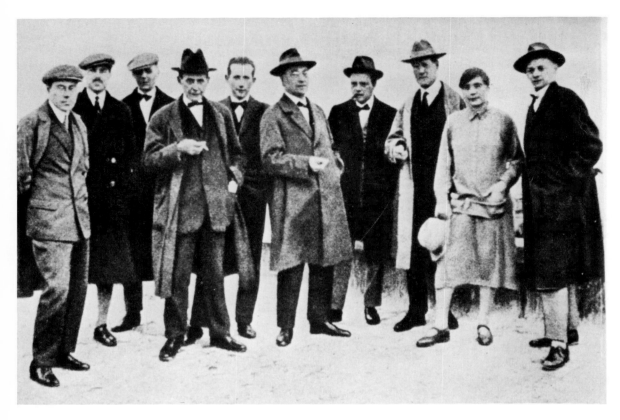

The Faculty of the Dessau Bauhaus, 1926. Gunta Stölzl is on the right

violence and were followed in 1920 by a right-wing putsch, which was, in its turn, foiled by a general strike and, in some areas, armed resistance.

Where earlier writers on design had condemned bourgeois taste for aesthetic reasons, Gropius now also condemned the values of bourgeois materialism which had gained ascendance before the First World War. An artist or designer committed to the new order could no longer design for a middle class which could condone such a war. 'The ultimate aim of all visual arts,' announced Gropius, 'is the complete building! . . . The mere drawing and painting world of the pattern designer and the applied artist must become a world that builds again.'[2] Gropius believed in the *Gesamtkunstwerk*, the total work of art, uniting the spiritual content of the fine arts with the material skill of the crafts as part of an architectural whole. The distinctions between fine and applied artists were to disappear in a new art which would be the 'cathedral of socialism'.

His call voiced a more widely felt demand for an architectural and design vocabulary which linked design inexorably to the building of a new society. As Anni Albers, who joined the Bauhaus in 1922, wrote much later,

In a world as chaotic as the European world after World War I, any exploratory artistic work had to be experimented in a very comprehensive sense. What had

existed had proved to be wrong; everything leading up to it seemed wrong too.

Anyone seeking to find a point of certainty amid the confusion of upset beliefs, and hoping to lay a foundation for a work which was orientated toward the future, had to start at the very beginning.[3]

She went on to spell out exactly how this translated itself in design terms. 'This meant focusing upon the inherent qualities of the material to be used and disregarding any previously employed device for handling it.'[4]

From the start, Gropius organised the Bauhaus in terms of both teaching and everyday life along lines which broke with the traditions of previous art schools. The basis of all training was to lie in workshop experience in the crafts, and painting and sculpture were to be regarded in the same light as woodwork, metalwork, stage design, typography or weaving. Nevertheless, all students had to attend an obligatory preliminary course. They were also encouraged to frequent all the different workshops and, after six months, to choose the craft in which they would specialise. The notion of teachers and pupils was abandoned in favour of masters, journeymen and apprentices who would collaborate on outside commissions and exhibitions, including work within industry, and 'friendly relations between masters and students outside of work' were encouraged.[5] 'The manner of teaching,' wrote Gropius in his *Programm*, 'arises from the character of the workshop: organic forms developed from manual skills. Avoidance of all rigidity; priority of creativity; freedom of individuality, but strict study discipline.'[6]

Until 1923 the preliminary course was taught by the Swiss painter Johannes Itten, who was also instrumental in bringing artists such as Paul Klee, Georg Muche and Wassily Kandinsky – who had taught at the revolutionary Moscow Vkhutemas – to the Bauhaus. Itten was interested in an intuitive approach to form and materials: once or twice a week the students gathered in an empty room, sitting on the floor with sketchbooks on their knees, while he showed slides of Old Master paintings for about a minute, then asked the students to draw the essentials of the compositions. Or he would pass around pieces of glass, paper, plaster of Paris, wood or coal and ask the students to consider their specific properties and qualities. He also taught theories of colour, form and structure. Itten was something of a guru; he held breathing and relaxation sessions at the start of his classes and believed in a vegetarian diet, which was not welcomed by his students who had little enough to eat. Nevertheless, his mystical fervour was initially popular among them.

In its early days, there were only about forty students at the Bauhaus, about a quarter of them women. The school itself was almost destitute; indeed the first job of the painting workshop was to wash and redecorate the walls of the old Kunstgewerbeschule building, which was desolate, having been used as a military hospital during the war. Many of the male students had fought in the war and often still wore their uniforms, which the women revamped, cutting off the collars and adding coloured trimmings. Materials generally were in short supply and, during the first winter, the students made toys, decorations

and puppets out of paper, carved wood and scraps of fabric which they sold on a 'Dada-ist stall' in the traditional Christmas market in Weimar. In this first year after the end of the war the students felt themselves to be part of a close-knit community, bound by their enthusiastic idealism.

Unlike other art schools in Germany, the classes at the Bauhaus were never segregated. Gropius encouraged social freedom within the school: the sexes mixed, there were several foreign students and the masters were both approachable and fascinating. The students organised parties, with a Bauhaus jazz band, led by a Hungarian student on the piano; they attended concerts and lectures in Jena; they walked to Dornburg to spend a few days camping out at the ceramic workshop there; or they spent informal evenings talking with Gropius. Within Weimar itself, the students supported the local socialist government, which, in turn, protected the Bauhaus from its right-wing critics.

Gropius, who was in his mid-thirties when the Bauhaus was founded, sympathised entirely not only with the students' idealism and belief that a phoenix could be made to rise out of the ashes of the war, but also with their rejection of outmoded social conventions. For some of the women students, who came from middle-class homes, this must have been a revelation. The equality which was practised at the Bauhaus eventually found its way into the design ethic of the school as the concept of the anonymous, functional designer replaced the old idea of the artist-craftsman, for the truly anonymous designer who subordinated personal expression to practical need was neither male nor female. The Victorian notion of 'feminine' art was, for the first time, neatly side-stepped.

The women students were free to choose any of the workshops, but in fact they overwhelmingly opted for textiles and, since the weaving workshop was run by women, any discussion of women's place at the Bauhaus must focus upon it. The women themselves were aware of the irony of the fact that, given complete freedom of choice, they gravitated towards a traditionally female field of activity and considered the reasons for it. In an article 'Woman's Place at the Bauhaus', 1926, Helene Nonné-Schmidt wrote:

> The artistically active woman applies herself most often and most successfully to work in a two-dimensional plane. This observation can be explained by her lack of the spatial imagination characteristic of men . . . In addition, the way the woman sees is, so to speak, childlike, because, like a child, she sees the details instead of the over-all picture. The woman's way of seeing things enables her to pick up the richness of nuances which are lost to the more comprehensive view. But let us not deceive ourselves into thinking that this aspect of her nature will change, despite all the accomplishments of the Women's Movement and despite all the investigation and experiments. There are even indications that woman is counting on her limitations, considering them a great advantage . . . Within the Bauhaus and its workshops the woman is primarily interested in the work of the weaving workshop and there finds the widest range of opportunities. Weaving represents the fusion of an infinite multiplicity to unity, the interlocking of many threads to make up a fabric. It is quite evident to what extent this field of work is appropriate to a woman and her talents . . . The ability of woman to become absorbed in detail and her interest in

experimental 'play' with surfaces suit her for this work. In addition, her feeling for colours finds reign for expression in the multitude of possible nuances.[7]

There was no pressure upon the women students at the Bauhaus to choose textiles as their specialist field, nor was weaving considered in any way less important than the other crafts. Nevertheless, the fact that, within the Bauhaus, where equality of the sexes was an ideal, textile work was seen by some as a 'womanly' skill may have contributed to a situation where, although women did enter other workshops, comparatively few male students chose to train in the weaving workshop. Although this reinforces Helene Nonné-Schmidt's belief that women were 'naturally' excluded by their 'limitations' from working successfully in other media, none of the women most closely associated with the weaving workshop felt the need to justify its sexual separatism.

The workshop, which was among the first to be set up at the Bauhaus, was established entirely on the initiative of a group of women students, with Gropius's support. After the success of the Christmas stall at the Weimar market in 1919, Gunta Stölzl, who had come earlier that year from the Munich Kunstgewerbeschule after reading Gropius's *Programm*, and two other women asked Gropius and Itten if they could start a class for women, begging odd remnants of fabric, lace, beads and thread from women in Weimar to make wall-hangings, covers and toys. Gunta Stölzl then discovered that a Weimar needlework teacher, Helene Börner, had access to some looms left over from the former Weimar Kunstgewerbeschule and Gropius arranged for these to be taken over by the Bauhaus under Helene Börner's supervision, despite the fact that she knew nothing of weaving, only embroidery. The old Kunstgewerbeschule dye-shop was also taken over and Gunta Stölzl and Benita Otte began to dye their own materials. For the first year, the women had to teach themselves by trial and error how to thread and work the looms, but in 1921 they were able to go on two-month courses in the textile town of Krefeld to learn dyeing and weaving techniques. Nearly all the students who trained subsequently in the weaving workshop were women. In 1929, by which time there were 170 students at the Bauhaus, nineteen of the fifty-one women belonged to the weaving workshop.

While the other workshops had both a technical master and a *Formmeister*, or master of form, who oversaw the designs, the weaving workshop had no technical master since there was no one available who was sufficiently qualified. The students could weave anything they chose: tapestry hangings, cushions, seat covers for Marcel Breuer's furniture, or even large carpets, one of which Gropius used in his office. Most of the work was individual pieces, made not for any specific use, but they were, as Anni Albers commented later, 'objects of often quite barbaric beauty'.

The character of the early Bauhaus textiles, in particular the use of strong blocks of colour, was due largely to the influence of the *Formmeisters* Georg Muche and, briefly, Paul Klee. These early, brightly coloured, geometric and

Left: **Carpet designed by Otti Berger, *c.* 1929**
Right: **Triple-weave wall hanging by Anni Albers, 1926–27**

abstract hangings and carpets were modern and extremely decorative, expressive of the forms and colours that Muche and Klee explored in their paintings and also – as at the Wiener Werkstätte in these years – of the themes of the peasant work with which some of the students were familiar from their native countries of Hungary or Austria. The work did, indeed, mark a departure from the textile patterns produced before the war in its abandonment of conventional patterning and naturalistic ornament. As in Russia, Paris and Vienna, it was primarily through textile design that the current ideas of abstract art were brought to a wider public.

Within a few years the weaving workshop followed the general opinion within the Bauhaus that individual, free expression should be abandoned in favour of a more logical approach to design. This sprang both from the development of new ideas within the school and in response to external

political changes in Germany. In 1921 the Dutch writer Theo van Doesburg had come to the Bauhaus. Horrified by Johannes Itten's often mystical theories and his loose teaching methods, he started his own De Stijl course in Weimar the following year which was attended by several Bauhaus students. Many *Bauhäusler* were becoming increasingly interested not only in the De Stijl movement but also in the work of the Russian Constructivists, shown in Berlin in 1922, in Le Corbusier's new magazine *l'Esprit Nouveau* and in the work of Adolf Loos in Vienna, all of which condemned subjective individual expression in favour of a more systematic exploration of form, function and materials. The revolutionary implications of the ideas they shared, which were most fully explored at the Bauhaus, were outlined much later by Anni Albers when she wrote,

> The material itself is full of suggestions for its use if we approach it unaggressively, receptively . . . It is better that the material speaks than that we speak ourselves . . . The good designer is the anonymous designer . . . the one who does not stand in the way of the material; who sends his products on their way to a useful life without an ambitious appearance.[8]

Where the Bauhaus – and especially the weaving workshop – differed from the other movements was that, almost from the first, they saw the importance of linking their aesthetics to the demands of industrial production.

In 1923 Itten resigned from the Bauhaus and was replaced by the Hungarian, Lazlo Moholy-Nagy, as *Formmeister* in the metal workshop and as head of the preliminary course. The move towards a closer link with industry which Moholy-Nagy encouraged was hastened by practical necessity following the defeat of the local socialist government in Weimar in 1924. Although some townspeople loved having the Bauhaus students about Weimar – the girls with short hair and fanciful dresses and the men in their converted uniforms – many of the inhabitants, retired civil and military officials, felt that the rowdy students were denigrating the town's association with German heroes such as Goethe, Schiller, Liszt and Nietzsche.

Gropius and his students now paid for their support of socialism; the Weimar Bauhaus had to close in April 1925 and Gropius moved the school to newly designed buildings in the industrial town of Dessau. The Dessau Bauhaus was poorly financed and outside orders became a vital source of income. The Bauhaus GmbH – a limited company – was set up to market their designs and products.

It was against this background, and under the leadership of Gunta Stölzl, that the weaving workshop began to change direction and became especially successful in selling designs to firms in Dresden, Berlin and Stuttgart. For the first two years at Dessau, Gunta Stölzl acted as technical head of the weaving workshop, although apart from a couple of months at Krefeld and a period in 1924 studying hand-loom weaving at Herrliberg, on the outskirts of Zürich, she was entirely self-taught. When Georg Muche resigned in 1927, she became 'junior master', a new title awarded to Bauhaus-trained masters who

Woven curtain fabric designed by Gunta Stölzl

were able to teach both technique and form. She was ably assisted by Otti Berger, a Hungarian who joined the Bauhaus in 1927 and did much to develop designs for industrial production (she was later to perish in a Nazi concentration camp), Benita Otte, Anni Albers, who was married to the Bauhaus furniture designer Josef Albers, and Margarete Leischner. In 1931 Gunta Stölzl summed up the changes which took place under her direction:

> We had a very different idea about the home in 1922–23 than we have today. Our textiles were still permitted then to be poems heavy with ideas, flowery embellishment, and individual experience! . . . they were the most easily understandable and, by virtue of their subject matter, the most ingratiating articles of those wildly revolutionary

Bauhaus products. Gradually there was a shift. We noticed how pretentious these independent, single pieces were: cloth, curtain, wallhanging. The richness of colour and form began to look much too autocratic to us, it did not integrate, it did not subordinate itself to the home. We made an effort to become simpler, to discipline our means and to achieve a greater unity between material and function. This way we came to produce textiles sold by the yard, which were clearly capable of serving the needs of the room and the problems of the home. The slogan of this new area: prototypes for industry![9]

New students in the weaving workshop now learnt from the very beginning of their course to work for actual production and to the limitations of designing for specific briefs. New fibres were tested to be transparent or light-reflective, to absorb sound, to be elastic, hard-wearing or to disguise seams; every solution had then to be made economically viable for large-scale production. The structure and texture of the weave, with simple colour combinations, became the central point of departure for their designs. As Anni Albers later wrote in her book *On Weaving*:

> Though elaborations are usually thought to be an advanced stage of work, they are often easy expansions from basic concepts. Intricacy and complexity are not, to my mind, high developments. Simplicity, rather, which is condensation, is the aim and the goal for which we should be heading. Simplicity is not simpleness but clarified vision – the reverse of the popular estimate . . . It is interesting to note that where the functional aspect of the basic structure is moderated, aesthetic qualities frequently move to the foreground: in fact, they often are the very reason for the structural change . . . the discipline of constructing is a helpful corrective for the temptation to mere decoration.[10]

In keeping with Gropius's original aim of rejecting the distinctions between fine and applied arts, the innate qualities of fabrics were seen to be as important a means of aesthetic expression as Itten or Moholy-Nagy's 'photograms', kinetic structures or collages, or indeed as traditional easel painting or sculpture. In this respect, there were close affinities between the work of the Bauhaus and that of individual artists such as Sonia Delaunay or Sophie Taeuber-Arp. Otti Berger observed that,

> Cloth has its own expression. Do we need flowers, foliage, ornaments? Stuff itself is alive. Why be so objective. A tapestry to express winter, need not be a bare tree on a light coloured background with a raven. The feeling of winter can be expressed without these actual objects, the material alone can convey the glitter and sparkle of winter. White stuff can express the hard porcelain-like quality of snow or even the transparency of a flower. Thus through the actual materials themselves, we can reach a higher plane of expression in stuff. The cover for a piano can itself be a piece of music – flowing, harmonious, full of melody and vibration . . . The feel of stuff in the hands can be just as beautiful an experience as colour can be to the eye, or sound to the ear.[11]

Through a rigorously practical training, the students could develop a flexibility in handling the raw materials of their trade. The preliminary course exercises in the nature of different materials encouraged them to consider the potentials

Gunta Stadler-Stölzl in
Zürich, 1980. Behind
her is an example of her
recent work

and applications of their yarns, thus acquiring what Anni Albers has called 'tactile sensibility', something that is now, perhaps, taken for granted as a quality vitally necessary to the textile designer, but which had previously been overlooked by textile designers in the desire to achieve a pictorial hegemony. 'Our materials,' Anni Albers has written, 'come to us already ground and chipped and crushed and powdered and mixed and sliced, so that only the finale in the long sequence of operations from matter to product is left to us: we merely toast the bread. No need to get our hands into the dough.'[12] The weavers at the Bauhaus not only mixed their own dough but, through the strict discipline and responsibility of working on concrete problems, came up with results which 'would not suffocate us with glamour but would retain the serviceable character useful objects should have'.[13] Although such work is more difficult for the untrained eye, better acquainted with work which bears the unmistakable imprint of the designer, the anonymous products of the Bauhaus weaving workshop met perfectly Gropius's ideal of putting the skills of the artist at the service of the public who merely wanted useful, serviceable and reasonably priced household goods. The designers of the Arts and Crafts Movement may have claimed the same ideal, but their work was always an expression of personal taste.

Despite the revolutionary step taken by the women of the Bauhaus weaving workshop in their decision to design exclusively for industry, in later years several returned to more individual forms of weaving. Gunta Stölzl, who had married in 1929, left the Bauhaus in 1931 and set up her own weaving studio in Zürich with Heinz Otto Hürlimann, a weaver who had also trained at the Bauhaus. She has continued to design and to weave, but has returned to the more decorative idiom of her first years as a student. In 1933 Anni Albers and her husband left Germany for America where, until 1949, they both taught at Black Mountain College in North Carolina. She then worked as a freelance designer, working on individual tapestries and commissions, including pictorial weaving, and also on experiments for industrial production. Since 1964 she has shifted her interest to various graphic techniques which gave her the chance to exhibit her work more widely. Throughout her work – and in her writings – she has, however, kept to the integrity of the design process as arriving out of technique, an approach which characterised the Bauhaus weaving workshop. Otti Berger worked as a textile designer in Berlin before disappearing in the Nazi holocaust and Margarete Leischner designed furnishing fabrics, curtaining and table linens for the Deutsche Werkstätte in Dresden and in 1937 moved to England where she designed hand-woven textiles for car upholstery and radio speakers with synthetic fibres, before becoming head of the weaving department at the Royal College of Art.

One noted *Bauhäuslerin* who did not join the weaving workshop was Marianne Brandt. Born in 1893 in Sachsen (now Karl-Marx-Stadt in East Germany), she studied at the Weimar Art Academy and afterwards worked as a painter. She decided to join the Bauhaus in 1923 after visiting an exhibition

Silver tea-pot designed by Marianne Brandt, 1924

organised by Gropius to display the progress made at the school and attended the preliminary course held by Moholy-Nagy. In fact, she would have liked to join the wood workshop, but, believing that the work there would be too heavy for her, instead joined the metal workshop. Initially, it had produced silverware and jewellery, but under Moholy-Nagy it had begun to produce items for serial production by industry.

In the early years Marianne Brandt designed silver tea services and other objects made by traditional metalwork designers, but by the mid-1920s she had become far more concerned with the design of simpler, functional objects, such as cooking utensils (including a set of dishes for use in a hotel), wall-brackets, ashtrays, shaving mirrors and, especially, lamps. In 1926 she developed glass globe lamps, which were produced by a firm in Berlin, and the following year designed the Kandem bedside lamp, with an adjustable reflector to give indirect lighting and a push-button switch to make 'switching easier even when one is half-awake', which was produced by the Leipzig firm, Korting and Matthieson.

In 1928 Marianne Brandt succeeded Moholy-Nagy as assistant head of the metal workshop. Later that year, Gropius resigned as head of the Bauhaus, nominating Hannes Meyer, the former head of the architecture department, in his stead. Meyer amalgamated the metal and cabinet-making workshops into the interior design workshop under Josef Albers, a logical step given that much of the furniture was of tubular steel and that many synthetic materials were being used in the metal workshop. The designs it produced were now

The Kandem bedside lamp, designed by Marianne Brandt, 1928

totally determined by functional needs rather than visual aesthetics and it was committed to producing new types of household equipment, with little interest in merely redesigning traditional articles.

Marianne Brandt says that she was never aware that her designs were revolutionary – 'I have simply followed my ideas and the need of the moment'[14] – yet numerous German firms were aware of the impact of the Bauhaus workshops, visiting them regularly to consult with the designers on the technical aspects of their new products. Marianne Brandt was truly the anonymous designer, responsible for a wide and innovative variety of adjustable lamps, modern ceiling lamps and unsurpassed designs for tableware which were, in their original forms, of such functional simplicity that they have stood as blueprints for countless subsequent models. In 1928 she left the Bauhaus to work in Gropius's Berlin construction office. She then designed for a metal goods factory and, after the war, taught in Dresden and Berlin. She has now retired to her home town.

By 1930 the true spirit of the Bauhaus was disappearing. Despite opposition from some of the masters and students (including Gunta Stölzl), Meyer was forced to resign and left to teach at the Moscow Vkhutemas. He was succeeded as head of the Bauhaus by Mies van der Rohe, who subordinated all the workshops to the demands of architecture, and brought in Lilly Reich, reputed to be a brilliant interior designer and his major collaborator on earlier architectural projects. She became head of both the weaving workshop and the interior design seminars. Lilly Reich had originally been connected with the

Wiener Werkstätte and with the more radical Deutscher Werkbund, which in the early 1920s had been involved in the various architectural exhibitions that had served as vital showcases for the new German architects. In 1927 she worked with van der Rohe on the Werkbund exhibition in Stuttgart, where his tubular steel furniture caused a sensation. Two years later she again collaborated with him on the German section of the International Exhibition in Barcelona and in 1931 designed a one-room flat for the Berlin Building Exposition. However, Mies van der Rohe and Lilly Reich had little opportunity to put their ideas into practice, for, in 1933, the Nazis came to power in the Dessau region. They found the Bauhaus designs 'degenerate' and although they could not yet entirely close the school, it was forced to move to Berlin, where right-wing forces finally succeeded in closing the Bauhaus later that year.

But despite the Nazis' attempts to purge its ideals, the Bauhaus has survived as the most important of all the design movements of the inter-war period. During the Bauhaus's short existence, many designs were manufactured – for example, the Leipzig firm which produced Marianne Brandt's Kandem lamp had a contract with the Bauhaus until 1932 during which time they produced over 50,000 Bauhaus designed or evolved lamps; but even after the school closed, designers all over the world borrowed heavily from the published Bauhaus designs. Many of its masters and students have spread all over the world and in America and Japan especially its design idiom has been enthusiastically endorsed. Even those who had merely heard of, or at best briefly visited, the Bauhaus were inspired by both its aims and its products. The women – the pioneering Gunta Stölzl, the 'born weaver' Otti Berger, the beautiful Marianne Brandt – all played their part not only in the work, but in the life and spirit, of the place. They took equal part in the theoretical debates; in the interior design workshop they focused attention on kitchens and nurseries; they created the weaving workshop which did so much to add softness and colour to the architectural schemes; and Marianne Brandt's easeful functionalism simplified many basic household appliances.

The most important legacy of the Bauhaus, however, was the rational critique of design which it evolved, borrowing whatever it needed from both art and architecture. In the products of the weaving workshop especially, the marriage of the craftswoman's mastery of technique with the artist's appreciation of colour and form was then subordinated to the practical requirements of interior design. The Bauhaus-trained textile designer was neither artist nor craftswoman; a new concept of the designer was created. Despite Helene Nonné-Schmidt's claim for 'the way the woman sees', the Bauhaus designer was essentially anonymous, neither male nor female in terms of the distinctions which had traditionally been made between male and female artistic activity. Textiles are still traditionally held to be a woman's art and, by their associations with natural fibres and vegetable dyes and with the home, reinforce the identification of woman with nature, not culture: the women of the Bauhaus, however, made culture their starting-point and, in so doing, removed themselves and their products from the divisive concept of 'women's work'.

9. The Simple Life

After the master craftsmen of the guild system were displaced by the machines of the industrial revolution, the practice of crafts fell into the category of women's work, as an embellishment of the home or as mere hobbies; as a corollary women themselves did not tend to value their work very highly. Yet during the 1920s there was to emerge a group of craftsmen and women that all, to varying degrees, espoused an ideal of a 'Simple Life', close to that evoked by Ruskin and Morris in the nineteenth century in reaction to the *laissez-faire* policies of nineteenth-century capitalism. Both the aesthetics and the social theories at the heart of the craft revival honoured a simplicity of purpose which, in the years after the First World War, when people craved values which they could understand, stood in sharp contrast to the complex political and economic forces which had condoned such carnage. The new generation of craft workers were concerned to revitalise and rediscover the techniques of crafts which had practically disappeared during the industrial revolution, such as spinning, dyeing, weaving, block printing or throwing and glazing pottery and, like Ruskin and Morris, saw the value of their work in relation to the community. The value of the 'Simple Life' lay in a return to humanity's intimate association with the artefacts which surround daily life and the benefits which a community derives from such an association. It was an ethic which replaced class distinctions with a notion of human value acquired and practised through the experience of the workshop, and it led to a re-evaluation of the practice of crafts without their appropriation by men.

Although the craft workers of the early twentieth century advocated a return to small, self-sufficient agricultural communities where, in rhythm with the seasons, people would once again have the freedom of body and spirit to appreciate the things that mattered in life – the divisions of class, education and sex would be overcome, intellectual work would be equal to physical labour, diet, dress and the way in which houses were furnished would reflect a simpler, more harmonious relationship with nature and with other people – they were more pragmatic than Morris's generation, basing their styles on the demands of function and the processes of production. Yet while a similar

rejection of nineteenth-century values underlay the idealism of the Bauhaus and the Vkhutemas, Britain lacked the revolutionary context of Europe and it was not until the mid-1930s that British craft workers fully escaped the doctrines of the nineteenth-century Arts and Crafts Movement and accepted ideas which, in Europe and Russia, were already being suppressed by Fascism.

The craft revival of the 1920s stressed the value of the individual lifestyle rather than the force of a co-operative group. As the potter Bernard Leach wrote: 'the artist-craftsman, since the day of William Morris, has been the chief means of defence against the materialism of industry and its insensibility to beauty.'[1] All the craft workers worked independently, but they met frequently to discuss their workshop philosophies and to compare notes on the best ways of selling their work. They realised the importance of explaining their techniques, giving the public the knowledge they required in order to enjoy what they saw and to discover some sympathy with the maker's aims through owning or using the work, for they saw themselves as the heirs to traditions which belonged to no single individual but to anyone who could develop a skill or express and idea, and believed that the fruits of their researches and experiments were to be shared.

The man who had the greatest influence on the craft workers of the 1920s was Edward Carpenter, a former clergyman who had set up his own small-holding at Millthorpe, near Sheffield, in the 1880s. Carpenter became the champion of an alternative way of living and was associated with many of the 'forward' circles interested in socialism, feminism, sexual freedom, psychology and mysticism; William Morris, C. R. Ashbee, who founded the Guild of Handicraft, the writer A. R. Orage, who later became involved with the mystic Gurdjieff, and many others all admired him. (Ashbee was a fervent follower of William Morris and in 1902 had moved his Guild of Handicraft from the East End of London to the Cotswolds. Although quixotic and short-lived – the Guild went into liquidation five years later – it was the most important attempt to found an idyllic rural community of artist-craft workers along the vaguely socialist lines admired by the Arts and Crafts Movement.) Carpenter and his followers saw the relationship between maker and materials as a unifying spiritual experience which was of crucial significance to society in general. The weaver Ethel Mairet and her husband Philip expressed this view in 1918 in *An Essay on Crafts and Obedience*:

> Social order, language, and art, all have their root in the same reality; and if that reality is truly felt in the soul of a people, it will find its one fundamental expression in that people's religion. So craftsmen see that no craft can now attain its greatest excellence until some unifying religious spirit is expressed through all of them . . . We must devotedly prepare ourselves and our working methods to receive the spiritual enlightenment when it shall come, and it will come the sooner for our doing so.[2]

The discipline of the craft workshop was to foster an intuitive approach to design, to form, colour and decoration, so that the objects they made would communicate this deeper meaning.

Through their unassuming independence and their sustained persistence, it was women who came to play a major role in re-establishing the relevance of their crafts to both the art world and the fields of design and, especially, industrial manufacture. Their emancipation from the role of women cast by Ruskin and Morris coincided with the more general freedoms won by women in these years in government, job opportunities and social conventions. For the women who, through the Arts and Crafts Movement, had begun to train in the new art schools and to find some professional independence through the crafts, life in a workshop now offered not only some measure of financial reward but also, perhaps most importantly, a welcome freedom in terms of how and where they lived. As girls who had grown up in Edwardian drawing-rooms, they found it exciting to concern themselves with the practicalities of looms, dye-vats or kilns, especially those who had first tasted the freedom of hard practical work while nursing or driving ambulances during the First World War and could not face returning to the pre-war restrictions of middle-class family life.

To an enormous extent, the success of the craft revival depended on a network of women which developed during the 1920s. All the major retail outlets where craftsmen and women could publicise and sell their work in the inter-war years were founded by women and it was very largely their taste which set standards for contemporary craft work and so won the public's support. In many ways, the network which women now established was similar to that pioneered in America in the late nineteenth century by such women as Candace Wheeler.

In 1921 Margaret Pilkington founded the Red Rose Guild of Art Workers in Manchester, her home town. It established itself, with the support of the leading craftsmen and women, as a central authoritative body, maintaining exacting standards for membership and providing both a vital sales outlet and a regular annual meeting place. In the early 1920s Dorothy Hutton, who had been a student at the Central School with Margaret Pilkington, opened the Three Shields Gallery in Kensington. The Gallery primarily gave her an outlet for her own work, which she sold under the name of Hollybush Publications, but also stocked prints, watercolours, drawings, pottery and hand-woven and hand-block-printed textiles.

Two other notable galleries founded by women in the inter-war years were Elspeth Ann Little's successful but short-lived Modern Textiles, which opened in London's Beauchamp Place in 1926, primarily selling fabrics (by Miss Little herself, by Marion Dorn and from Celandine Kennington's Footprints work-shop) but also pottery and wallpapers, and Dunbar Hay, opened in 1936 by Cecilia Dunbar Kilburn and Athole Hay as a sort of marriage bureau to put young designers from the Royal College of Art in touch with manufacturers. It specialised in well-designed, commercially produced goods, but also stocked pottery, hand-block-printed textiles and embroidery designs. In addition, the Guild of Weavers, Spinners and Dyers, an organisation which did much to promote hand-weaving as part of education in schools, was founded by

women in 1930 at the Sussex workshop of the weaver Elizabeth Peacock.

Undoubtedly the most important of all these galleries, however, was the Little Gallery, near Sloane Square in London, founded by Muriel Rose and Peggy Turnbull in 1928. Overtly simple and totally unpretentious, the Little Gallery's style relied upon attention to detail and texture and, especially, upon a fine, discriminating sense of colour. With a ground-floor room covered in white tiles and a basement also painted white, it had a pure but eclectic atmosphere, totally unique in its subtle, understated taste. Although other shops stocked some of the same work, none created such an effect of careful selection, nor set such formidably high standards. Through her selection and presentation of the best contemporary craft work, Muriel Rose helped to establish a coherent style, which appealed to her customers as a complete approach to interior decoration rather than the occasional purchase of a pot or length of fabric for curtains.[3]

Muriel Rose gained the respect and gratitude of those whose work she sold for her uncompromising taste and her tireless work in explaining and publicising the aims and values behind the work she sold. Although, as Fiona MacCarthy has termed it, it was 'conscientious furniture for conscientious clients',[4] her customers included aristocracy, interior decorators and art critics.

This supportive network which emerged to publicise and sell craft work enabled scores of women – and men – to earn a living or at least supplement their incomes through craft work in the 1920s and 1930s. In particular, women dominated every area of textile design, from rugs to printed dress fabrics, yet the achievements of women such as Ethel Mairet or Phyllis Barron have been overlooked precisely because their greatest influence has been on modern textiles which are, largely, marketed anonymously. As on the Continent at this time, it was widely believed that women had a more intuitive feel for textiles, not only because of the associations with dress and the home, but also because the softness, pliability and colour of textiles were felt to be qualities which appealed more directly to women. Embroidery and, later, weaving were taught in girls' schools, but woodwork or metalwork were generally considered too strenuous, dangerous and unsuitable. At the same time, art schools were beginning to offer a more specialist training, in keeping with the evolution of the concept of the designer who understood the technicalities of specific media. It was therefore almost inevitable that a woman who wanted to be a designer should choose the field of textiles for her profession. Nevertheless, given the early association of manufacturing and textiles in nineteenth-century Britain, it was one of the most important fields reclaimed by the craft movement and in no way an area simply left to women.

One of the first women to establish herself in this field was Ethel Mairet. An extraordinary woman, swift and energetic, she was one of the few craftswomen who bridged the gap between the utopianism of the nineteenth-century Arts and Crafts Movement and the growing belief that the true role of the crafts lay in evolving prototypes for industrial production. As a weaver she was almost entirely self-taught, but she was to become a highly respected

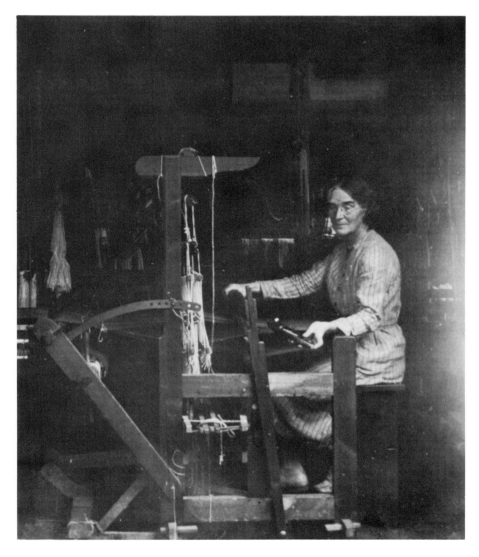

Ethel Mairet at her loom at Gospels, c. 1933

figure within the world of design in England, gaining the admiration of such exacting critics as Bernard Leach and Edward Johnston. Ethel's greatest practical talent lay in her mastery of vegetable dyes, but she was also an inspiring teacher, always open to new ideas and able to communicate her zest and enthusiasm for her craft to her pupils, who saw her role as a pioneer of the Simple Life, guarding the values of the community life of the workshop. She continued to weave until the day she died, at the age of eighty, in 1952.

Ethel Mairet led a rich and eventful life, and one which mirrors the experience of countless less well-known craftswomen of the 1920s in the intertwining of her work with her personal life and ideals. The daughter of a Barnstable chemist, she came into contact with Arts and Crafts ideals through her younger brother, Fred Partridge, who had studied metalwork at Birmingham

Interior of Ethel Mairet's workshop, Gospels

School of Art and worked briefly with C. R. Ashbee's Guild of Handicraft before setting up his own workshop in London with his wife, May. Ethel worked as a governess in London and Bonn until, in 1902, she married at the age of thirty. Her husband, Ananda Coomaraswamy, was half English, half Ceylonese and in 1902 they left England to spend four years in Ceylon and India, where they made a study of the local arts and handicrafts.

In 1907, on their return to England, the Coomaraswamys settled in Broad Campden, a small village near Chipping Campden. They became friends with Charles and Janet Ashbee and the Guild of Handicraft renovated their ancient house, Norman Chapel. In the evenings they and their friends would often meet there. Ethel would wear Eastern draperies and Ceylonese jewellery; Coomaraswamy would outline his theories about combining the metaphysical and the functional in art, and the importance of expressing spiritual values in everyday objects.

In 1911 Ethel's idyllic world was shattered when, during a second trip to India, Coomaraswamy declared that he intended to take a second wife, a young musician, Alice Richardson, who bore his son the following year. Ethel returned alone to Broad Campden to dismantle Normal Chapel and moved to Saunton, where she planned to build herself a bungalow. Here she met a woman who taught her the rudiments of vegetable dyeing and she began to teach herself to weave. Ethel was helped and gradually consoled by a young draughtsman from Ashbee's architectural office, Philip Mairet, who had in fact first introduced Coomaraswamy to Alice Richardson. In 1913 they married. Fourteen years Ethel's junior, Philip was a resilient but impressionable man with no real aim in life, but a leaning towards mysticism. Their marriage was conducted on the banks of the river Isis in Oxford, with a contract written on sheepskin: they later married more formally in a London registry office, celebrating with lunch at a vegetarian restaurant.

The same year, Ethel took over an existing weaving school in Shottery, called the 'Thatched House', near Stratford-upon-Avon, and began to devote herself to weaving. She remained there during the first years of the war, while Philip, under the influence of a Serbian writer and mystic, Dmitri Mitrinovic, whom he met in 1915, resigned his work with the Red Cross in France and went to work on a farm in Ditchling, Sussex; when conscription was introduced, he joined the army, but was imprisoned until a few months before the end of the war for refusing to obey orders. Meanwhile, in 1917, Ethel's sister-in-law, May Partridge, had hanged herself in the 'Thatched House'; Ethel, who discovered the body, felt unable to continue living there and also moved to Ditchling, where she was joined by her widowed brother, Fred, and her mother and sister. After his release by the military authorities at the end of the war, Philip also joined Ethel in Ditchling, where she had built a new weaving workshop, called Gospels after the field on which it was built.

Ditchling already had an established community of craft workers, originally founded by the sculptor and typographer Eric Gill, who had moved there in 1907. The community also included the calligrapher Edward Johnston, who

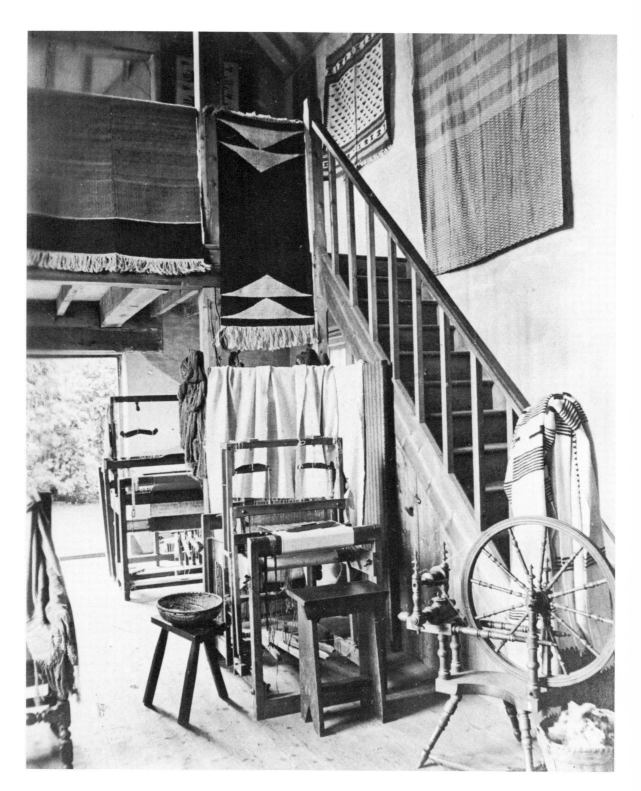

became a respected friend, and Douglas Pepler, who had established a small press in the village on which he had printed Ethel's book, *Vegetable Dyes*, in 1916. They admired each other's work and shared a common concern for the role of the craft worker in society. Gill, like Coomaraswamy, believed in the importance of a spiritual content in art, although, in his case, it was to be an expression of Catholicism. Another idea which they shared was the belief that the traditions of craft work allowed the maker access to past expressions of humanity. Through their talk, the way they lived, ate, dressed and furnished their homes and in their attitudes to human relationships these craft workers shared a feeling of solidarity in voicing their opposition to an age of commerce and a society which could wage war in defence of its material wealth.

During the 1920s Ethel worked hard to establish Gospels' success, perfecting her own skills and increasing the workshop's output. She was not a particularly innovative designer, but relied principally on her fine colour sense and the appeal of bright vegetable dyes at a time when it was rare to find natural-dyed fabrics. Like Bernard Leach, she considered the teaching of her craft vitally important and she took on students who stayed with her for at least eighteen months, paying about a pound a week, learning every stage in the weaving process. All the work which the Gospels workshop produced went out under Ethel's name, yet it was often her students who wove the cloth, deciding upon their own patterning and the texture of the weave.

Ethel once said that, to make the perfect scarf, one must begin with the sheep; her students had to master every skill required to make such a perfect scarf. Ethel initially used local South Down wool, but in 1924 the Wembley Empire Exhibition introduced new sources of raw materials, such as Nigerian cotton and Indian silk. The rough South Down wool was carded and spun on a wheel in its original greasy state, then washed in soap and rainwater which was collected in an underground tank. It was then ready to be dyed, first by mordanting, which prepares the stuff to receive the dye and fixes the colour, then boiling in dye in baths set over a huge fireplace in the dye-shed next to the weaving room. Having been dried, the wool was then ready for the loom. Ethel advocated vegetable dyes, not merely because she preferred their clear colours, but also because, in the early years, like William Morris, she was opposed to industrial methods. Visitors to Gospels were struck, above all else, by the magnificent hanks of dyed wool hanging from the wooden pillars which supported a gallery running the length of the weaving room. Over the balcony rail Ethel displayed the samples of textiles which she had collected on her travels abroad and finished woven lengths from her own looms. The place glowed with colour – blue indigo, red madder and yellow fustic and weld.

She worked hard also to make the workshops commercially viable. In the early days, she was almost entirely dependent on her own efforts: she sold her work at exhibitions in London and also at the Red Rose Guild exhibitions in Manchester and in 1933 opened a small shop in Brighton, a few miles away. In 1928 she had also been involved in the short-lived New Handworkers Gallery in Percy Street in London, which Philip Mairet ran. The potters Bernard

Leach and Michael Cardew and the furniture maker Romney Green were also involved in establishing the gallery and Pepler printed a series of pamphlets by Mairet, Gill, Leach and Romney Green which outlined their beliefs about the value of craft work which lay behind its products. The venture did not survive, but was nevertheless an important expression of solidarity among independent workers.

In the 1930s Ethel began to examine the role of weaving in a wider context, in terms of both techniques and her craft philosophy. Students who now came to Gospels from Europe introduced more sophisticated weaving techniques and spoke of the type of work being done at the Bauhaus in Germany. She also began to experiment with aniline dyes. Through *The New English Weekly*, an unorthodox periodical of which Philip Mairet became editor in 1934, Ethel came into contact with many writers, economists and social critics, although Philip himself had largely severed his connections with Ditchling. Ethel read widely in these years, making extensive notes and occasionally corresponding with old friends like Ashbee on the works of Marx, Jung, Frank Lloyd Wright, Lazlo Moholy-Nagy and H. G. Wells, among others. She also began to travel widely: she had already visited Yugoslavia and Macedonia (encouraged by Mitrinovic) and now went to Denmark, Sweden, Finland, Germany and Switzerland, studying local textiles and meeting weavers and designers who were able to bring her up-to-date with the more advanced design theories current in Europe. In Helsinki she met the celebrated Finnish architect and designer Alvar Aalto; in Switzerland she visited Heinz Otto Hürlimann and Gunta Stölzl, both of whom had worked in the weaving workshop at the Bauhaus; in Sweden she studied the organisation of the Hemslöjd, the rural craft societies; in Germany she met Margarete Leischner, who had worked at the Bauhaus, and Hilda Jesser, who taught at the Kunstgewerbeschule in Vienna and who had been associated with the Wiener Werkstätte.

Ethel was especially thrilled by what she learnt from Gunta Stölzl about the Bauhaus and it proved a turning-point in her examination of the theory and practice of weaving. On her return, in 1939, she published her ideas in *Hand-Weaving Today: Traditions and Changes*. She looked back at the Arts and Crafts Movement as a false step which had disastrously separated craft from industry and she welcomed the new architecture of Walter Gropius and Le Corbusier. She especially praised the training promoted by the Bauhaus, which stressed the designer's responsibility to the whole environment within which his or her work had its place:

> Hand-weaving has been in danger of developing on the wrong lines. It has set itself up on a pedestal as 'art', instead of recognising its immense and interesting responsibilities to present needs and to the machine . . . It is dependent on architecture and clothing; it must work in close collaboration with both. It cannot ever be an art by itself . . . for always it must be part of a building (curtains, rugs, hangings, etc.) or associated with the necessities of life (clothes, table-cloths, towels).[5]

In this, she was the first craft worker in England to abandon her opposition to

Woven cushion cover from Ethel Mairet's workshop, *c.* 1935

the machine and to accept that the aesthetic sense developed in a small workshop, the intuitive response to colour and texture, could survive and be of benefit in an industrial context and so reach a much wider audience. Where William Morris had attempted to subvert the art of his century by returning to a more beautiful past, Ethel had the wisdom and the courage to discard the past entirely when designing for the present.

Unfortunately it proved impossible to put many of her ideas into practice. She did begin to make contact with textile manufacturers, especially in Manchester, where Margaret Pilkington was able to introduce her to Sir Thomas Barlow, one of the most progressive textile manufacturers who later became Chairman of the Council of Industrial Design, and to put forward her case for the involvement of hand-loom weavers in industrial production. At Gospels she encouraged her students to experiment with different weaves and to think in terms of producing prototypes which could be used in industry. But her determination to start a Ditchling School of Weaving based on the example of the Bauhaus was made impossible by the coming of war, when the workshops had to be scaled down.

Nevertheless, perhaps Ethel Mairet's single most important contribution to the design of Gospels cloth in those years was its freedom from historical models, a lesson learnt from her travels and study of peasant textiles as much as from the Bauhaus. In her book she wrote:

> The museums, although immensely useful, have done much harm. They have presented to the young worker extreme textile beauty impossible of his attainment, with the result that the surface has been skimmed, while the background, making such work possible, is unknown ... The textile workers of today have to solve the problems of present needs. It is difficult to face boldly a present decision if our minds are overstocked with dead men's decisions on past problems.[6]

Ethel's enormous contribution to the practice of design had been recognised in 1938 when the Royal Society of Arts appointed her as the first woman RDI (Royal Designer for Industry). She had been largely responsible for the initial rediscovery of the disappearing art of vegetable dyeing and her book *Vegetable Dyes* was to become a vital reference book for those who followed her. Her perception of the importance of her role as teacher established Gospels as a centre for the development of her craft, opening up the fields of spinning and hand-loom weaving far more swiftly than if she had concentrated primarily on her own work. Her generosity, energy and clearsighted vision of the role that hand-weaving could play in industry inspired her students, several of whom (unlike Bernard Leach's pupils, who were never encouraged to apply their skills outside the studio), most notably Marianne Straub, went on to work for industry, bringing to mechanical weaving a technical familiarity and a 'feel' for colour and texture that had been lost during the industrial revolution.

Ethel Mairet's aim of continuing the work that the Bauhaus had begun in forging closer links between industrial manufacture and the experience of the craft worker could have had a vital effect on the British textile trade had the war not intervened, for, in the 1950s, art colleges endorsed her approach wholeheartedly. But, by the end of the war, Ethel was in her early seventies and even her prodigious energy was insufficient to the task of starting her Ditchling School of Weaving, although she continued to take students at Gospels. Nevertheless, she was successful in persuading individual manufacturers to employ designers who, from their experience of hand-loom weaving, could introduce a greater variety of weaving techniques to the machine, and the kind of textured woven curtains or upholstery fabrics which we take for granted today are, to a very large extent, the result of her pioneering work.

Ironically, and contrary to the traditional image of women's textile arts – the lady with her embroidery frame – not all branches could be pursued without danger or hard physical exertion. Fabric printing, for example, involved both hard physical labour and perilous experiments. Phyllis Barron, the remarkable woman who rediscovered the lost art of discharge printing, recalled with hilarity her early, disastrous experiments with overflowing vats of boiling urine and barrels of indigo which set fire to her workshop as she attempted to

master the art of discharge printing. Her eventual success was due entirely to her courage and perseverance. Barron, who was generally known by her surname and once described by a friend as 'a great oak', was an independent and forceful woman with a robust sense of humour from a wealthy, conventional Buckinghamshire family. Like her friend Ethel Mairet, she undertook her pioneering work quite untaught and independently of any college or workshop. She first became interested in block printing when, on holiday in France when she was fifteen, a friend bought some old French blocks as a curio. In 1911, when she was twenty-one, she went to the Slade and, despite the lack of practical training there, began seriously to research the processes involved. She visited the Patent Office to discover the ingredients of the necessary dyes and unearthed eighteenth- and nineteenth-century books which described the production of hand-block-printed textiles in India. A lecturer at the Victoria and Albert Museum, G. P. Baker, who had seen calico printing in India and who owned a printing firm, advised her on how to improvise with home-made equipment and she began, entirely on her own initiative, to try to print, using nitric acid to discharge the colour on indigo-dyed cotton, leaving a white pattern on the blue ground.

Barron's amateur but enthusiastic experiments in a friend's studio, using old French and Russian blocks, were messy and frequently hopeless, but she persisted and gradually began to produce passable printed textiles. One of her earliest blocks – called 'Clifford' after the hairdresser's where she thought out the design – was a large, jagged, geometric pattern, based on the grain of the wood, very different from the flowery designs of the antique blocks. Although far from successful, it earned her the admiration of Slade friends who were now working at Roger Fry's Omega Workshops, applying Post-Impressionist designs to furniture, fabrics and a host of other objects. Fry invited her to join the Omega, but although she exhibited there she preferred to work independently, pursuing her own researches. At the end of the First World War, during which Barron gave up her researches and went to work in a Belgian hospital and then to paint luminous aircraft dials in a London workshop, she came across Ethel Mairet's book, *Vegetable Dyes*, and wrote to her at Ditchling, enclosing some samples of her work.

Ethel, who had seen calicoes in India, was impressed and replied enthusiastically, suggesting a meeting. Ethel helped Barron to begin selling her work and invited her to stay at Gospels for a couple of weeks to perfect her dyeing techniques. The two women became friends and from then on frequently exhibited together. It was as a result of her first exhibition with Ethel at the Brooke Street Gallery in London that Barron received her first major commission. Detmar Blow asked her to furnish all the fabrics for the Duke of Westminster's luxurious forty-cabin yacht, *The Flying Cloud*. It was an enormous order, involving far more work than Barron had yet undertaken, but, undaunted, she agreed to produce the work within three weeks and, when the completion of the yacht was delayed by a boilermakers' strike, was able to meet the entire order. Further commissions followed both for the

Duke's houses in London and France and for other private clients. Barron was creating new designs every fortnight and for some of the patterns she had to use linoleum, rather than wood blocks, cutting fresh blocks every night as the nitric acid wore away the originals in two days of printing.

Phyllis Barron and Dorothy Larcher at a French market in the 1930s

In 1923 Barron was introduced by the embroideress Eve Simmonds to Dorothy Larcher, a friend who was also interested in Indian dyeing and printing techniques. After studying at Hornsey School of Art – she was a contemporary of Philip Mairet and shared a flat with Alice Richardson – Dorothy Larcher had accompanied Lady Herringham to India in 1914 to record the frescoes in the Ajanta Caves. Unable to find transport home during the First World War, she remained in Calcutta, living with an Indian family, and teaching English. It was during these years that she learned about Indian dyeing and printing techniques. Barron and Larcher were ideally suited to work together and their meeting led to a lifelong partnership. They moved to another workshop in Hampstead and took on a young girl to help with the printing, as well as employing two upholsterers and a needlewoman, who also made up curtains and dresses for other customers. Barron, determined and energetic, organised the business and administration of the workshop while the gentler, more patient and chatty Dorothy marshalled the girls who worked for them; Barron controlled all the processes of dyeing and fixing, while Dorothy supervised the final printing and finishing.

Indigo resist-printed cotton by Phyllis Barron and Dorothy Larcher, 1930s

Their personalities are well expressed by their designs. Both designed their own wood blocks; Dorothy's first design was called 'Old Flower' and her patterns tended to be more naturalistic and chintz-like, more homely and comfortable than Barron's bolder designs. Barron had a greater mastery of abstract and geometric pattern and she evolved a smart modern idiom which was full of vitality – as Roger Fry wrote in *Vogue* in 1926, 'some vital quality that has not been pressed and stamped and tortured'. Her designs grew out of her craft in an immediate and uninhibited way. Some of them, such as 'Lines', were plain and conservative, while others, such as 'Basket', were large and flouncy. The size of the repeat depended upon whether the fabric was to be used for dresses or furnishings, for they printed on a wide range of textiles, from linen, hand-woven Indian cotton, Chinese silk and French Rodier woollens to chiffon, crêpe de chine, organdie and velvet.

Barron used two dyeing techniques. For blue indigo, the entire length of cotton was dyed and the pattern discharged by printing with nitric acid. For other colours, the dye was printed directly on to the length, although the silks

Block-printed linen designed by Barron and Larcher

were often dyed first. Bright vegetable dyes, such as red madder, orange-brown cutch and yellow quercitron, were used as well as more subdued, sophisticated colours of brown rust or black iron dyes. Chrome colours then had to be steamed to be made fast. The block which carried the dye, made of pear for a fine print, or teak or lino for bolder designs, was placed in position and struck sharply with a maul, or hammer, before being replaced to repeat the pattern. Sometimes for lightweight fabrics one pattern was printed on top of another either to give a more complex design or to add an additional colour. Barron and Larcher also introduced a characteristic mottled effect by adding a thickening gum to the dye and carefully controlling the printing, which was done with unfelted lino blocks. They achieved a consistently high standard of work and a large output – making clothes, scarves, table linen, lampshades, curtains and upholstery to order as well as uncut lengths – despite the fact that much of the equipment was home-made, such as the steamer, a converted dustbin.

In 1925 Barron and Larcher were joined for a year by Enid Marx, a young

student from the Royal College of Art, introduced to them by a friend, the potter Norah Braden. Enid Marx later described the processes and work involved in dyeing and printing:

> There were four of us printing in the workshop, not all at the same time as there was much else to be done: dye mixing, dyeing and all the preparations for this, such as mordanting and even in some instances collecting the dye-stuffs, walnut husks for example; steaming and washing, an onerous job before the days of the washing machine, when everything had to be washed and rinsed a number of times by hand, much of it hosed down out of doors. Then there was ironing galore. Indeed, sometimes it seemed as if more time was taken up with the preparations than in the designing and printing.[7]

Enid Marx made good use of the techniques which she learnt during her year with Barron and Larcher and applied them to create a rich, crisp and stylish idiom of her own. In 1927 she moved to her own studio over a cowshed in Hampstead and began printing independently, selling her work through the Little Gallery, which opened the following year. Unlike Barron, Enid Marx was first and foremost a designer and her textiles show a far more controlled sense of pattern; while less exuberant they are also more finished and in some ways more satisfying.

With the opening of the Little Gallery Barron and Larcher were assured the vital regular publicity of an annual exhibition and a permanent base where orders could be taken and delivered. Their work never failed to attract favourable reviews in the press. While they never allied themselves to the kind of beliefs held by Eric Gill or Bernard Leach, they nevertheless appreciated the freedom of lifestyle which their work allowed them and, with the business on a more secure financial basis, they felt able to leave their cramped London quarters in 1930 for a country house at Painswick in Gloucestershire where Barron exulted in 'a lovely big indigo vat' built into the workshop floor. Here they expanded their operations to meet their increasing orders and could lead a more rounded life. Barron loved good wine and food and they entertained their friends; she was also a keen gardener. In the summers they went to Barron's sister's house in France. Dorothy was more retiring, but Barron, an eccentric, generous and 'larger than life' character, was excellent company.

However, the Second World War brought an end to their work as textile printers, as raw materials disappeared and demand gradually declined. Both the Little Gallery and Dunbar Hay closed with the outbreak of war and never re-opened. Barron turned instead to local government and education, while Dorothy spent her time painting flower studies. She died in 1952, Barron in 1964.

Enid Marx remained a freelance designer, doing book jackets, patterned papers, stamps, posters for London Transport, laminates and textiles. With Margaret Lambert she also published two books on English popular and folk art, a design rhetoric which enjoyed a vogue in the years immediately following the Second World War and which she appreciates for its 'forth-

rightness, gaiety, delight in bright colours and sense of well-balanced design'.[8]

Katharine Pleydell Bouverie, or 'Beano' as she is known to her friends, was, like Ethel Mairet and Phyllis Barron, a pioneer in her craft. She chose to specialise in one particular aspect of ceramics – wood ash glazes – and her results have gained her the respect and admiration of her contemporary studio potters.

Born into an aristocratic family in Berkshire in 1895, at the age of nineteen she went to work in the canteens of the French Red Cross after her brother, Edward, was killed in the trenches in the First World War. In the early 1920s she went to London to study history, but then became interested in pottery after Margery Fry showed her some of the pieces her brother, Roger, had made for the Omega Workshops. She began to take classes at the Central School and soon became a full-time student there under Dora Billington. In 1923 she

> walked by chance into Paterson's small gallery in Bond Street and found the walls lined, and myself surrounded, by the sort of pots I had never seen before. Quiet coloured, gentle surfaced pots with a pleasant sense of peace about them. There was also Bernard, talking earnestly about stoneware and Japan.[9]

Bernard Leach had returned from Japan three years earlier to found his pottery in St Ives, Cornwall, helped by the young Japanese potter, Shoji Hamada. Katharine Pleydell Bouverie asked him if she could become his pupil and he agreed to let her come to St Ives when she had completed her course at the Central School.

In January 1924 Katharine Pleydell Bouverie moved to Cornwall. Hamada had recently returned to Japan, but another young potter, Michael Cardew, had joined Leach a few months earlier. He recalls 'Beano's' arrival:

> I had been expecting someone fragile and over-civilised, very delicate, very 'Dresden China'. But to my relief I found myself talking to a tall, strong girl, not much older than me, who was built like a peasant, with a peasant's large and practical hands. Not that the delicacy and the civilisation were absent; you were aware of it in the twinkling of her eyes, set deep and almost lost in her cheeks; and above all in the curve of her mouth, which was sensitive and finely drawn, in contrast with the robust scale on which she was built.[10]

She took a small house in the village which she shared with her friend, Ada, or 'Peter', Mason. Every day she went to the pottery where she did odd jobs and watched Leach throwing and decorating his pots. In the evenings a Japanese potter, Tsurunoske Matsubayashi, gave technical lectures in his broken English. Also in 1924 her first novel was published: called *January*, it is a strikingly poignant story of a young girl's forbidden love for her paternal uncle which ends happily when she discovers that she is not her father's child. The novel draws both on her childhood home and on her wartime experiences, but

also, sensitively, on her feeling of belonging to a more practical world than that of her family.

In March 1925 Katharine Pleydell Bouverie and Ada Mason moved to the 'Mill Cottage' in the grounds of 'Coleshill', Katharine's family home, where her mother and elder sister were living. Matsubayashi designed a wood-fired kiln and she began her experiments with wood and vegetable ash glazes. In many ways, it was 'Coleshill' that made her researches possible, for the estate supplied a wide variety of timber and vegetation and she was able to ask the gardener and woodmen to keep all the cuttings from trees and hedges. The kiln required about two tons of wood for a single firing and an enormous bonfire of wood had to be burnt to provide a bucketful of ash, which was washed and sieved before being added to feldspar and Dorset ball clay to make the glaze. A range of colours can be derived from different types of ash, although the results are often unpredictable: larch, laburnum, ash, spruce, maple, lime, elder and horse-chestnut generally give matt glazes, varying from creamish grey to greyish blue; walnut, cedar, apple and yew give matt white, oatmeal or grey glazes; elm, holly, laurustinus, hawthorn, box, oak, beech and rose give pale blue, dove grey or smoky-green colours; scotch pine, peat or blackcurrant give a black 'tenmoku', grey or olive tones; grass, reeds, nettles or lavender a white or pale grey colour and a mixture of different ashes gives a distinctive thunder blue. Almost every pot made by Katharine Pleydell Bouverie bears a number and today, when one asks her about a particular glaze, she goes to a cabinet in her Wiltshire manor house and draws out a note-book; against every number is recorded the glaze recipe used for each pot and the temperature at which the pot was fired. She makes no secret of her work and is delighted to pass on her knowledge.

Katharine Pleydell Bouverie has always made functional pots and seldom decorated her ware, claiming that she never learnt to handle a brush. She aims at the 'harmonious blending of shape, colour and surface'[11] and likes 'quiet colours . . . because they are better for flowers'. A pot 'must have spring and balance of form'.[12] 'I imagine,' she wrote,

> that the great thing about potting – for those of us who work on the wheel – is that one works with things that are alive. The clay comes to life as the pot grows: the fire – even in its most malleable form of electricity or gas – is always alive. So the element of chance, in a sense the element of adventure, is always present, apart from one's own immediate effort.[13]

In 1928, a year after Ada Mason had emigrated to America, Katharine Pleydell Bouverie was joined by Norah Braden, who had studied art at the Central School and the Royal College of Art and in September 1925 had gone to St Ives where, like Katharine Pleydell Bouverie, she did chores and learnt by watching Leach at work. Leach considered her in many ways his best pupil, Katharine Pleydell Bouverie maintains that she 'has more sense than I have' and Muriel Rose described her as 'an artist of sensitive ability, a fine draughtsman and possessed of incisive powers of criticism'.[14] She had initially

Bottle by Katharine Pleydell Bouverie, thrown, glazed and fired at 'Coleshill', 1930s

Stoneware jar with lid made by Norah Braden for Bendicks, early 1930s

gone to 'Coleshill' to make kiln furniture for her own kiln but, also interested in wood ash glazes, she worked there on and off for eight years, systematically exploring the effects gained from different types of ash. Norah Braden's output was smaller than that of her friend. She did not make tableware and, unlike Katharine Pleydell Bouverie, tended to decorate her pots with firm, sure brushwork. In September 1936 she left 'Coleshill' and went to teach at Brighton Art School; except for the war years she continued to teach part-time at Brighton, Chichester and Camberwell until she retired in 1967. Apart from occasional holidays with Katharine Pleydell Bouverie, she ceased potting.

In 1940 Katharine Pleydell Bouverie stopped potting, as she could no longer fire her kiln during the black-out, and went to nurse refugees. Her mother had died in 1936 and in 1946 'Coleshill' was sold and she moved to 'Kilmington Manor' in Wiltshire where, with Norah Braden's help, she built an oil-fired kiln in the ancient malt-house which adjoins the house. 'The kiln and I persisted,' she wrote, 'in a slightly uneasy fellowship till thirty-hour firings became too much for a septuagenarian and I opted for electricity, lower

temperatures and an easy life.'[15] She sums up the difference in kilns by saying, 'if you've got a wood kiln you're sort of partners . . . and if you've got an electric kiln you're more or less the boss, aren't you?'[16] Unlike Bernard Leach, she has never become involved in the polemics of the 'art versus craft' debate which has surrounded studio ceramics and she is rather scathing of the flourishing market for twentieth-century pots: 'Well I'm a simple potter,' she says, 'I like a pot to be a pot, a vessel with a hole in it, made for some purpose.'[17] While she admits that, due to her family's wealth, she could always afford to ignore Leach's view of pottery as art and to sell her work at functional prices, both she and Norah Braden share a modesty about their achievements which complements the quiet integrity of their work.

While inheriting and expanding the opportunities created for women by the Arts and Crafts Movement, women such as Ethel Mairet, Phyllis Barron and Katharine Pleydell Bouverie through their work destroyed the myth of the Blessed Damozel. Not only did their chosen crafts require strength, physical resilience and courage, but each researched, experimented and perfected her craft singlemindedly and independently. And Ethel Mairet was the first craft worker to break the sterile dichotomy of craft versus machine established by Ruskin and Morris. The craft movement of the 1920s brought women and their work out of the drawing-room and into the workshop.

It also laid class barriers aside in favour of a mutual respect founded on individual skill and knowledge. It had been symptomatic of the unspoken class barriers hitherto plaguing crafts that when the Women's Institute movement was established in Britain during the First World War in order to utilise women's craft skills, the most highly skilled women, who were often the humbler women in a community, had felt uneasy at the one-member-one-vote system, which appeared to challenge the traditional authority of the vicar's wife or the lady of the manor. However, those who made a living from craft work in the 1920s and who joined the network centred on the Red Rose Guild found that the values held by the pioneers of the group – the belief in the Simple Life – made such class deference an irrelevancy. As Margery Kendon, a weaver who had trained at Gospels, found when she visited Irish weavers deep in the Irish countryside: 'If knowing how to use a spinning wheel, or wanting to know how, gives one the right to walk into these cottages and talk to them about it, then that is the best of spinning.'[18] These values were to re-appear – their origins largely unacknowledged – in the hippie, back-to-the-land movements of the 1960s, bringing in their wake a concern for ecology and conservation. In some ways, Coomaraswamy's theories or Philip Mairet's involvement with Dmitri Mitrinovic – ideas and values which were shared by many of their friends and co-workers – foreshadowed the religious and mystical cults of the 1960s. The aims of these craftsmen and women and the disillusion with society that prompted the protests of the 1960s were motivated by similar issues and both movements offered a simplistic critique of a materialistic way of life and a re-affirmation of human values which included a reconsideration of the position and role of women.

10. Art and Industry

Woman's place – particularly middle-class woman's place – has traditionally been held to be in the home. A part of that notion is the belief that the light, indefinable touch of a woman's hand can transform even the barest room into a home, giving comfort, warmth and serenity. Yet, until this century, women played little part in the actual furnishing of a house. Their re-arrangement, or the addition of a bowl of flowers, a cushion, or a shaded lamp, might add the finishing grace, but it was men who commissioned architects, bought paintings and patronised cabinet-makers. Only aristocratic women, in previous centuries, could claim the prerogative of exercising their own taste. As a middle class emerged in the nineteenth century, the paterfamilias arranged the household furnishings not only because of their cost, but also because the table at which he entertained his business associates spoke volumes about his financial standing. It was the Aesthetic Movement that first introduced the idea that a woman's touch should – indeed, must – be tasteful, an idea that was liberalised by Elsie de Wolfe and Syrie Maugham's belief that an interior could be a vital means of self-expression for women, although only for those who could afford it.

The First World War and its aftermath brought a new awareness among the middle classes of the conditions in which their servants and women poorer than themselves lived. The entry of women into Parliament created an idealism and a sense of comradeship between women of all classes. Conscription had brought to light the poor state of health of the majority of Britain's poor, and attention was now focused on the unpaid work undertaken by women in the home and on the conditions in which they brought up their children and cared for the elderly. For the first time, writers on the home went into the bathroom and the kitchen. 'I wonder if it ever occurs to architects,' wrote Leonora Eyles in 1922, 'that they put labour-saving devices . . . into the wealthy houses, where there is a staff of servants, not one of whom does half as much work as the woman in a five-roomed house in Peckham?'[1]

However, developments in household technology in the years after the First World War did begin to make inroads into middle-class women's and

servants' work in the home. While tiled kitchens, enamelled stoves and indoor plumbing remained undreamed-of luxuries for the woman in Peckham tied to the mangle, the chamber pot and the coal fire, such amenities had a revolutionary influence within the homes of middle-class women. The hauling of coal, the copper for heating water and the annual upheaval of spring cleaning became things of the past and the clothes-horse and the flat iron assumed less burdensome proportions. For the mother of a family, the changes in the technology of cooking, washing and heating meant that a staff of live-in servants could be reduced to one part-time maid. The electrical servant now replaced the human and, as services such as gas, electricity and water were re-organised under the aegis of national corporations, housewives were encouraged to make use of vacuum cleaners, electric toasters and coffee percolators, gas fires, electric irons and washing machines in addition to electric light. Freed from the need to employ servants to undertake the exhaustingly hard physical labour demanded by the nineteenth-century house, the housewife of the 1920s could begin to care for her own home, including such activities as making curtains. For the first time, the decisions about the arrangement of the home came under her jurisdiction.

The modern woman wanted furniture which she could move regularly herself as she cleaned the house with her new Hoover. Curtains and rugs could be in lighter colours and even less durable materials, as the days of beating out the dust had passed. Fine china and glass which could be left to servants to wash gave way to practical, everyday tableware. Household furnishings were cheaper and no longer designed to last a lifetime: prices for furnishings fell and more shops opened to cater for the expanded market.

As the consumer industry for household goods got under way, the manu- only they knew firsthand to exist. They did this swiftly and effectively. began to offer specialised products for use with different machines, and to create new needs and new occupations for women to fulfil within the home. While introducing their products as labour-saving, or merely as achieving results superior to older methods, the manufacturers' real aim was to increase the size of this new consumer market as fast as possible. Parallel to this ran developments in the products the washing powders were designed to clean, such as fabrics (first pioneered by the Bauhaus weaving workshop) using synthetic fibres which could be washed, which were light and easy to handle, or which were less susceptible to dust.

By 1930 the modern middle-class home had become a reality and comfort had become paramount. *The Studio* magazine had this to say of 'The Modern Home and Its Decoration':

> The prime consideration is comfort. We seek a standard of luxury which is perhaps permissible in these strenuous days when people's energies are exhausted by the day's programme of work or play. Instead of sitting in dignified but disconsolate fashion on chairs designed apparently for the mortification of the flesh we sprawl at full length at so low an elevation that it has become necessary to introduce special low tables so that we can reach our cocktails or cigarettes without any serious physical exertion.

> Everything is arranged as near at hand as possible so that when we have once subsided into the depths of our chairs we are not called upon for further effort. Here may be noted a significant change in our social habits affecting the character of our furnishings.

All that remained was for the designers to refine and improve its services and furnishings.

By 1930 domestic design was at the forefront of the debate about the role of the artist in an age of industrial design. Herbert Read asked in his influential book *Art and Industry*,

> If we decide that the produce of the machine can be a work of art, then what is to become of the artist who is displaced by the machine? Has he any function in a machine-age society, or must he reconcile himself to a purely dilettante role – must he become, as most contemporary artists have become, merely a social entertainer?[2]

While the fine arts moved increasingly in the directions of abstraction and such movements as Surrealism, domestic design benefited from the decision of many artists to ally themselves to the machine and to provide designs for textiles and china, or to work in some area of interior decoration. Francis Bacon designed a Constructivist room for himself, with white walls, low glass tables and wall mirrors as a setting for neutral 'thought form' rugs. Rex Whistler, John Banting, Mary Adshead, Duncan Grant and Vanessa Bell executed murals. Ben Nicholson, Barbara Hepworth, Graham Sutherland, Frank Dobson, Edward Bawden and Paul Nash were among those who designed textiles for progressive firms such as Edinburgh Weavers, who tended towards the abstract, or Allan Walton, who was more frankly decorative. Even the Government, through the Board of Trade, was concerned to foster the involvement of artists in industry.

As a result the language of interior decoration became ever more refined. Curtis Moffat, the American designer, offered this advice in 1930:

> The furniture of the modern interior tends towards the establishment of a definite rhythm, rather than to following a series of minor, and possibly conflicting, notes . . . Broad spacing and the elimination of trivial detail are of valuable assistance to this end.[3]

The fashionable woman eliminated trivial detail at all costs; there were to be no mouldings or cornices and instead flush veneered doors, plain walls, square armchairs and sensible pelmets were contrasted with the only allowable pattern in curtains or rugs. *Vogue*, in 1929, included a visit to a decorator's shop in the day of the 'woman of fashion', and *Woman and Beauty* declared that, 'The china that is making the tea tray in a smart house as much a matter of fashion as the hostess's gown can be seen in the 1931 shapes of utter modernity.' The key-notes of the new interior decoration were air, light, cleanliness and utility – qualities which were impossible to achieve before the revolution in household technology.

It was largely women who pioneered the more practical approach to home

furnishings, designing easy-to-maintain interiors and attractive, washable and dust-resistant textiles and smart but robust tablewares for the easy-care home, a fact obscured by the still continuing accepted practice amongst the majority of commercial firms, especially textile firms, to market their products anonymously. Women's leadership was only logical: as the greater range of products increased the number of tasks which a woman could accomplish alone at home, housework became a skill known only to the women who practised it. It was therefore up to women to solve the design problems which only they knew first hand to exist. They did this swiftly and effectively, enabled to do so by the late nineteenth-century legacy of a network of art schools, training courses and women's craft organisations and shops. At the same time they revolutionised ideas about the style of home furnishings and created an idiom which is still in vogue today: women such as Betty Joel, Susie Cooper, Marion Dorn and Marianne Straub, in their collaboration with architects and with industry, added a new dimension to the woman's touch about the house.

With so many conflicting theories and images of design – drawn from Hollywood films, from the Bauhaus in Germany or Le Corbusier in France, and from the craft revival in England – fashions in furnishings moved rapidly. Books and magazines offering advice on furnishings proliferated and heated debates took place, especially in the pages of the *Architectural Review*, between those who advocated a strictly modernistic rejection of 'decoration sickly with charm' and those who, despite being labelled 'trivial' and 'obsolete', clung to pattern and cosiness in their rooms.

Perhaps the most avant-garde designs in London came from such specialist galleries as that of Curtis Moffat, who offered dining-tables made of thick pavement glass resting on legs plated with aluminium, or writing tables with tops of black rubber. Those women who wanted neither such pretentions to modernity nor the ornate luxury of a Syrie Maugham and who desired a well-made chic that wouldn't date could shop at Betty Joel Ltd in Knightsbridge. The typical Joel interior was cool, restful and casual, with plain floors and abstract rugs, smooth curved furniture in exotic woods, a few distinctive accessories, such as unadorned circular mirrors, and sometimes veneered walls, curved to meet the floor and ceiling. It had evolved from a quite personal vision of the modern interior, with the stress on easy-to-maintain furnishings for a woman without servants who did not wish to spend all her time at home.

Betty Joel was born in 1896 in China, where her father, Sir James Stewart Lockhart, was an administrator. She was sent to school in England, but then returned to China where she met her wealthy South African husband, David Joel, who was stationed in Ceylon with the British Navy. At the end of the First World War they returned to live in England and set up their firm at South Hayling near Portsmouth, with a showroom in Sloane Street in London. They employed yacht fitters to make simple, functional teak and oak furniture to Betty's designs and, although she worked closely with her craftsmen, her

'Mary Manners'
showroom at 25
Bruton Street,
decorated by Betty
Joel, 1930

early designs betray the fact that she was self-taught. At this time she also designed a number of wooden bungalows built near their works at South Hayling. By the late 1920s she had established a distinctive style, making use of curved edges which, she said, echoed 'the Feminine form', abolishing all unnecessary mouldings and projections and introducing an innovative recessed drawer handle. She used a range of luxurious, contrasting woods, exploiting veneer for decorative purposes.

About this time Betty Joel moved her London showrooms to a large house, 25 Knightsbridge, where she built room-sets in a dozen of the rooms and held exhibitions in a picture gallery at the back. For her first show she chose rugs by the French artist, da Silva Bruhns, with abstract or geometric designs, often in only two colours, and also exhibited drawings by Henri Matisse and Raoul Dufy and paintings by her favourite artist, Marie Laurençin. Betty also designed her own abstract and subtly coloured rugs, which she had woven for her in China. The gallery sold fabrics by Rodier and Edinburgh Weavers, light fittings by Lalique, and powder compacts and cigarette cases by French designers. The firm won many contracts to decorate libraries, board rooms,

shops and hotels, including those in the Savoy Group. Through her husband's naval acquaintances Betty Joel also won private commissions from Lord Mountbatten, the Duchess of York and Winston Churchill.

But Betty Joel's true ideal was to design for the working woman. She believed in furniture which, while made to the highest standards of craftsmanship, was nevertheless comfortable, dust-free and easy to maintain; even at the height of her business success, she kept only one maid in her small Mayfair flat. While her designs were praised by women's magazines of the period, she was seldom flattered by the design press and her work is remembered by critics as rather low-brow, even kitsch, a view that is hardly justified, except perhaps by her approach to advertising: she horrified Rolls Royce by painting one of their cars bright yellow and converting it into a delivery van. In the mid-1930s Betty Joel suffered several unwelcome visits from Oswald Mosley's supporters who believed her, wrongly, to be Jewish and it is said that, in retaliation, she promptly hired several Jewish people to work in the gallery. She retired from business in 1937 and she and her husband were later divorced; she resumed her maiden name and moved to Scotland while David

Sycamore bedroom suite designed by Betty Joel, 1929

Marion Dorn, *c.* 1930

Joel continued to manufacture furniture after the war.

Although Betty Joel now dismisses her contribution to design, she did much to popularise the aims of the European modernists and it was her style of furniture which was copied more cheaply by other manufacturers. In Britain she was unique in realising that, as women took up careers, they required homes which were simple and uncluttered and which, above all, banished unnecessary and time-consuming housework. Her largely classless style of furniture embodied a view of the home as primarily practical, a place where one could relax and cast off the bustle of the working day.

The area in which the British householder had the greatest choice was that of textiles, which were to play an increasingly important role in interior decoration. The years after the First World War saw an influx of stylised and geometric patterns – a mélange of contemporary French design and the brighter colours of the Ballets Russes. The career of one of the most celebrated textile designers of the inter-war period, Marion Dorn, spans the changes which took place during these two decades.

Born in San Francisco in 1899, Marion Dorn graduated from Stamford University in 1916 with a degree in education (graphic art). In Paris in 1923 she fell in love with the artist Edward McKnight Kauffer, whom she had first met in New York two years earlier. He left his wife and young daughter and moved with Marion to London, where he had already established a name for himself as a designer of advertising posters. T. S. Eliot described McKnight Kauffer as 'an exceptionally loveable man'; he was then in his early thirties, handsome, romantic, sensitive and generous. Marion was a beautiful and talented young woman and, with his help, was able to establish herself as a designer in London; as one friend commented, Marion could 'get away with murder' on account of her beauty and her relationship with McKnight Kauffer. In the early 1920s she made batiks for curtains and hangings – large, semi-abstract patterns incorporating birds, horses or mermaids, which must have totally dominated the rooms they were made for – which were sold by shops such as Modern Textiles.

Around 1927 McKnight Kauffer began to adopt the more abstract idioms of modernism and the following year he and Marion Dorn began to collaborate on rug designs for Wilton Royal. French designers, such as da Silva Bruhns, or the British expatriates Eileen Gray and Evelyn Wyld, had pioneered the design of abstract patterned, borderless rugs, but McKnight Kauffer and Marion Dorn were the first to establish the modernist rug as an indispensable item in the modern British home. Where McKnight Kauffer's rugs were essentially painterly, using blocks of pure colour, Marion's designs showed a greater appreciation of the medium, using cut pile to obtain three-dimensional effects which highlighted and refined basically simple motifs and almost calligraphic sweeps of line. Many of her rugs were in natural colours of cream, oatmeal and dark brown, in keeping with the neutral colours in fashion for walls and upholstery; she had about five hundred specially dyed shades at her disposal, including 'six different tones of white and cream, three blacks

Rug designed by Marion Dorn for Wilton Royal, *c*. 1935

and literally dozens of beiges, browns and greys'.[4] In the 1930s the modernist rug took the place of the framed painting, while retaining the presence of the artist, within the room: both McKnight Kauffer and Marion Dorn signed their rugs. *The Studio* magazine noted that:

> The easel-picture has already lost something of its predominance in the house. It has too often in the past been a feature of incongruity, and now that a more unified arrangement is being demanded in interior decoration, its pride of place is being seriously imperilled.

Marion Dorn also designed rugs as part of a building's overall design, working with architects such as Oliver Hill, Brian O'Rorke and Wells Coates, all of whom were in the forefront of modern architecture. For example, in 1932 she designed a stunning suite of geometric patterned carpets in shades of black, grey and cream for the entrance halls at Claridges Hotel and in 1935 contributed rugs for Wells Coates's 'Embassy Court' at Brighton and for the passenger liner SS *Orion*, the interiors of which were designed by Brian O'Rorke. In 1933 the *Architectural Review* dubbed her 'Architect of Floors'.

Printed linen designed by Marion Dorn for Donald Bros, 1938

Marion Dorn always worked on a freelance basis, acting as consultant to her various clients, and in 1934 she founded her own firm, Marion Dorn Ltd, in a converted stable in Lancashire Court, a mews off Bond Street. Marion Dorn Ltd was a chic establishment, with whitewashed walls and samples of fabrics hung from chromium rings fixed high on the walls. By this time she had also begun to design fabrics, both printed and woven, for various firms. Alec Hunter at Warner & Sons Ltd taught her much about the techniques of designing for woven fabrics and, again, she brought her feeling for texture to bear on her designs. Her patterns for screen-printed fabrics displayed her earlier training in graphic arts, with clearly defined repeating motifs. In May 1940 Nikolaus Pevsner declared one of her newest prints, 'Delamere', to be 'a new proof of her extraordinary talents and versatility . . . She was leading when highly stylised patterns with one bold motif repeating were the fashion. She is leading now when something more lyrical is desired.'[5] Marion Dorn's fabrics supplied an answer to Herbert Read's question about the role of the artist in a machine-age society, for her designs, especially some of her sculptural-effect pile rugs, reflect an equal understanding of contemporary

artistic ideas and of how they could, with no apparent sign of strain, be adapted to a domestic environment. Far from trivialising her aesthetic sense, Marion Dorn all but created a new art form.

Marion was at the height of her success when Americans were urged to leave England and in July 1940 she and McKnight Kauffer sailed at short notice for New York, where their fortunes began to wane. McKnight Kauffer felt badly about deserting England, where he had enjoyed his greatest acclaim. He found, too, that in America his taste was too European for American advertisers; he was forced to begin his career from scratch. Despite Marion's continued 'sweet devotion', he had a breakdown. Marion managed to obtain some freelance commissions to design wallpapers and fabrics and eventually set up her own studio in New York, working on interior decoration schemes. New York, however, had its own stars of the design world, such as Ruth Reeves, who also did batiks and who had designed wallpapers for the Rockefeller Center, and Marion's work was never again as fêted as it had been in England. In 1954, four years after their marriage, McKnight Kauffer died, a premature death brought on by alcoholism. Marion later abandoned her New York studio and settled in Tangiers, where she died in 1964.

Many other women worked as freelance designers for textile companies: Marion Mahler, who had trained under Hoffmann at the Vienna Kunstgewerbe-schule, designed for Edinburgh Weavers; Minnie McLeish, who had been a student of Herbert MacNair at Liverpool, designed for Foxton's; Vanessa Bell and Margaret Simeon, who taught textile design at the Royal College of Art, designed for Allan Walton. Woven textiles, however, required a greater understanding of the technical requirements of production. Theo Moorman, encouraged by Alec Hunter, established a hand-weaving department at Warner's in 1935, inspired by Scandinavian woven fabrics, and Marianne Straub, the woman who stood out as the most technically innovative designer, worked for a smaller firm, Helios.

Marianne Straub, who is Swiss by birth, had become fascinated by weaving as a small child who had been confined to her bed for four years, during which time a small table loom had been her main distraction. In 1928 she studied weaving at art school under Heinz Otto Hürlimann, a gentle teacher who encouraged independent exploration among his students. He had been a student with Gunta Stölzl at the weaving workshop at the Bauhaus, where Marianne hoped to continue her training. However, the Bauhaus was closed in 1933. As the two technical schools in Switzerland were closed to women, and with the deteriorating political situation in Germany, Marianne applied to the Technical College in Bradford, since she had heard from a family friend about their courses.

> I took no notice of the fact that they addressed their correspondence to Mr Straub, and when I arrived they were surprised to find I was a girl, and although they were not used to having girls in the textile department they saw no objection to accepting me . . . I had preferential treatment, being the one and only girl in the department, and one that enjoyed working with machines.[6]

She spent a year at Bradford and then nine months at Ethel Mairet's workshop where she designed and wove lengths of cloth and helped with all the other activities of the workshop. After three years working in Wales on behalf of the Rural Industries Bureau, designing a wide range of cloths, from blankets to men's ties, for Welsh weaving firms, as a result of which she decided that her real interest lay in designing for domestic requirements, she accepted a job offered by Sir Thomas Barlow to design for his newly formed company Helios, in Bolton.

Helios, like Edinburgh Weavers, was founded to provide furnishing fabrics in tune with modern developments in architecture; unlike Edinburgh Weavers, however, Helios did not rely on established artists to provide designs on a freelance basis and Marianne's designs were sold anonymously. Although Marianne Straub had always wanted to design for firms producing fabrics which would be available to the general market, Helios catered for a fairly exclusive clientele. The firm was small, with limited capital, and Marianne had to establish the scope of its production, forming the basic colour range for the yarns and developing the designs. Her advanced approach to her work,

influenced by the Bauhaus, guaranteed the firm's success. In the late 1920s and the 1930s,

> an original approach to designing was considered all-important. The Bauhaus thinking was based on exploring the essential quality of the material and using the available technology for production. The designing of domestic articles was related to the new ideas in architecture . . . The designer had to be an originator. Although I was never at the Bauhaus, its thinking has been the main influence on my design philosophy.[7]

She loved the discipline of constructing a fabric for the loom and never wanted to work as a freelance designer precisely because she would then have lost control of some aspects of production, especially colour.

Marianne Straub stayed at Helios for thirteen years, until she was made Managing Director, when she resigned and took a job with Warner's in order to continue designing. In 1964 she became the major designer of a range woven by Warner's for Tamesa Fabrics, a firm founded by Isabel Tisdall. Unlike the fabrics produced by Marion Dorn, few people who bought her soft, elegant and unusually textured designs knew the name of the designer. Nevertheless, despite the fact that Helios catered for a small clientele, Marianne Straub has had an enormous influence on the quality of the textures and designs of today's woven fabrics. She is one of the many 'anonymous' women of the 1930s who helped to form present-day tastes.

Marion Dorn and Marianne Straub were not alone in their field. Marian

**Rug designed by
Marian Pepler, 1920s**

Pepler went to the Architectural Association in the early 1920s to learn model making, but became so interested that she stayed and completed the five-year course. It was there that she met her future husband, R. D. Russell, who designed furniture for his brother's firm, Gordon Russell Ltd. He encouraged Marian to design rugs. She learnt the techniques at the London School of Weaving and later wove on her own loom, as well as designing for firms such as Edinburgh Weavers and Tomkinsons. Her designs are simple, in colours of white, grey, red, brown and black: 'I suppose that my chief interest has always been in colour,' she wrote, 'and my aims for my designs were to express the technique of making, and the quality of the medium, rather than to impose a completely unrelated pattern on the woven fabric.'[8] Another rug designer, who used the medium to express aspects of the environment in which they were made, was Jean Milne. She had trained as a sculptor and had studied Macedonian and African Bushongo raffia textiles. In 1937 she was invited to establish a rug-weaving industry in Skye as an alternative for the crofters to tweed. She worked out simple patterns, based on local motifs, such as furrows, ripples and waves, with wide fringes knotted in patterns used in the local fishing nets. With alternate bands of tufting and weaving, using natural yarns in black, grey and white, the rugs were simple, yet sophisticated in their symbolism. She, too, wove herself, in her house in Kensington, and her rugs are among the most striking and unusual of the period.

It was not only in interior design and textiles that women contributed so much to the design of the modern home. Tableware was trailing behind the changes in both social and domestic management: there was little available in the way of cheap, well-designed tableware for the new class of people who no longer gave elaborate dinner parties, nor had the servants to wash up afterwards. Between 1929 and 1931 the Burslem pottery, A. J. Wilkinson Ltd, had expanded enormously following the success of Clarice Cliff's 'Bizarre' range of tableware. Clarice Cliff had worked in the Potteries since leaving school at the age of thirteen. She had attended evening classes at the local art school and in the late 1920s began designing for her employers, A. J. Wilkinson; in 1930 she was appointed Company Art Director. Her designs were outrageously bold and colourful, with distinctive, if impractical, shapes for handles, sugar bowls and tea-pots. Orange, yellow, black and green landscapes, flowers and geometric patterns were all hand-painted to her designs, but, although they sold extremely well, they were not for those who aspired to modernist elegance.

The person who did the most to revolutionise the British breakfast table was another Potteries-born woman, Susie Cooper. Perhaps the British inter-war designer most deserving of fame, she has received remarkably little recognition for her pioneering work. She determined to fill a gap in the market between fine china and cheap transfer-printed wares, aiming at 'professional people with taste but not necessarily money', and her discreet but cheerful washbanded earthenware plates and small motifs captured the refined middle-class market.

Born in Staffordshire in 1902 Susie Cooper left school aged seventeen and began attending evening classes at Burslem School of Art. Encouraged by her teacher, the designer Gordon Forsyth, she joined the school full time, then, in 1922, in order to qualify for a scholarship to the Royal College of Art, began working for a local pottery, A. E. Gray & Co., on the understanding that she would be able to design in lustres and paint her own ideas. Within two years she had given up the idea of trying for the RCA and had become their resident designer. Susie Cooper's influences at this time included artists and illustrators such as Frank Brangwyn, Edmund Dulac and Arthur Rackham and her work for Gray's, some of which was exhibited at the 1925 Paris *Exposition d'Arts Décoratifs*, showed bold, colourful, stylised designs, with a directness which she returned to in the 1960s.

In 1929, at the age of twenty-seven, she left Gray's and set up her own firm in Tunstall, but almost immediately her landlord was bankrupted in the depression which followed the Wall Street Crash, and she was forced to close the company. The following spring she re-opened in Burslem and in August 1931 moved again to the Crown Works there, following an offer by the Works' owner, Wood & Son, to make shapes for her to her own designs. They were in part, no doubt, prepared to take the chance on supplying her firm because of the general depression throughout the industry. Her move was well timed, too, following the boost to 'designer tableware' given by Clarice Cliff's work.

Wood & Son had backed a winner. A buyer from the John Lewis Group of department stores ordered Susie Cooper's 'Polka Dot' line of tableware, which she showed at the British Industries Fair in 1932, and over the next few years Miss Cooper established a good working relationship with her. She consulted her on new lines and John Lewis, in return, were prepared to try out new designs and report back on the public's reactions. Susie Cooper's firm expanded, producing over fifty tableware patterns of which the most successful were the simple 'Polka Dot' or 'Exclamation Mark' and the washbanded 'Wedding Ring' designs. She also launched new shapes, such as 'Curlew' and 'Kestrel', which were both practical and stylish, and in 1935 produced a range of lithographed designs, the most popular of which was the delicate 'Dresden' motif. Clients such as Selfridges and Waring & Gillow followed John Lewis; each department store was supplied with the designs in a different colour range, so that each had exclusive stock. Susie Cooper's colours were very different from the startling combinations used by Clarice Cliff; a muted green, turquoise or blue, or a shell-pink and sand beige, or smart greys and blacks, distinguish Susie Cooper's wares from other ceramics of the period. Enormous care went into the detail of her tableware, both in the liveliness of the design and the function of the shapes.

Miss Cooper says that she could never have achieved her success if she had not been her own boss. Although the business arrangements with clients were handled by the firm's travellers and by her brother-in-law, who was the London agent, she was able to learn from direct contact with the buyers and

Susie Cooper, c. 1930

181

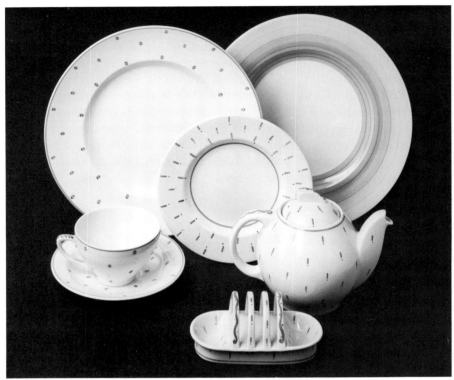

Three early tableware patterns designed by Susie Cooper and decorated at her pottery. *From left:* 'Polka Dot' (1932) – the John Lewis group placed large orders for this in blue, red and orange. 'Exclamation Mark' in orange (1933); 'Wedding Ring', produced in many colours and stocked by many large department stores in Britain and Canada

to back up her own judgements and intuitions.

Production at the Susie Cooper Works was halted in 1942 after a fire, as it was impossible to rebuild during the war. In 1938 she had married an architect, Cecil Barker, and in 1943 had a son. In 1945 she began production once more and with her husband's encouragement also began to make bone china. Her designs continued to be popular throughout the 1950s, with distinctly modern shapes, such as the 'Can' shape, selling as well as her earlier designs. In 1961 her earthenware lines were phased out when she merged with a larger firm and five years later she was bought out by the Wedgwood Group, for whom she has continued to design.

Despite Susie Cooper's innovative approach to both design and marketing, her work is today obscured by the brightness and quirkiness of Clarice Cliff's pottery. Yet Clarice Cliff, despite the personal support of her firm's director, Colley Shorter, whom she married in 1940, remained an employee. It was Colley Shorter who saw the potential in her designs and who was the driving force behind their commercial application, although her name, and also personal appearances to launch new patterns, were used for promotion. Clarice Cliff's name was also used in the early 1930s for a series of tableware designs by artists such as Graham Sutherland, Vanessa Bell, Duncan Grant and Laura Knight, which emphasised her role as a trademark or symbol for the firm. Her smiling face and plump figure, sporting a cloche hat, epitomised her

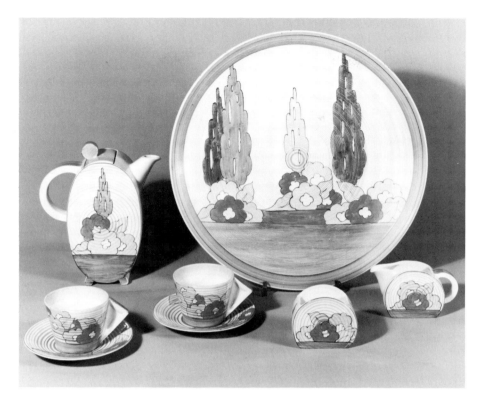

A large circular wall
plaque and part of a
coffee service designed
by Clarice Cliff, 1935

designs, but the part she played in promoting her tableware did little to establish her as a person to be taken seriously in the design world. The popularity of her work had waned by 1939 and she produced nothing of any note after her marriage. She died in 1972.

Despite the vogue for artist-designed products, there were many women who worked successfully but anonymously in the ceramics industry. Wedgwood was one firm which contributed to the vogue for hand-decorated tableware in the 1920s and 1930s, employing women as both designers and painters. Daisy Makeig-Jones designed a range of 'fairyland lustre' for them and Millicent Taplin headed their hand-painters department, originally founded by Alfred and Louise Powell, who had begun decorating blanks supplied by the firm in an Arts and Crafts manner in the 1920s.

It is the mark of the successful industrial designer to be able to work to a strict brief and, with the coming of the war, with the accompanying shortages of raw materials, the practical approach of the professional designers was put to the test. Furniture, textiles and tableware had to be produced cheaply and with limited resources to meet the demand from families whose possessions were destroyed during the bombing of towns and cities. In 1942, the Board of Trade, which, throughout the 1930s had encouraged the participation of artists in industry, established the Utility Furniture Committee to specify

design restrictions for furniture, thus controlling the materials used and the prices charged. Enid Marx, who, like Marion Dorn and Marianne Straub, had experienced the need to work to a tight brief when designing fabrics for use on London Transport, was made responsible for designing Utility fabrics.

Many designers, however, were unable to work during the war because of the shortages of materials and because their firms were turned over to military production. Both Susie Cooper and Marian Pepler had children during the war years and those not directly involved in industry helped the war effort in other ways: Muriel Rose, the founder of the Little Gallery, for example, took on the job of touring America and Canada for three years with a British Council exhibition of British crafts and design, which included work by Jean Milne, Susie Cooper, Enid Marx, Ethel Mairet and other women designers, helping to keep alive some small segment of Britain's export market.

Nevertheless, the Second World War ended an era of the most prolific and imaginative domestic design. Artists in every field had tried their hand at applying their ideas to industrial production, while professional designers had passionately believed that the closest possible association with art and architecture was a vital part of their brief. Most particularly the war also seemed to bring to an end a period when women were at the forefront of domestic design. In England, as in Russia or Germany, it had been women who had shown themselves most adept at combining art with industry, successfully putting their ideas into production, influencing each other and the design world as a whole and creating a fresh, elegant and practical style of their own. Whether their original training had been in an artist's studio or a craft workshop, women such as Marion Dorn, Susie Cooper, Vanessa Bell, Marianne Straub or Phyllis Barron were responsible for some of the period's most innovative designs.

The general public may not know their names, but they live with the results of their pioneering work and take for granted the curtains, carpets, upholstery on buses and tube trains, tableware, or even wrapping papers or suitcase linings which surround them. Such changes in the trappings of everyday life did not happen automatically, or 'naturally', but were due to the devotion of the many advanced women designers of this century both to their chosen trades and to the ordinary people whose lives influenced their aesthetic judgements. Their very anonymity made their products more acceptable to a public who might have been intimidated by claims of 'art'. Linda Nochlin, in the catalogue to an exhibition of women artists in Los Angeles, summed up their contribution appropriately:

> If, however, we take a less conventional view of what constitutes value in the avant-garde production of the twentieth century, we can see that women artists, by remaining faithful to their time-honoured role as decorative artists, have advanced the cause of abstraction and, at the same time, spread its message beyond the walls of the studio, museum and gallery into the realm of daily life – a goal devoutly sought by artists – whether 'high' or 'applied', male or female – from the time of Ruskin and Morris to the Russian Revolution, the Bauhaus, and afterwards.[9]

11. The Return to 'Normality'

In the 1940s, as in the years after the First World War, people longed for colour, for a fresh approach and a new style for their homes after the restrictions of the war. With the growth of a new consumer market, aided initially by government-backed recovery schemes and, later, by the spread of hire purchase and an increase in advertising – all of which promoted the belief that enjoyment was derived from spending – manufacturers not only launched new products but also recognised that the design of a commodity was a crucial aspect of its success in the market-place.

Britain desperately needed to boost spending and exports and, as household goods were obviously going to be an enormously important new field in the consumer market, the Government did all it could to ensure the success of the new industries by organising exhibitions, examining the training of designers, commissioning new public buildings and promoting British products abroad. This new form of government involvement in design did little to protect the interests of women designers. The public was already accustomed to the Government taking an active role in interior design. In 1942 the Utility Furniture Committee and in the following year the Utility Design Panel had both been set up by the Board of Trade to specify design restrictions for furniture and other furnishings and to create prototypes for manufacture. The majority of Enid Marx's textile designs for the Panel were geometric, with small patterns to reduce wastage in matching repeats and limited colours due to the shortage of dyestuffs, but 'she did produce some more naturalistic patterns after asking her charlady, who had been bombed out, what she would like, and her preference had clearly been for something floral'.[1] Many families turned to her designs when remaking their homes: 'Skelda', 'Flora', 'Star and Stripe', 'Thisbe', 'Chevron', 'Dot' and 'Catseye' were just some of her many solutions to designing three- to four-inch patterns, using initially four, then five, colours. The Utility scheme was eventually revoked only in 1953, despite opposition from the Labour benches in the House of Commons who had always seen it as a natural extension of the welfare state.

After the war, the Council of Industrial Design, set up by the Board of

**'Spot and Stripe',
woven textile designed
by Enid Marx for the
Utility Board, 1945**

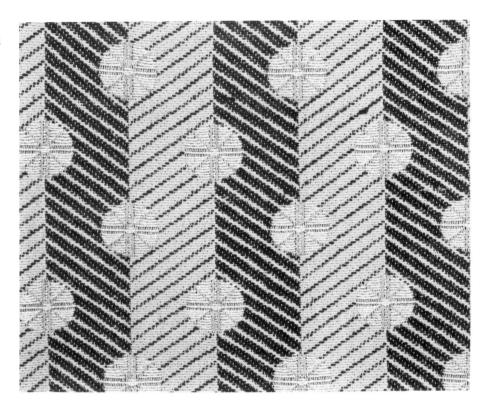

Trade in the 1930s, continued to take an active interest in manufacturing standards and in the promotion of British design. In 1946 it organised *Britain Can Make It*, an exhibition showing the public the progress being made in design, although it was to be nicknamed 'Britain Can't Have It' because so many of the exhibits were for export only or not yet in full production. The exhibition, which included textiles and ceramics designed by Marianne Straub and Susie Cooper, celebrated the role that would be played in the future by the industrial designer.

In 1951, the council organised a second exhibition, the Festival of Britain, which for the first time in more than a decade introduced a host of new products. The Festival, although centred on London's South Bank, was a national event, with permanent exhibitions in Glasgow and Belfast as well as travelling shows. It celebrated almost every aspect of British achievement and was an enormous success. The visual impact of contemporary scientific work on the structure of crystals and molecular models was reflected in furniture with thin steel legs and ball feet and in fabric designs such as Marianne Straub's 'Helmsley', produced by Warner & Sons Ltd. Free-form 'boomerang' shapes were popular and echoed the organic forms of much American furniture which made use of new techniques for injection-moulded frames. Just as Victorian designers such as Dr Christopher Dresser had made use of contemporary botanical theories, so the 1950s designs reflected scientific

advances; the jet-age also supplied a popular variety of motifs – indeed, Enid Marx, who had supplied a design with aircraft for a lining fabric for suitcases before the Second World War, was asked to bring it up to date in the 1950s by removing the propellors! The Council of Industrial Design also looked at the training that British designers received and in 1951 the Royal College of Art awarded the first diplomas in design, acknowledging the need for a more specialised training course.

During the 1950s government involvement in design matters remained, but took a different course. In 1956 the Design Centre made its first awards to products selected as examples of good design. A quarter of the first awards went to designs by women: to Audrey Levy for a wallpaper, to Millicent Taplin for tableware and to Lucienne Day for a carpet. However, among the other award-winning products were a television set, a convector fire and plastic and Pyrex wares, all designed by men, demonstrating the start of the sexual division between decorative and functional design which had also been seen at the Festival of Britain.

The radical changes in English manufacturing in the post-war years affected furnishings and household equipment as much as other products. New processes and materials, such as injection moulding, plastics or improved methods of screen printing, which could not be applied on a one-off basis, took design in a new direction; the process of designing prototypes for mass production in craft workshops, evolved at the Bauhaus and the Wiener Werkstätte, could not play such a vital role. Thus the scope and role of the designer diversified, but design split – just as art and craft had done in earlier centuries – into culture and nature, with industrial design, advertising and office design identified with culture, and interior decoration and the independent craft workshop associated with nature. Despite the fact that many of the products which women regularly used remained in the sphere of male-dominated culture, women designers, still identified with nature and despite their pioneering work in the 1930s in bringing the experience of the craft workshop to bear on industrial design, were never able to develop the influence they had gained in the inter-war years. The market for home furnishings was aimed almost exclusively at women, who were bombarded with new magazines devoted to interior decoration and with advertising which was directed at the 'homemaker', yet women designers were increasingly excluded from industrial design studios. In the 1940s and 1950s, women designers lost a tremendous amount of ground and their influence was once more limited to the adornment, rather than the function, of the home. Design remained a fashionable profession for women, but they chose to specialise in the fields in which they had succeeded before the war. A woman was unlikely to train as a car designer, but textiles were another matter. Since in schools subjects such as domestic science, woodwork, science subjects which included making radio sets or primitive engines and art subjects which included pottery or needlework were divided on sexual lines and girls generally excluded from non-domestic classes, it was perhaps inevitable that

industrial design was cast as a male activity.

At the heart of this sexual division within design in the 1940s and 1950s lay the revitalisation of the ideology of separate spheres for men and women. Memories of the unemployment of the 1930s were fresh at the end of the war and women were once again encouraged to take up the nineteenth-century view of their role as guardians of the hearth, leaving the demobbed heroes to take up their places once more in the 'battlefield' of the workplace. The home front still had a role to play and women were encouraged to accept their specified, narrow domestic role in a return to post-war 'normality'.

The critic Diana Trilling has described the parallel shift in attitude which took place in the 1940s in America and its consequent effect on domestic design:

> During the war, although women often did the work that had been done by men and made the decisions that had previously been made by husbands and fathers, this change in status was understood to be only temporary. It wasn't allowed to challenge in any basic fashion the way that women had always thought about the distribution of power between the sexes. What women were doing was holding things together until men would reclaim their old place in the social order . . . A major effort of public relations was mounted to prepare women for demobilization and the return to female submission . . . true female fulfillment lay in women's pursuit of their destiny as wives, mothers, homemakers. It was the function of women to be nourishers and sustainers, not doers or achievers. This is when the concept of gracious living was introduced into American popular culture. It had the lasting benefit of making American women into better cooks than they'd been before and of making the design and equipment of kitchens a major American industry.[2]

It also had the drawback of removing the application of female skills and perceptions from many areas of design.

British women were likewise encouraged to conform to a new image of themselves – an image epitomised by the 'New Look' in fashion, with longer skirts, pinched waists, sloped shoulders and big hats. Any discussion of children's future careers was based upon the idea of separate spheres for men and women and the occupations open to women were assessed more on the basis of a girl finding a job which she could continue once she was married with a family than on establishing herself within a career which was both self-fulfilling and self-supporting. As a fighter on the home front, woman's role was also to improve the living standards of her husband and children. The extension of government control during the war and the establishment of the welfare state immediately afterwards had created a basic standard of living for 'ordinary people' which, as in the years following the First World War, was focused on the domestic sphere: better housing, better food and better childcare. It was repeatedly argued that the improvement of living standards depended on women remaining at home.

As if to compensate for being returned to the home, woman's role was glamorised; the new femininity was cast in the role of specialist consumer. Housework was not only a skill but a joy and the wise housewife spent her

Scraperboard drawing by Harry Hemus to advertise Pyrex glassware, *c*. 1958

money on the home discriminatingly but enjoyably. In recognition of women's supposed search for perfection, new technologies in kitchen equipment, cleaning agents, easy-care fabrics and the like were developed especially for them in unprecedented quantities. In advertisements, manufacturers took on the role of domestic science experts, there to help the housewife towards her unattainable goal, for, despite the new gadgets, liquids and powders, the proud homemaker's work was never done.

In the 1950s, while women became consumers *par excellence*, their contribution to design was limited by post-war ideology. Discouraged from science subjects at school, virtually excluded from industry and the chance to acquire the new skills required to work with modern materials and technologies, but praised for their influence within the home, women designers excelled only where they were able. Increasingly, they were forced into the mould where they designed only for other women or for children.

One of the most fashionable furnishing styles of the 1950s was the Scandinavian 'Contemporary' look, which made use of natural materials, hand-crafted textiles, glass and other items. Many of the Scandinavian craft associations had been founded in the nineteenth century by women; they particularly excelled in the field of rugs and textiles. One designer who maintained close links with

British textile designers, and whose use of contrasting textures and neutral, natural colours was widely influential, was Astrid Sampe; indeed, she was a member of the first selection committee for the 1957 Design Centre awards. In 1937 she had become head of the textile studio run by the Stockholm department store Nordiska Kampaniet, where she developed woven furnishing textiles for industrial production.

In keeping with the vogue for Scandinavian design, there was a ready market for work from independent craft studios. Many craft workers shared the values that had inspired the 'Simple Lifers' of the 1920s – values which were to be voiced in the 1960s when the experience of the craft workshop was once again heralded as the alternative to industrialisation and bureaucracy – and in ceramics Bernard Leach remained a dominating influence well into the 1970s. In the 1950s, however, his aesthetic was questioned by the work of an Austrian potter, Lucie Rie, who came to England as a refugee in 1938.

Lucie Rie was born in Vienna in 1902 and trained at the Kunstgewerbeschule there under Michael Powolny. She also worked in Vally Wieselthier's studio for a few weeks, but her interests were very different from Wieselthier's expressionistic approach; although her early work echoed some of the forms of the Wiener Werkstätte ceramics, she seldom decorated her pots and never emulated the playful, decorative style of her contemporaries. Lucie Rie's aim was to make pottery which would be in keeping with modern furniture and architecture. In the 1930s, while still living and working in Austria, she won several international prizes for her work; she used earthenware to make simple but distinctive forms enhanced by irregular surface effects. When she came to England, however, she found that her work was judged by different aesthetic criteria: Muriel Rose at the Little Gallery found her pots insufficiently controlled and recommended that she go to see Bernard Leach. This she did, spending a week with him, learning how to pull handles, but this experience only diminished her confidence in her own ideas.

During the war she completely abandoned her pottery, first for a factory job adjusting optical instruments, then making buttons (for a fellow Viennese designer, Fritz Lampl, who had re-established his Bimini Workshops in London) for the fashion trade. In 1946 she was joined in this work by a young German sculptor, Hans Coper. After a year, he began to make pots and together they began to turn the button workshop into a pottery once again as Lucie Rie regained confidence in her ideas.

Lucie Rie and Hans Coper made functional pieces, especially tablewares, which were perfectly suited to the new style of interior: the work was smart and modern, often in white, dark brown and black, and decorated with fine incised *sgraffito* lines which enhanced the surface qualities of the stoneware body. They sold their work at Heal's and at a new gallery, Primavera, which Henry Rothschild opened in Sloane Street in London in 1945, where it was now very well received.

Lucie Rie's work has been described as 'metropolitan' in contrast to the rusticity of the Leach tradition. Her cups, tea-pots and bowls have a special

Earthenware bowl made by Lucie Rie in Vienna, 1931

sophistication of their own in the balance and rhythm of their forms; nothing is redundant, the handles, shapes, colours and decoration all supporting the integrity of purpose. As her work gained acceptance, Lucie Rie turned increasingly to making bowls and vases. In describing her work one is driven to use opposing terms; severe but graceful, lyrical but disciplined, sensitive but with a sense of controlled strength. Her great contribution to contemporary pottery is that her pots are unmistakably an expression of personal taste executed with consummate skill and judgement; her taste is not an ever-changing search for new insights and attitudes, but the constant restatement of an intuitive reaction to life. In 1981 Lucie Rie was awarded the CBE and the following year the Victoria and Albert Museum held a retrospective exhibition of her work, which is internationally respected.

In stark contrast to the 1930s, there were few outstanding professional freelance designers in the 1940s who were women, although some began to establish themselves in the 1950s, by which time the obstacles were greater since the design world had become far more complex in its organisation. The most successful women designers of the 1950s were, unsurprisingly, concerned with textiles, a field which was also greatly influenced by the influx of European designers who had come to Britain as refugees during the war.

Lucienne Day, the textile designer whose work encapsulates the 1950s style, trained at Croydon Art College and then the Royal College of Art. However, she taught for some years before beginning work as a freelance

Award-winning 'Calyx' design by Lucienne Day in linen, 1951

designer in 1948. She started by producing designs for dress fabrics, following the fashions of the time in colour but always trying to put over to manufacturers more sophisticated 'unpretty' designs. Lucienne Day, like Marianne Straub, has always been more interested in the whole area of interior decoration than most of her women contemporaries and her designs have been more directly influenced by the needs of modern architecture. In 1948 her husband, Robin Day, won a competition organised at the Museum of Modern Art in New York for the design of low-cost furniture and in 1951 she designed a furnishing fabric called 'Calyx' to complement his designs for the Homes and Gardens Pavilion at the Festival of Britain.

'Calyx', produced by Heal's, marked the start of a new design rhetoric for the 1950s. Lucienne Day's new fabric designs, influenced by the spiky look of the work of artists such as Jean Miro, Paul Klee and Alexander Calder who used primary reds and yellows with thin lines balanced against solid masses, worked well with the overall 'Festival' style. It won awards in both Milan and New York and Lucienne Day was launched on a successful career in which she was able to produce designs which she felt broke new ground, rather than

having to adapt to an established style. Over the next few years she won many international awards for the textiles she designed for Heal's, such as 'Graphica', 'Ticker-tape', 'Linear' and 'Spectators', and also for designs for carpets and kitchen linens. Through Heal's, she was able to produce relatively cheap but good-quality textiles by the mile rather than by the yard and she valued this aim of reaching a mass audience and also of providing a fresh approach to pattern. Geoffrey Dunn, one of the most progressive British retailers in the 1950s, described her work as 'new and fresh but with wonderful scholarship to it'.

Although Lucienne Day also designed wallpapers, decorations for tablewares and many textiles for German, Swedish and American manufacturers as well as British, she now concentrates on one-off silk mosaic hangings for both domestic and public interiors.

Another versatile textile designer who shared the limelight with Lucienne Day in the 1950s was Jacqueline Groag, a Czech by birth, who had studied in Vienna in the 1920s under Josef Hoffmann at the Kunstgewerbeschule. She had also studied under Franz Cizek, who believed in a teaching approach which allowed the student to retain a naive, childlike attitude to art; he had an enormous influence upon her and her designs are imbued with an untram-melled clarity, a spontaneity which captures the essential simplicity of her observation. Like Lucienne Day, she pays tribute to the influence of Paul Klee, whose work she greatly admires.

In Vienna Jacqueline Groag designed for the Wiener Werkstätte and in 1929 worked in Paris, designing dress fabrics for Chanel, Schiaparelli, Poiret, Worth, Lanvin and other couturiers. In 1931 she became engaged to the architect, Jacques Groag, and returned to Vienna, where they married in 1937. Jacques Groag was a follower of Adolf Loos, who rejected the decorative style of the Wiener Werkstätte in favour of a severe functionalism in architecture, and Jacqueline began to work closely with her husband. In 1939 they moved to London where she continued to design textiles; her printed fabrics and large decorative panels were exhibited at *Britain Can Make It* and a screen was included in the Living World Pavilion at the Festival of Britain. For more than twenty years she worked as a freelance designer, supplying designs for textiles, wallpapers, carpets, laminates, plastics, cards and wrapping papers to many firms, including London Transport, Dunlop, ICI and the British airlines BEA and BOAC.

Jacqueline Groag's style was very different from Lucienne Day's; the style of the 1950s and early 1960s is not discernible in any particular vocabulary of design so much as in the overall effect of the interior. Pattern, whether bold and colourful or complex and geometric, returned to wallpapers, textiles and carpets, while furniture and tableware became more distinctly formed, in curving, organic shapes. The impact of the interiors of this period lay in the juxtaposition of elements and the balancing of colours and textures. The more individual the design, the more likely it was to succeed amid a mixture of contrasting items. Each of the British textile designers – women such as

The Silver Town by
Jacqueline Groag, 1981

Marianne Straub, Lida Ascher, Shirley Craven, Marion Mahler, Audrey
Tanner, Barbara Brown and Althea McNish – had a distinctive style of her
own.

In the early 1960s a new approach to marketing was developed which was to
have a profound effect on the image of the woman designer. The coverage
given to the personalities of the 'swinging sixties' ensured that any product
bearing the right name would sell successfully; two women who first made
their names in fashion were thus able to branch out into retailing furnishings.
Mary Quant, who opened her first fashion boutique, Bazaar, in Chelsea in
1955, and Barbara Hulanicki, who founded Biba in the early 1960s, both had
an enormous influence on how women dressed and how they furnished their
homes.

Barbara Hulanicki, like Quant, trained as a fashion illustrator and began
designing clothes. In 1969 she diversified into household goods, selling
wallpapers, towels, bed linen, cutlery and lampshades through Biba. When
Biba took over the large, former Derry & Toms department store building in
London, she expanded into complete room-sets, china, glass, kitchenware and
paint, selling a luxurious, dark, Edwardian image for interior decoration.
However, it closed in 1975. Mary Quant, whose ideas came to epitomise the
style of the 1960s, set up the Ginger Group in 1969 to market her designs and,

under licence with established manufacturers, Quant's motifs are now used for carpets, textiles, blinds, ceramic mugs, bed linen and kitchen linens, 'bringing fashion into the home'.

In 1964 Terence Conran opened the first Habitat shop in London, offering a 'pre-digested shopping programme . . . [which] we are confident that many women will take to . . . with enthusiasm'.[3] Habitat set the fashion for a new style of professional decorator – the retailer who selects an individual 'look': within one shop the client could buy a complete style for her home merely by choosing whose shop to patronise. Habitat, Biba, Laura Ashley or Designers' Guild brought the services of the professional interior decorator to a wider audience and at a cheaper price.

Laura and Bernard Ashley began in 1953 by producing screen-printed furnishing fabrics and household linens which they sold to stores such as Heal's, Liberty and John Lewis. In the early 1960s they opened their first shop, selling clothes with small floral prints based on the new vogue for Victorian and Edwardian styles. They later expanded into furnishings, selling a range of wallpapers and fabrics with small floral patterns in pastel colours; they now have shops all over Europe and America. Tricia Guild started the Designers' Guild in 1972 with her husband, an interior decorator. She now runs the business herself and also has stockists and shops all over Europe and America. She does not design herself, but oversees a team of designers, choosing the colours and themes and imposing her own style and ideas. Hers is a more sophisticated rendering of Laura Ashley's rustic charm, with motifs and colours drawn from English gardens, countryside and sea shores and from an idealised notion of the 'ordinary' 1930s home. She avoids the dramatic in interior decoration and her decorating contracts have reflected this; apart from domestic interiors, she has received commissions for hotel bedrooms and offices for women executives rather than the grander schemes which have made the name of such post-war decorators as David Hicks. Part of the huge success of Laura Ashley and Tricia Guild's style is its 'naturalness'; it is a sophisticated design rhetoric which refers not only to a 'natural' world of flowers, leaves or sea shells which works better with wood than with plastic and laminate, but also to an idealised democratic past, a common heritage which, whatever one's present affluence, was once unpretentiously lower middle class.

Since the 1960s, fashions in home furnishings have strongly reflected certain polarisations within society, between male, ambitious, uncaring culture and female, comforting and socially aware nature. In visual terms, culture is typified by a 'classic' elegance, such as Charles Eames's leather-upholstered 'Lounge Chair 670', for example, which 'works' visually only if one imagines a smartly dressed man sitting in it, while nature is cast as the country kitchen with stripped pine furniture, chintz fabrics, hand-thrown pottery tableware and natural-dyed fabrics. Both are problematic.

Ironically, the classic elegance now more readily associated with the modern office than with the home originated from the tubular steel and

leather furniture first produced at the Bauhaus as prototypes for worker housing. Tom Wolfe, in *From Bauhaus to Our House*, has described the appropriation of the Bauhaus ideal in the cause of radical chic in America:

> . . . the reigning architectural style in this, the very Babylon of capitalism, became worker housing. Worker housing, as developed by a handful of architects, inside the compounds, amid the rubble of Europe in the early 1920s, was now pitched up high and wide . . . [and] made to serve every purpose, in fact, except housing for workers . . . The only people left trapped in worker housing in America today are those who don't work at all and are on welfare – these are the sole inhabitants of 'the projects' – and, of course, the urban rich who live in places such as the Olympic Tower on Fifth Avenue in New York . . . Which is to say, pure nonbourgeois housing for the bourgeoisie only.[4]

The minimalism of the International style has been adapted and enriched by a new generation of Italian designers in Milan, such as Vico Magistretti, Ernesto Gismondi and others, who use expensive marble, glass, leather and fine woods in their furniture. Although there are a few Italian women who design furniture in this style, such as Gae Aulenti, Giovanna Barbieri and Maria Luisa Tomacelli, Afra Scarpa, who works with her husband Tobia, and Antonia Astorio, who works with her brother Enrico, it remains an essentially masculine style, a backdrop for male activities.

Similarly, the country kitchen ideal, which has largely been associated with such women designers as Laura Ashley and Tricia Guild, while claiming a tacit support of conservation and the 'Simple Life', has in fact dominated female-oriented advertising in the past decade. It is used to sell everything from washing machines to cornflakes to a female consumer market. In advertising aimed at women, they are continually identified with a type of cosy, home-loving, pretty design which reinforces the post-war ideology of separate spheres for men and women, stressing the idea that women are soft, whimsical and house-bound. Their world is domestic, full of sunshine, the table spread with wholesome food, its inhabitants practical, cheerful and perfectly fulfilled. In contrast, when men appear in female-oriented commercials, they often do so as comedians: they spill things and are unable to carry out the simplest household tasks and are gently tolerated by the family.

However, a totally different rhetoric is employed when the consumer is male. The design image which permeates the design and advertising of cameras, cars, video and hi-fi equipment and other electronic goods is predicated on a world of male fantasy where men are potent and in instant control of their environments. When women appear in advertisements for male products, the kitchen sink and the children are replaced by images of male reward – the glamorous but passive women who will sit in the passenger seat of the car or pose for the camera.

Advertising has supplied the post-war iconography of women that the Pre-Raphaelites and the early Arts and Crafts designers created in the nineteenth century. While less specific in its ideal of beauty, it has nevertheless created a

modern home which is as restrictive to women as the Victorian image of the medieval castle. While women may have some professional role to play in its creation, women designers now inhabit a world where women design for women, inevitably reinforcing an ideology which controls education, job opportunities, advertising, the design of material products and also an individual's sense of self-worth within society.

The type of anonymous, socially motivated design which women in Russia, at the Bauhaus and in England did so much to develop and promote in the 1920s and 1930s has, ironically and tragically, been appropriated by men. If women enter fields of design which cater for a male market, they must accept a kind of half-life where their work shows the strains of accommodating specifically male concepts – speed, glamour, sophistication – and when they are involved in discussion it is, for example, to choose the colour of the car seat upholstery, or to advise on the size of ovens or the functions necessary to a food-mixer. Ironically, given that it was Marianne Brandt who first developed the push-button light-switch, one British cooker manufacturer decided against introducing an electronic relay system for the timer switch because he believed that 'the housewife' preferred a mechanical switch (which cost the same to install) as she might mistrust a technology which she would not understand.

The design office is now an indispensable section of industry, but it is a profession dominated at management level by men. However, women excel and succeed in fashion, interior decoration and craft work, not because that is where their talents invariably and 'naturally' lie, but because those are the areas where their contribution has a market value. Yet even women's professionalism has been eroded to some extent: the Victorian prohibition on women working for money has been replaced by the frequently unarticulated prohibition of working without artistic intention. The Crafts Council – the last in the line of government bodies set up to improve design standards in Britain – now has an annual grant of over £1 million which, by the late 1970s, was increasingly allocated to craft workers who explored conceptual theories in their work rather than the practical application of their crafts. Nevertheless, in ceramics for example, it has been women like Alison Britton, Jacqueline Poncelet, Dorothy Feibleman, Jill Crowley or Carol McNicholl who have broken most convincingly from the now sterile Leach tradition or, like Janice Tchalenko, have transformed his aims into a thoroughly modern idiom.

Women are caught within a system of values which they cannot outwit, for it judges women's potential to be limited, when it is the system itself which limits what women can achieve; so long as women stay within the fields where their contribution is welcomed, they are merely fulfilling a prescribed 'natural' destiny. The most debilitating aspect of the existing value system is that it continues to denigrate the contribution made by women to society, and, so long as women remain outside the economic and ideological structures which effectively control the organisation of society, they can only voice their protest from outside those structures, never practise it from within.

Chronology

World Events

1848 Year of revolutions throughout Europe
Karl Marx and Friedrich Engels issue the
Communist Manifesto

1849 Bedford College for Women founded in
London

1853 Outbreak of the Crimean War

1857 The development of E. G. Otis's safety
elevator makes the skyscraper possible

1859 Charles Darwin publishes *The Origin of
Species*

1861 Outbreak of the American Civil war
Edict for the Emancipation of the Serfs
issued in Russia by Tsar Alexander II

1865 First carpet-sweeper and the first
mechanical dish-washer developed

1867 Karl Marx publishes *Das Kapital*, volume I
Second Reform Act in Britain extends male
suffrage

1869 The first electric washing-machine
developed

1870 Outbreak of the Franco-Prussian War

1871 The establishment of the German Empire
under Kaiser Wilhelm I

1875 London Medical School for Women
founded

1876 Alexander Graham Bell patents the
telephone

1883 The first skyscraper built in Chicago

1885 Gottlieb Daimler invents the combustion
engine and Karl Benz builds an engine for a
motor car

1890 Bismark is dismissed by Wilhelm II

1895 Sigmund Freud publishes his initial work on
psycho-analysis, *Studies in Hysteria*

1899 In France, Captain Dreyfus is sentenced to
ten years penal servitude
Outbreak of the Boer War

1901 Queen Victoria dies

1903 Women's Social and Political Union
founded in Manchester, England, by
Emmeline Pankhurst
Orville and Wilbur Wright make a
successful flight in a petrol engine aeroplane

1908 The Hoover electric carpet-sweeper is
patented

1909 Henry Ford introduces the 'Model T' car
Women are admitted to German
universities

1914 Outbreak of the First World War

1915 Bill proposing women's suffrage in the
United States defeated in the House of
Representatives

1917 Russian Revolution

1918 First World War ends
A Republic is declared in Austria
In Britain, the Parliamentary Reform Act
gives women of thirty and over the vote

1919 In Austria, women are enfranchised
In Britain, the Sex Disqualification
(Removal) Act opens nearly all public
offices and professions to women
In Germany, women over twenty are
enfranchised

1920 Women are enfranchised in the United
States
Prohibition enforced in the United States

1922 Mussolini seizes power in Italy
Marie Stopes holds meetings in London to
advocate birth control

1923 A birth control clinic is opened in New York

1924 Lenin dies

1926 The General Strike in Britain collapses after
eight days
Rudolph Valentino dies

1927 Sound films first introduced

1928 In Britain, the Equal Franchise Act gives the
vote to all men and women over twenty one
Alexander Fleming discovers penicillin

1929 Wall Street Crash
Leon Trotsky exiled from the Soviet Union

1933 Adolf Hitler establishes the National
Socialist (Nazi) party in Germany
President F. D. Roosevelt introduces the
New Deal

1936 Outbreak of the Spanish Civil War

1938 Hitler's troops enter Austria, and declare it
part of the Third Reich

1939 Outbreak of the Second World War

1940 French armistice with Germany

1941 Japan attacks Pearl Harbor, and USA enters
the war

1945 USA drops atomic bombs on Hiroshima and
Nagasaki, bringing the Second World War
to an end
Women are enfranchised in France

1946 The National Insurance Act becomes law in
Britain. The National Health Service is
established and the coal mines, road and rail
transport services, and Cable and Wireless
Ltd are nationalised

198

1950 Outbreak of the Korean War
1952 The first contraceptive 'pill' is made
1955 Commercial television launched in Britain
1957 Soviet Union launches Sputnik 1
1963 President J. F. Kennedy assassinated in Dallas
The Beatles introduce the Liverpool sound
1964 American military involvement in Vietnam escalates under President L. B. Johnson
1965 The American Early Bird communications satellite is first used by television
1969 Apollo 11 lands the first man on the moon
1970 The Equal Pay Act passed in Britain
1975 The Sex Discrimination Act passed in Britain

Decorative Arts – General

1848 The Pre-Raphaelite Brotherhood is formed
1851 The Great Exhibition held in London
1859 Philip Webb designs 'The Red House' for William and Janey Morris
1861 William Morris founds Morris, Marshall, Faulkner & Co
1862 The International Exhibition held in London introduces Japanese design to the West
1872 The Royal School of Art Needlework founded in London
1874 First Impressionist Exhibition held in Paris
1875 Liberty & Co. founded in London
1876 The Centennial Exposition held in Philadelphia inspires American ceramists and embroiderers
1878 The Exposition Universelle held in Paris: Agnes and Rhoda Garrett exhibit furniture and a 'cottage room'
1882 Oscar Wilde undertakes a successful lecture tour of the United States, promulgating Aesthetic Movement ideals
1888 The Arts and Crafts Exhibition Society founded in London; its exhibitions provide an outlet for women's work
1892 Elbert Hubbard visits William Morris in London and returns to America to found the Roycroft craft community near Buffalo
Susan Frackleton founds the National League of Mineral Painters in Chicago
1893 The World's Columbian Exposition held in Chicago; it includes the Women's Building, designed by Sophia Hayden and decorated by Candace Wheeler
The Studio first published in Britain
Frank Lloyd Wright sets up his own architectural practice in Chicago
Female students at the Royal Academy are allowed to draw from draped male nudes
1896 The Central School for Arts and Crafts founded in London
Samuel Bing opens his shop l'Art Nouveau in Paris
House Beautiful launched in Chicago
1897 Arts and Crafts societies founded in Boston and Chicago
The Vienna Secession founded
Deutsche Kunst und Dekoration and *Dekorative Kunst* launched in Germany
Country Life, to which Gertrude Jekyll was a regular contributor, first published in England
1898 *World of Art* first published by Serge Diaghilev in Moscow
1900 The Eighth Secession exhibition in Vienna includes rooms by the Glasgow School of Art
1901 Gustav Stickley publishes the first issue of *The Craftsman* in Syracuse
1902 Margaret and Charles Mackintosh exhibit the 'Rose Boudoir' at the Turin International Exhibition
1903 Josef Hoffmann and Koloman Moser found the Wiener Werkstätte
1906 Lucia and Arthur Mathews found the Furniture Shop and the Philopolis Press in San Francisco
1907 The Deutsche Werkbund founded
The Women's Guild of Arts founded in Britain
Cubist paintings exhibited in Paris
1909 The Futurist Movement begins in Italy
1910 Natalia Goncharova and Mikhail Larionov organise the *Jack of Diamonds* exhibition in Moscow
1911 Paul Poiret founds the Atelier Martine in Paris
1913 Roger Fry founds the Omega Workshops in London with Vanessa Bell and Duncan Grant as co-directors
Josef Hoffmann establishes the Kunstlerwerkstätte within the Wiener Werkstätte

1916 Dadaist movement launched in Zürich

1917 Piet Mondrian, Theo van Doesburg and J. P. Oud launch the De Stijl movement in Holland

1919 The Bauhaus founded in Weimar with Walter Gropius as its head

1920 Inkhuk (Institute of Artistic Culture) formed in Moscow with Vassily Kandinsky, Alexander Rodchenko, Varvara Stepanova, Liubov Popova and Alexander Vesnin as co-directors. In November the Svomas are re-organised as the Vkhutemas (Higher Technical Artistic Studios)

1921 The Red Rose Guild founded in Manchester at Margaret Pilkington's instigation
Theo van Doesburg gives a De Stijl course to the Bauhaus students in Weimar
The exhibition 5 × 5 = 25, held in Moscow, shows works by Stepanova, Rodchenko, Popova, Exter and Vesnin

1923 Le Corbusier publishes *Vers une Architecture*

1925 The Bauhaus moves to Dessau
L'Exposition des Arts Décoratifs held in Paris

1926 Sophie Taeuber-Arp, Jean Arp and Theo van Doesburg design the interior of the Café L'Aubette in Strasbourg

1928 Charlotte Perriand, Le Corbusier and Pierre Jeanneret exhibit the *Chaise Longue*, the *Basculant* and the *Grand Confort*
International Exhibition of Ceramic Art held at the Metropolitan Museum, New York

1929 Wiener Werkstätte ceramic workshop closes
Salvador Dali joins the Surrealists

1931 Wiener Werkstätte goes into liquidation

1933 The Bauhaus closes

1934 The Council for Art and Industry is set up by the Board of Trade in Britain with Frank Pick as chairman
Walter Gropius arrives in England, but leaves for America two years later

1936 Cecilia Dunbar Kilburn and Athole Hay open Dunbar Hay in Albermarle Street, London

1942 The Utility Furniture Committee is set up by the Board of Trade: Enid Marx is made responsible for designing fabrics

1945 Henry Rothschild opens Primavera in London

1946 *Britain Can Make It* exhibition held in London

1951 Festival of Britain held in London

1953 Laura Ashley and her husband first begin printing textiles

1956 The Design Centre opens in London

1958 American Abstract-Expressionist works first exhibited in Europe

1964 First Habitat shop opens in London
'Op' art launched

Decorative Arts – Women

1871 Agnes and Rhoda Garrett begin their training as architects

1877 Candace Wheeler founds the New York Society of Decorative Art

1879 Candace Wheeler resigns from the Society of Decorative Art to found Associated Artists with Louis C. Tiffany
The Women's Pottery Club founded in Cincinnati by Louise McLaughlin

1880 Maria Longworth Nichols founds the Rookwood Pottery in Cincinnati
Two designs by Gertrude Jekyll included in *Modern Embroidery*, a book compiled by the secretary of the Royal School of Art Needlework which featured designs by William Morris, Walter Crane and Edward Burne-Jones

1882 Associated Artists decorate President Arthur's White House

1885 May Morris takes over the embroidery section of Morris & Co

1893 Princess Maria Tenisheva founds an artists' colony at Talashkino

1894 Jessie R. Newbery establishes embroidery classes at Glasgow School of Art

1895 Newcomb College Pottery established for women students in New Orleans

1896 Margaret and Frances Macdonald open their own studio in Glasgow

1899 Adelaide Alsop Robineau begins publication in Syracuse of *Keramik Studio*

1903 Isabella Stewart Gardner opens 'Fenway Court' in Boston

1905 Elsie de Wolfe undertakes the decoration of New York's Colony Club

1908 Jessie R. Newbery is succeeded by Ann Macbeth as head of the embroidery department at Glasgow School of Art

1909 Adelaide Alsop Robineau begins work at University City, Missouri

1910 May Morris undertakes a lecture tour of America

1913 Eileen Gray begins making lacquer furniture for the art connoisseur Jacques Doucet

1914 Natalia Goncharova designs the drop curtain and costumes for the Paris production of Diaghilev's *Le Coq d'Or*, the first of several ballets she designed for the Ballets Russes

1916 Sophie Taeuber-Arp becomes professor of textile design at the Zürich Kunstgewerbeschule

1917 Ethel Mairet moves to Ditchling and begins to build Gospels

1918 In the Soviet Union, Olga Rozanova initiates the Industrial Art Section of the Visual Arts Section of the Svomas

1920 The weaving workshop founded at the Bauhaus by Gunta Stölzl.
Vally Wieselthier and Susi Singer join the Kunstlerwerkstätte at the Wiener Werkstätte

1922 Eileen Gray founds Jean Désert in Paris
Anni Albers joins the Bauhaus
Syrie Maugham opens her decorators' shop in London

1923 Sonia Delaunay's textile designs launched
Phyllis Barron and Dorothy Larcher begin their lifelong collaboration as fabric printers
Dorothy Hutton founds the Three Shields Gallery in Kensington, London
Marianne Brandt joins the Bauhaus

1924 Marie Laurençin designs the sets and costumes for Diaghilev's ballet *Les Biches*
Sonia Delaunay begins her collaboration with the couturier Jacques Heim
Varvara Stepanova becomes professor of textile design at the Vkhutemas
Alexandra Exter settles in Paris
Katharine Pleydell Bouverie goes to St Ives to work with Bernard Leach

1926 Elspeth Ann Little founds Modern Textiles in London
Gudrun Baudisch joins the Kunstlerwerkstätte at the Wiener Werkstätte

1927 Charlotte Perriand joins Le Corbusier's office
Marianne Brandt designs the Kandem lamp

Syrie Maugham unveils her 'all-white' room
Eileen Gray designs her house 'E-1027'

1928 Muriel Rose establishes the Little Gallery in London

1929 Susie Cooper sets up her own ceramics firm in the Potteries

1930 Clarice Cliff appointed Company Art Director of A. J. Wilkinson Ltd

1931 Susie Cooper opens new works

1934 Marion Dorn founds her own company in London

1937 Lucie Rie comes to England

1937 Sophie Taeuber-Arp founds the review *Plastique*
Marianne Straub joins Helios
Jean Milne establishes a rug-weaving industry in the Isle of Skye
Astrid Sampe becomes head of the Nordiska Kampaniet textile studio in Stockholm

1941 Rookwood Pottery goes into liquidation

1946 Gudrun Baudisch establishes the Keramik Hallstatt near Salzburg

1955 Mary Quant opens Bazaar in Chelsea, London

1964 Barbara Hulanicki opens the first Biba boutique in Kensington, London
Marianne Straub begins to design for Tamesa Fabrics

1969 The Ginger Group is set up to market Mary Quant's designs

1972 Tricia Guild starts Designers Guild in London

Women's Publications in the Decorative Arts*

1876 Agnes and Rhoda Garrett: *Suggestions for House Decoration in Painting, Woodwork and Furniture*

1877 Louise McLaughlin: *China Painting*

1878 Lucy Orrinsmith: *The Drawing Room, its Decoration and Furniture*
Mrs M. J. Loftie: *The Dining-Room*

1880 Louise McLaughlin: *Pottery Decoration under the Glaze*

1881 Mrs H. R. Haweis: *The Art of Decoration*

1882 Mrs H. R. Haweis: *Beautiful Houses*
Lucy Crane: *Art and the Formation of Taste*

* See Bibliography for publishing details of books listed below

1883 Louise McLaughlin: *Suggestions to China Painters*

1893 May Morris: *Decorative Needlework*

1897 Edith Wharton and Ogden Codman: *The Decoration of Houses*

1899 Gertrude Jekyll: *Wood and Garden*

1900 Gertrude Jekyll: *Home and Garden*

1904 Edith Wharton: *Italian Villas and Their Gardens*

1911 Ann Macbeth and Margaret Swanson: *Educational Needlecraft*

1913 Elsie de Wolfe: *The House in Good Taste*

1916 Ethel Mairet: *Vegetable Dyes*

1921 Candace Wheeler: *The Development of Embroidery in America*

1939 Ethel Mairet: *Hand-weaving Today*

1946 Enid Marx and Margaret Lambert: *English Popular and Traditional Art*

1951 Enid Marx and Margaret Lambert: *English Popular Art*

1955 Muriel Rose: *Artist-Potters in England*

1959 Anni Albers: *On Designing*

1965 Anni Albers: *On Weaving*

Notes

Chapter 1: The Blessed Damozel

1. John Ruskin, *Sesame and Lilies*, Smith, Elder & Co., London, 1865, p. 178.

2. Quoted by Harriet Prescott Spofford in *Art Decoration Applied to Furniture*, New York, 1878, p. 23.

3. Georgiana Burne-Jones, *Memorials of Edward Burne-Jones*, 2 vols; Macmillan & Co., London, 1904, Vol. I, p. 169.

4. Mrs H. R. Haweis, *The Art of Beauty*, Chatto & Windus, London, 1878, pp. 273–4.

5. Lewis F. Day, 'William Morris and His Art', *Art Journal*, The Easter Annual 1899, p. 3.

6. Henry James to Miss Alice James, 10 March 1869, *The Letters of Henry James* (ed. Percy Lubbock), Macmillan & Co., London, 1920, Vol. I, pp. 18–19.

7. W. Graham Robertson, *Time Was*, first published London, 1931, Quartet Books, 1981, pp. 93–4.

8. May Morris, *Decorative Needlework*, Hughes & Co., London, 1893, pp. 84–6.

9. Oscar Wilde, *The Importance of Being Earnest*, 1895, Act 1.

10. Lucy Orrinsmith, *The Drawing-Room*, Macmillan & Co., London, 1878, p. 82.

11. Mrs M. J. Loftie, 'Work for Women', reprinted from the *Saturday Review* in *Social Twitters*, Macmillan & Co., London, 1879, pp. 137–42.

12. Rhoda Garrett, *The Electoral Disabilities of Women*, a speech delivered at Cheltenham to the Bristol and West of England Branch of the National Society for Women's Suffrage on 3 April 1872.

13. Gertrude Jekyll, *Colour Schemes for Flower Gardens*, *Country Life*, London , 1911, pp. vi–vii.

Chapter 2: Not a Lady Among Us!

1. Edith Wharton, *A Backward Glance*, D. Appleton-Century Co. Inc., New York and London, 1933, pp. 14–15.

2. Candace Wheeler, *Yesterdays in a Busy Life*, Harper & Brothers, New York, 1918, p. 211.

3. ibid., p. 210.

4. ibid., p. 211 and p. 222.

5. Candace Wheeler, *The Development of Embroidery in America*, Harper & Brothers, New York, 1921, p. 107.

6. *Yesterdays in a Busy Life*, p. 232.

7. ibid., p. 253.

8. *The Development of Embroidery in America*, p. 124.

9. ibid., p. 123.

10. Quoted by Madeleine B. Stern in *We The Women*, Artemis, New York, 1974, p. 287 and p. 283.

11. *Yesterdays in a Busy Life*, p. 421.

12. Constance Cary Harrison, *Woman's Handiwork in Modern Homes*, New York, 1881, p. 158.

13. *Yesterdays in a Busy Life*, p. 346.

14. ibid., p. 422.

15. M. Louise McLaughlin, *Pottery Decoration Under the Glaze*, R. Clarke & Co., Cincinnati, 1880, p. 41.

16. Herbert Peck, *The Book of Rookwood Pottery*, Crown Publishers, New York, 1968, p. 45.

17. Adelaide Alsop Robineau: *Keramic Studio* 15, No. 1, May 1913.

18. Frederick Rhead, *The University City Venture*, published in *Adelaide Alsop Robineau: Glory in Porcelain,* Syracuse, University Press, 1981, p. 107.

19. Charles F. Binns, 'The Art of the Fire', *The Craftsman*, Vol. 8, 1905, p. 208.

20. Carlton Atherton, memoir written in 1935, quoted by Peg Weiss in *Adelaide Alsop Robineau: Glory in Porcelain*, op. cit., p.23.

21. Report of the Panama Pacific Exposition, San Francisco, 1915.

22. Sadie Irvine, 'The Sadie Irvine Letters: A Further Note on the Production of Newcomb Pottery', by Robert W. Blasberg, *Antiques*,

August 1971, p. 250.

23. *The Craftsman*, October 1903, p. 71.

Chapter 3: Two Laughing, Comely Girls

1. J. W. Gleeson White, 'Some Glasgow Designers and Their Work: Part One', *The Studio*, Vol. 11, July 1897, p. 90.

2. *Neue Freie Presse*, report on the opening of the 8th Secession Exhibition, Vienna, 3 November 1900.

3. Letter from C. R. Mackintosh, 1902, quoted by Thomas Haworth in *Charles Rennie Mackintosh and the Modern Movement*, Routledge & Kegan Paul, London, 1977, p. xxxix.

4. J. W. Gleeson White, 'Some Glasgow Designers and Their Work: Part Two', *The Studio*, Vol. 12, 1897, p. 48.

5. C. R. Ashbee, *Memoirs*, 1915, MS, Victoria & Albert Museum, London.

6. J. W. Gleeson White, ibid., note 4.

Chapter 4: The Heyday of the Decorators

1. Elsie de Wolfe, *The House in Good Taste*, Century & Co., New York, 1913, pp. 18–21.

2. Mrs Jane Ellen Panton, *In Garret and Kitchen: Hints for the Lean Years*, Heath Cranton, London, 1920, p. 18.

3. *The House in Good Taste*, p. 9.

4. ibid., p. 48.

5. ibid., p. 6.

6. ibid., p. 72.

7. ibid., p. 21

8. Beverley Nichols, *A Case of Human Bondage*, Secker & Warburg, London, 1966, p. 26.

9. Morris Carter, *Isabella Stewart Gardner and Fenway Court*, published by the Trustees of the Isabella Stewart Gardner Museum, Boston, 1925, p. 105.

10. Letter from Henry Adams, 9 February 1906, quoted by Morris Carter.

11. L. J. Webb (Gertrude Vanderbilt Whitney), *Walking the Dusk*, Coward-McCann Inc., New York, 1932.

12. Beverley Nichols, *A Case of Human Bondage*, p. 124.

13. Ronald Fleming, unpublished MS, Victoria & Albert Museum, London.

14. Letter from Virginia Woolf to Ethel Smyth, 14 November 1930, *The Letters of Virginia Woolf*, Vol. 4, Hogarth Press, London, 1978, pp. 254–5.

15. Gwen Raverat, *Period Piece*, 1st edition Faber & Faber, 1952, London, 1954, p. 96.

16. ibid., p. 31.

Chapter 5: From Icon to Machine

1. Sergei Shcherbakov, *The Artist in Russia's Past*, New York, 1955, quoted by Szymon Bojko in *Russian Women-Artists of the Avant-garde*, exhibition catalogue, Galerie Gmurzynska, Cologne, 1979, p. 22.

2. Natalia Goncharova, quoted by John Bowlt in *Russian Art of the Avant-garde: Theory and Criticism 1902–1934*, Viking Press, New York, 1976, p. 58.

3. ibid.

4. Varvara Stepanova, statement from the catalogue of the *Tenth State Exhibition: Nonobjective Creation and Suprematism*, 1919, quoted by John Bowlt, p. 142.

5. Nadezhda Udaltsova, autobiography 1933, quoted in Galerie Gmurzynska catalogue, p. 312.

6. Liubov Popova, 'On Exact Criteria, Ballet Numbers, Deck Equipment on Battleships, Picasso's Latest Portraits, and the Observation Tower at the School of Military Camouflage in Kuntsevo', 1922, quoted in *The Avant-garde in Russia 1910–1930*, exhibition catalogue, Los Angeles County Museum, 1980, p. 222.

7. Liubov Popova, quoted by Camilla Gray in *The Russian Experiment in Art, 1863–1922*, Thames & Hudson, London, 1971, p. 204.

Chapter 6: Something Colourful, Something Joyful

1. 'Neue Keramik von Vally Wieselthier', *Deutsche Kunst und Dekoration*, 1928.

2. Vally Wieselthier, 'Zu Meinen Keramischen Arbeiten', *Deutsche Kunst und Dekoration*, 1922.

3. Vally Wieselthier, 'Ceramics', *Design*, November 1929.

4. *Deutsche Kunst und Dekoration*, 1929.

5. Adolf Loos, 'Ornament und Erziehung', 1924, quoted in *The Werkbund: Studies in the History and Ideology of the Deutscher Werkbund 1907–33*, The Design Council, London, 1980, pp. 112–13.

Chapter 7: Equipment and Couture

1. Paul Poiret, *My First Fifty Years*, translated by S. H. Guest, Victor Gollancz Ltd, London, 1931, p. 158.

2. Elsa Schiaparelli, *Shocking Life*, J. M. Dent & Sons Ltd, London, 1954, p. 229.

3. Charlotte Gere, *Marie Laurencin*, Academy Editions, London, 1977, p. 9.

4. Harold Acton, *Memoirs of an Aesthete*, Methuen & Co., London, 1948, p. 150.

5. Sonia Delaunay, quoted in *La Rencontre Sonia Delaunay-Tristan Tzara*, exhibition catalogue, Musée d'Art Moderne de la Ville de Paris, 1977.

6. Quoted by Philippe Garner in 'The Lacquer Work of Eileen Gray and Jean Dunand', *The Connoisseur*, May 1973, pp. 5–6.

7. Charlotte Perriand, an interview with Charlotte Perriand by P. Renous in *La Revue de l'Ameublement*, June 1963, pp. 73–84, author's translation.

8. Charlotte Perriand, 'Wood or Metal?', *The Studio*, Vol. 97, 1929, pp. 278–9.

9. *La Revue de l'Ameublement*, 1963.

10. *The Studio*, 1929.

11. ibid.

12. *La Revue de l'Ameublement*, 1963.

Chapter 8: The Rational Woman

1. Gunta Stadler-Stölzl, 'In der Textilwerkstatt des Bauhauses 1919 bis 1931', *Werk*, November 1968, author's translation.

2. Walter Gropius, 'Program of the Staatliche Bauhaus in Weimar', 1919, translated in *The Bauhaus*, MIT Press, Cambridge, Mass., 1978, p. 31.

3. Anni Albers, 'Weaving at the Bauhaus' in *On Designing*, Wesleyan University Press, Middletown, Connecticut, 1962 (first edition 1959), pp. 38–40.

4. ibid.

5. Gropius, 'Program', p. 32.

6. ibid.

7. Helene Nonné-Schmidt, 'Woman's Place at the Bauhaus', from the journal *Vivos voco* (Leipzig), Vol. V, No. 8/9, August–September 1926, translated in *The Bauhaus*, 1978, pp. 116–17.

8. Anni Albers, *On Designing*, pp. 6–7.

9. Gunta Stölzl, *Bauhaus Journal*, 1931, No. 2, translated in *The Bauhaus*, 1978, p. 465.

10. Anni Albers, *On Weaving*, Studio Vista, London, 1966 (first edition 1965), p. 47.

11. Otti Berger, 'Stoffe im Raum', *Red*, published by the Bauhaus, 1930, pp. 143–5, translation among Ethel Mairet's papers in the Crafts Study Centre, Bath.

12. Anni Albers, *On Weaving*, p. 62.

13. Anni Albers, *On Designing*, p. 27.

14. Marianne Brandt, letter to the author, 12 February 1981.

Chapter 9: The Simple Life

1. Bernard Leach, *A Potter's Book*, Faber & Faber, London, 1940, p. 1 (1976 edition).

2. Ethel and Philip Mairet, *An Essay on Crafts and Obedience*, a pamphlet published by Douglas Pepler's Ditchling Press in 1918.

3. At the Little Gallery, Mexican rugs, Italian embroideries and old patchwork quilts were displayed next to modern Swedish glass, pottery by Bernard Leach, Shoji Hamada, Katharine Pleydell Bouverie and Norah Braden and fabrics by Ethel Mairet, Barron and Larcher and Enid Marx. Other items, from jewellery to furniture, were also stocked.

4. Fiona MacCarthy, *The Simple Life: C. R. Ashbee in the Cotswolds*, Lund Humphries, London, 1981, p. 13.

5. Ethel Mairet, *Hand-Weaving Today*, Faber & Faber, London, 1939, pp. 12–13.

6. ibid., pp. 91–2.

7. Enid Marx, in the exhibition catalogue *Hand Block Printed Textiles by Phyllis Barron and Dorothy Larcher*, Crafts Study Centre, Bath, 1978.

8. Enid Marx and Margaret Lambert, *English Popular and Traditional Art*, Collins, London, 1946, p. 8.

9. Katharine Pleydell Bouverie, *Ceramic Review* No. 58, p. 21.

10. Michael Cardew, in the exhibition catalogue *Katharine Pleydell Bouverie*, Crafts Study Centre, Bath, 1980.

11. *Apollo*, December 1943, p. 163.

12. *Harpers & Queen*, April 1978.

13. Katharine Pleydell Bouverie, Crafts Study Centre exhibition catalogue.

14. Muriel Rose, *Artist-Potters in England*, Faber & Faber, London, 1955, p. 19.

15. Crafts Study Centre exhibition catalogue.

16. *Ceramic Review*, No. 58, p. 21.

17. ibid.

18. Margery Kendon, unpublished MS diary, 1936.

Chapter 10: Art and Industry

1. M. L. Eyles, *The Woman in the Little House*, Grant Richards Ltd, London, 1922, p. 123.

2. Herbert Read, *Art and Industry*, Faber & Faber, London, 1934.

3. *The Studio Yearbook*, 1930, p. 67.

4. Dorothy Todd, 'Marion Dorn, Architect of Floors', *The Architectural Review*, October 1933.

5. *The Studio*, May 1940.

6. 'A Weaver's Life', an interview with Marianne Straub in *Crafts*, No. 32, May/June 1978, p. 39.

7. Marianne Straub, a letter to the author, 1 October 1982.

8. Marian Pepler, a letter to the author, 30 September 1981.

9. *Women Artists 1550–1950*, by Ann Sutherland Harris and Linda Nochlin, exhibition catalogue, Los Angeles County Museum of Art, 1979, p. 61.

Chapter 11: The Return to 'Normality'

1. *Utility Furniture and Fashion 1941–1951*, exhibition catalogue, Geffrye Museum, London, 1974, p. 30.

2. Diana Trilling, *Mrs Harris: The Death of the Scarsdale Diet Doctor*, Hamish Hamilton, London, 1982, pp. 315–16.

3. Quoted by Fiona MacCarthy in *A History of British Design 1830–1970*, George Allen and Unwin, London, 1979, p. 103.

4. Tom Wolfe, *From Bauhaus to Our House*, Farrar Straus Giroux, New York, 1981, pp. 68–70.

Select Bibliography

General Criticism

Greer, Germaine, *The Obstacle Race*, London (Secker and Warburg), 1979.

Los Angeles County Museum of Art, *Women Artists: 1550–1950* (exhibition catalogue), Los Angeles, 1979.

Mitchell, Juliet, and Oakley, Ann (eds.), *The Rights and Wrongs of Women*, London (Penguin Books), 1976.

Parker, Rozsika, and Pollock, Griselda, *Old Mistresses: Women, Art and Ideology*, London (Routledge and Kegan Paul), London, 1981.

Strachey, Ray, *The Cause*, London (Bell & Sons Ltd), 1928; reprinted London (Virago), 1978.

Design Movements and Individual Artists

The numbers in square brackets indicate the chapters to which the particular work is most relevant.

Books and Pamphlets

Albers, Anni, *On Designing*, Middletown, Connecticut (Wesleyan University Press), 2nd enlarged edition, 1962. [8]
——*On Weaving*, Middletown, Connecticut (Wesleyan University Press), 1965.[8]

Anscombe, Isabelle and Gere, Charlotte, *Arts and Crafts in Britain and America*, London (Academy Editions), 1978. [1 and 2]

Anscombe, Isabelle, *Omega and After: Bloomsbury and the Decorative Arts*, London (Thames and Hudson), 1981. [4]

Arts and Crafts Essays, by Members of the Arts and Crafts Exhibition Society (including May Morris), London (Longmans Green & Co.), 1983. [1]

Aslin, Elizabeth, *The Aesthetic Movement, Prelude to Art Nouveau*, London (Elek Books), 1969. [1]

Billcliffe, Roger, *Charles Rennie Mackintosh: The Complete Furniture, Furniture Drawings and Interior Designs,* Guildford and London, 1979. [3]

Bowlt, John E. (ed. and trs.), *Russian Art of the Avant-garde. Theory and Criticism 1902–1934*, New York (Viking Press), 1976. [5]

Burne-Jones, Georgiana, *Memorials of Edward Burne-Jones*, 2 vols, London (Macmillan & Co.), 1904. [1]

Callen, Anthea, *Angel in the Studio: Women in the Arts and Crafts Movement 1870–1914*, London (Astragal Books), 1979. [1]

Carrington, Noel, *Carrington, Paintings, Drawings and Decorations*, Oxford (Oxford Polytechnic Press), 1978. [4]

Carter, Morris, *Isabella Stewart Gardner and Fenway Court*, Boston (Trustees of the Isabella Stewart Gardner Museum), 1925. [4]

Clark, Garth and Hughto, Margie, *A Century of Ceramics in the United States 1878–1978*, New York (E. P. Dutton), 1979. [2]

Conway, Moncure Daniel, *Travels in South Kensington*, London (Trübner & Co.), 1882. [1]

Crane, Lucy, *Art and the Formation of Taste*, London (Macmillan & Co.), 1882. [1]

Damase, Jacques, *Sonia Delaunay: Rhythms and Colours*, London (Thames & Hudson), 1972. [7]

Eyles, Margaret Leonora, *The Woman in the Little House*, London (Grant Richards Ltd), 1922. [10]

Fairclough, Oliver and Leary, Emmeline, *Textiles by William Morris and Morris & Co. 1861–1940*, London (Thames & Hudson), 1981. [1]

Fisher, Richard B., *Syrie Maugham*, London (Duckworth), 1978. [4]

Garrett, Agnes and Garrett, Rhoda, *Suggestions for House Decoration in Painting, Woodwork and Furniture*, London (Macmillan & Co.), 1876. [1]

Gray, Camilla, *The Russian Experiment in Art 1863–1922*, London (Thames & Hudson), 1971. [5]

Haweis, Mrs H. R. (Mary Eliza), *The Art of Beauty*, London (Chatto & Windus), 1878. [1]
——*The Art of Dress*, London (Chatto & Windus), 1879. [1]
——*The Art of Decoration*, London (Chatto & Windus), 1881. [1]
——*Beautiful Houses*, London (Sampson Low & Co.), 2nd edition, 1882. [1]
——*Words to Women*, London (Burnet & Isbister), 1900. [1]

Haworth-Booth, Mark, *E. McKnight Kauffer: A Designer and His Public*, London (Gordon Fraser), 1979. [10]

Henderson, Philip, *William Morris, His Life, Work and Friends*, London (Thames & Hudson), 1967. [1]

Howarth, Thomas, *Charles Rennie Mackintosh and the Modern Movement*, London (Routledge & Kegan Paul), 2nd edition, 1977. [3]

Jekyll, Francis, *Gertrude Jekyll: A Memoir*, London (Jonathan Cape), 1934. [1]

Jekyll, Gertrude, *Wood and Garden*, London (Longmans, Green & Co.), 1899. [1]
——*Home and Garden*, London (Longmans, Green & Co.), 1900. [1]
——*Colour in the Flower Garden*, London, Country Life, 1908. [1]

Joel, David, *Furniture Design Set Free*, London (J. M. Dent & Sons Ltd), 1969 (First published as *The Adventure of British Furniture*, 1953). [10]

Lipsey, Roger, *Coomaraswamy: Vol 3: His Life and Work*, Princetown (University Press), 1977. [9]

Loftie, Mrs M. J., *The Dining-Room*, London (Macmillan & Co.), 1878. [1]
—— *Social Twitters*, London (Macmillan & Co.), 1879. [1]

Macbeth, Ann and Swanson, Margaret, *Educational Needlecraft*, London, 1911. [3]

MacCarthy, Fiona, *The Simple Life: C. R. Ashbee in the Cotswolds*, London (Lund Humphries), 1981. [9]

Mairet, Ethel, *Vegetable Dyes*, Sussex (Ditchling Press), 1916. [9]
——*Hand-Weaving Today*, London (Faber & Faber), 1939. [9]

Mairet, Ethel and Mairet, Philip, *An Essay on Crafts and Obedience*, Sussex (Ditchling Press), 1918. [9]

Mairet, Philip, *Autobiographical and Other Papers* (ed. C. H. Sisson), Manchester (Carcanet), 1981. [9]

Marx, Enid and Lambert, Margaret, *English Popular and Traditional Art*, London (Collins), 1946. [9]
——*English Popular Art*, London (B.T. Batsford), 1951. [9]

McLaughlin, Louise, *China Painting*, Cincinnati (Robert Clarke & Co.), 1897. [2]

——*Pottery Decoration Under the Glaze*, Cincinnati (Robert Clarke & Co.), 1880. [2]
——*Suggestions to China Painters*, Cincinnati (Robert Clarke & Co.), 1883. [2]

Mendes, Valerie, 'Marion Dorn, Textile Designer', in *The Journal of The Decorative Arts Society, 1890–1940*, No. 2. [10]

Morgan, Ted, *Somerset Maugham*, New York (Simon & Schuster), 1980. [4]

Morris, May, *Decorative Needlework*, London (Hughes & Co.), 1893. [1]
——*William Morris: Artist, Writer, Socialist*, 2 vols, Oxford (Blackwell), 1936. [1]

Neuwirth, Waltraud, *Wiener Keramik*, Würzburg (Klinkhardt & Bierman, Braunschweig), 1974. [6]
——*Wiener Werkstätte Keramik, Vol 1, Original Keramiken 1920–31*, Vienna (Selbstverlag Dr W. Neuwirth), 1981. [6]

Ormond, Suzanne and Irvine, May G., *Louisiana's Art Nouveau: The Crafts of the Newcomb Style*, Louisiana (Pelican Publishing Company), 1976. [2]

Orrinsmith, Lucy (née Faulkner), *The Drawing Room, Its Decorations and Furniture*, London (Macmillan & Co.), 1878. [1]

Parry, Linda, *Morris and Company Textiles*, London (Thames & Hudson), 1983. [1]

Peck, Herbert, *The Book of Rookwood Pottery*, New York (Crown Publishers Inc.), 1968. [2]

Powell, Nicholas, *The Sacred Spring: The Arts in Vienna 1898–1918*, London (Studio Vista), 1974. [6]

Rose, Muriel, *Artist-Potters in England*, London (Faber & Faber), 1955. [9]

Ruskin, John, *Sesame and Lilies*, London (Smith, Elder & Co.), 1865. [1]

Schiaparelli, Elsa, *Shocking Life*, London (J. M. Dent & Sons Ltd), 1954. [7]

Schmidt, Georg, *Sophie Taeuber-Arp*, Basel, 1948. [7]

Schweiger, Werner J., *Die Wiener Werkstätte: Kunst und Handwerk 1903–1932*, Vienna (Christian Brandstätte), 1982. [6]

Sparling, H. Halliday, *The Kelmscott Press and*

William Morris Master-Craftsman, London (Macmillan & Co.), 1924. [1]

Staber, Margit, *Sophie Taeuber-Arp*, Lausanne, 1970. [7]

Stein, Gertrude, *The Autobiography of Alice B. Toklas*, London (The Bodley Head), 1933. [7]

Strasser, Susan, *Never Done: A History of American Housework*, New York (Pantheon Books), 1982. [10]

Tate Gallery: *Towards a New Art: Essays on the Background to Abstract Art 1910–20*, London (Tate Gallery), 1980. [7]

Thompson, Paul, *The Work of William Morris*, London (Quartet), 1977. [1]

Vergo, Peter, *Art in Vienna 1898–1918*, London (Phaidon), 1975. [6]

Weiss, Peg (ed.), *Adelaide Alsop Robineau: Glory in Porcelain*, Syracuse (Syracuse University Press), 1981. [2]

Wentworth-Shields, Peter and Johnson, Kay, *Clarice Cliff*, London (L'Odéon), 1976. [10]

Wharton, Edith, *Italian Villas and Their Gardens*, New York (Century Co.), 1904. [4]

Wharton, Edith and Codman, Ogden, *The Decoration of Houses*, New York (Charles Scribner), 1897. [4]

Wheeler, Candace, *Yesterdays in a Busy Life*, New York (Harper & Bros), 1918. [2]
——*The Development of Embroidery in America*, New York (Harper & Row), 1921. [2]

Wiches, George A., *Nathalie Barney: The Amazon of Letters*, London (W. H. Allen & Co.), 1977. [7]

Willett, John, *The New Sobriety: Art and Politics in the Weimar Period 1917–33*, London (Thames & Hudson), 1978. [8]

Wingler, Hans M., *The Bauhaus*, Cambridge, Mass. (MIT Press), 1976. [8]

Wolfe, Elsie de, *The House in Good Taste*, New York (Century & Co.), 1913. [4]
——*After All*, London (Heinemann), 1935. [4]

Wutzel, Otto, *Gudrun Baudisch Keramik*, Linz (Oberösterr. Landesverlag), 1981. [6]

Exhibition Catalogues, Articles and Papers

Arts Council of Great Britain, *Thirties: British Art and Design Before the War*, 1979. [10]

Bauhaus Archiv Museum für Gestaltung, *Sammlungs-Katalog*, Berlin (Gebr. Mann Verlag), 1981. [8]

Billcliffe, Roger, 'J. H. MacNair in Glasgow and Liverpool', Walker Art Gallery, Liverpool, Annual Report and Bulletin, Vol. 1, 1970–1. [3]

Camden Arts Centre, London, *Enid Marx, A Retrospective Exhibition*, 1979. [9 and 10]

Crafts Council, London, *Lucie Rie*, 1981.[11]

Crafts Study Centre, Holburne Museum, Bath, *Hand Block Printed Textiles by Phyllis Barron and Dorothy Larcher*, 1978. [9]

Crafts Study Centre, Holburne Museum, Bath, *Katharine Pleydell Bouverie*, 1980. [9]

Galerie Gmurzynska, Cologne, *Russian Women-Artists of the Avant-garde*, 1979. [5]

Geffrye Museum, London, *Utility Furniture and Fashion, 1941–1951*, 1974. [10 and 11]

Glasgow Museums and Art Galleries, *Glasgow School of Art Embroidery 1894–1920*, 1980. [3]

Guggenheim Museum, New York, *Art of the Avant-garde in Russia: Selections from the George Costakis Collection*, 1981. [5]

Jordan-Volpe Gallery, New York, *Ode to Nature: Flowers and Landscapes of the Rookwood Pottery 1880–1940*, 1980. [2]

Künstlerhaus, Vienna, *Moderne Vergangenheit Wien 1800–1900*, 1981. [6]

Los Angeles County Museum of Art, *The Avant-garde in Russia 1910–1930. New Perspectives*, 1980. [5]

Mendes, Valerie, 'Marion Dorn, Textile Designer', *The Journal of the Decorative Arts Society, 1890–1940*, No. 2. [10]

Museum of Modern Art, Oxford, *Alexander Rodchenko*, 1979. [5]

Oakland Museum, *Mathews: Masterpieces of the California Decorative Style*, 1972. [2]

Oesterreichische Museum für Angewandte Kunst, Vienna, *Oesterreichische Keramik des Jugendstils*, 1974. [6]

Scottish Arts Council, *Jessie M. King 1875–1949*, 1971. [3]

Sotheby's at the Charles Rennie Mackintosh Society, London, *Jessie M. King and E. A. Taylor, Illustrator and Designer*, 1977. [3]

Victoria & Albert Museum, London, *The Way We Live Now: Designs for Interiors 1950 to the Present Day*, 1978. [11]

Victoria & Albert Museum, London, *Eileen Gray: Designer 1879–1976*, 1979. [7]

Josiah Wedgwood & Sons Ltd, Ballaston, *Elegance and Utility: 1924 to 1978. The Work of Susie Cooper RDI*, 1978. [10]

Index

Numbers in *italics* refer to illustrations; italicised roman numerals refer to plates in the colour section.